THE DOGIST
PUPPIES

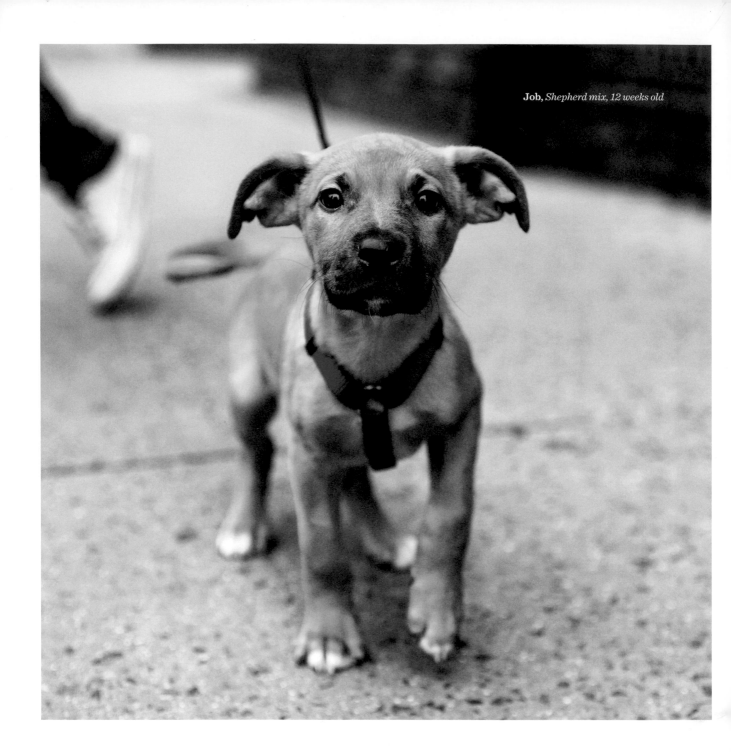

Job, *Shepherd mix, 12 weeks old*

THE DOGIST
PUPPIES

ELIAS WEISS FRIEDMAN

ARTISAN | NEW YORK

Library of Congress Cataloging-in-Publication Data

Names: Friedman, Elias Weiss, author.
Title: The dogist puppies / Elias Weiss Friedman.
Description: New York : Artisan is a registered trademark of Workman
Publishing Co., Inc., [2017] | Includes index.
Identifiers: LCCN 2017019705 | ISBN 9781579657437
Subjects: LCSH: Working dogs—Pictorial works.
Classification: LCC SF428.2 .F75 2017 | DDC 636.73022/2—dc23 LC record available
at https://lccn.loc.gov/2017019705

Book design based on an original design by Toni Tajima

Artisan books are available at special discounts when purchased in bulk for
premiums and sales promotions as well as for fund-raising or educational use.
Special editions or book excerpts also can be created to specification. For details,
contact the Special Sales Director at the address below, or send an e-mail to
specialmarkets@workman.com.

Published by Artisan
A division of Workman Publishing Co., Inc.
225 Varick Street
New York, NY 10014-4381
artisanbooks.com

Artisan is a registered trademark of Workman Publishing Co., Inc.

Published simultaneously in Canada by Thomas Allen & Son, Limited

Printed in China

3 5 7 9 10 8 6 4 2

To everyone who considers dogs family

introduction

Puppy. There are few other words that conjure such happiness all on their own. The definition of puppy—a young dog—hardly does the concept justice. I've photographed more than 25,000 dogs since I began The Dogist in the fall of 2013, and nothing gets me more excited and focused than spotting a jumpy puppy from across the street. "Is that a small dog... or a... *puppy*? That's a puppy!" (This is when I have to restrain myself from sprinting across oncoming traffic to reach the pup and its owner.) Once I get to the puppy, I'm usually competing against other passersby attempting to take pictures of the dog—as if seeing a puppy is the eighth wonder of the world. But a puppy is a wondrous creature, with its wrinkles, oversized ears and paws, wobbly walk, and innocently curious disposition. It's not always easy to get a clear shot, but when I do, the photo will put a smile on your face.

Photographing puppies isn't easy. First, newborns aren't outside taking walks, so visiting them with their mom and litter is the only way to see puppies when they're just a few days or weeks old. My photographs almost always capture a focused moment of eye contact between the dog and me, which makes newborn puppies especially difficult subjects—it's easier to photograph a blind and deaf senior dog. Newborn puppies are basically nursing/sleeping dog blobs until they open their eyes at around 2 weeks of age. It's not until they are 5 to 8 weeks old that their personalities emerge, and not coincidentally, they become even cuter. A 5-week-old puppy looks like a little stuffed animal, and everything he does is adorably dopey. This is when a pup's curiosity about the world starts to pique; he is interested in his surroundings, is easily distracted, and wants to bite everything.

At 8 to 12 weeks old, a puppy can finally venture outdoors (with some restrictions). At this age, he hardly knows more than the room he was born in.

Outside, there are new people, sounds, smells, and textures overwhelming his little puppy brain, which is more than enough stimulation for most *adult* dogs. When I see a young puppy on the street, I'm armed with my usual squeaky tennis ball and biscuits to get his attention. But a puppy barely knows up from down and certainly hasn't mastered the "sit" or "stay" command. Getting him to compose himself for a photo is a tall order. I set my camera's shutter to burst and the autofocus to "cheat mode" and about 20 blurry photos later, I have my moment: He's tired himself out from pulling on his harness in his attempt to play with me. He plops his little butt down and looks into the camera with a wistful stare and—*click, click, click*—I've got my shot.

I hope when you look at the pictures in this book they make you smile, but I also hope the book gives people a better understanding of responsible dog ownership. Some might read this book and immediately want to get a puppy. I often find myself surrounded by these adorable creatures, and it gives me a regular reality check as to what goes into the care and well-being of a young dog. Take some advice from me: Bringing a puppy home is much more responsibility than you think and is a decision that should be thoughtfully considered before acted on—not only whether to get a dog, but what type and where to get it. Consider what size and breed of dog best suits your lifestyle. An active dog meant to perform a task like herding or hunting should never be contained to life in a city apartment. And a dog with a short nose and temperature sensitivity might not be right for you if you live in an extreme climate or have an especially active lifestyle.

People interested in getting a puppy should consider rescuing from a shelter first, especially if the dog's primary role will simply

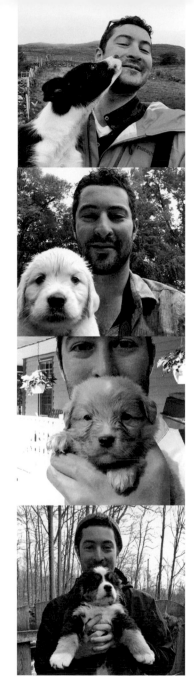

be that of a pet and family member. Shelters around the country have dogs of all breeds and ages available, and shelter pups make great companions for anyone who believes in serendipity. Never buy a puppy from a pet store. If a breeder is careless enough to allow their puppies to be featured in a store window and to go home with anyone with a credit card, you can be sure their breeding programs and health protocols are equally as careless. Breeders who capitalize on cultural breed trends are unethical, give responsible breeders a bad stigma, and are a huge contributor to canine overpopulation in shelters. Puppies who are bought on a whim are often abandoned on a whim. If you're considering becoming the owner and guardian of a highly emotional, time-consuming, expensive, and beautiful dog, the process should not be easy. The majority of people who buy puppies at pet stores are simply uninformed about dogs in general and fall for the puppy in the window. Those dogs deserve homes too, but if you're going to window-shop, I encourage you to do it at a shelter. And if you're not quite sure if you're ready for a puppy, try fostering before

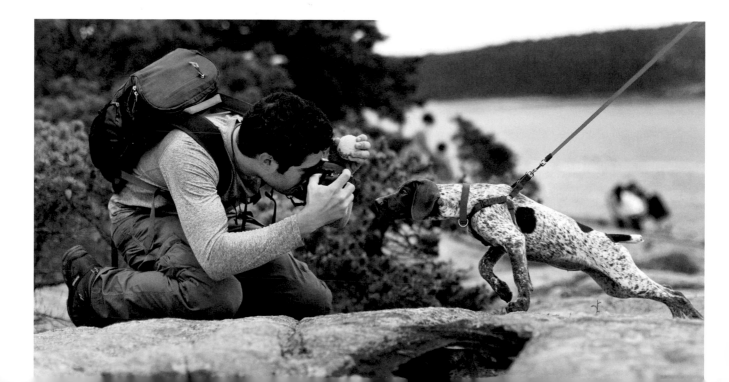

you commit to adopting. You can be a puppy parent for a few days and test the waters of life with a dog.

If you know you want to work with a breeder, make sure they prioritize their dogs' best interests before anything else (like financial gain). I'd recommend looking for reputable breeders through a local or national breed club or the American Kennel Club. The breeders I met while making this book are people who have dedicated their lives to preserving and maintaining the many standards of their particular breed. Good breeders ensure their animals are healthy, checking hip and eye scores (among others) and varying their dogs' gene pool sufficiently to avoid genetic abnormalities. Each breed's overall temperament, physical characteristics, and health are the product of decades of carefully selected breeding by responsible people with a passion for their breed's purpose. It's critical to work only with breeders who live up to these standards—and you'll know it when you see it. When you drive up to the breeder's home and are greeted by a pack of eight happy, healthy, free-roaming adult Bernese Mountain Dogs, you know you've found a good breeder. When a breeder has a wait list that's over a year long because they don't want to overstress the mother, you've found a good breeder. If unfortunate circumstances arise and you need to give up your new puppy and the breeder insists that the dog be brought back to them, that's another sign of a good breeder.

Creating this book has certainly deepened my fascination with dogs. In these pages, you'll learn about puppies of all breeds and witness their unique characteristics. Border Collies are bred to herd sheep, and Nova Scotia Duck Tolling Retrievers learn to lure ducks to within a hunter's shot and then fetch them from the water. Labrador and Golden Retrievers were also bred to be hunters' sidekicks, but their eagerness to work and capacity to learn make them great service dogs. French Bulldogs nowadays mostly fill the role of family pet/clown, but their ancestors did indeed fight bulls. You'll see how puppies double and even triple in size within a span of just a few months through the photos I've taken of the same puppies in the Then and Now sections. And you'll find adorable galleries of puppy pairs, puppy paws,

puppy ears, and even puppies at their first vet visit. You'll see mixed-breed puppies that aren't *just* "mutts"—they might carry genes from 10 different dogs to give them short legs, a curly tail, a spotted coat, and icy blue eyes. This book, just like my first one, shows that the beauty of dogs is in their diversity of form and function, and while beauty may be in the eye of the beholder, all dogs deserve recognition for who they are and why they're here. If you've read this far, I admire your restraint. There are about 800 puppies, anywhere from newborn to age 1, that await you in the pages to follow.

Dogs of all ages teach us about love and bring a pure sense of joy to our lives. They give us so much yet ask for so little in return. I hope this book entertains you and encourages you to consider getting a dog, but also informs you of the responsibilities puppy ownership entails. Puppies pee, poop, vomit, gnaw on everything, and can't do any tricks. They are fragile little beings that cry incessantly and are about as expensive and time-consuming to care for as a human child. But after you get through the up-all-night puppy phase, you've made yourself a best friend for life.

Stella, »
Labrador Retriever,
8 weeks old

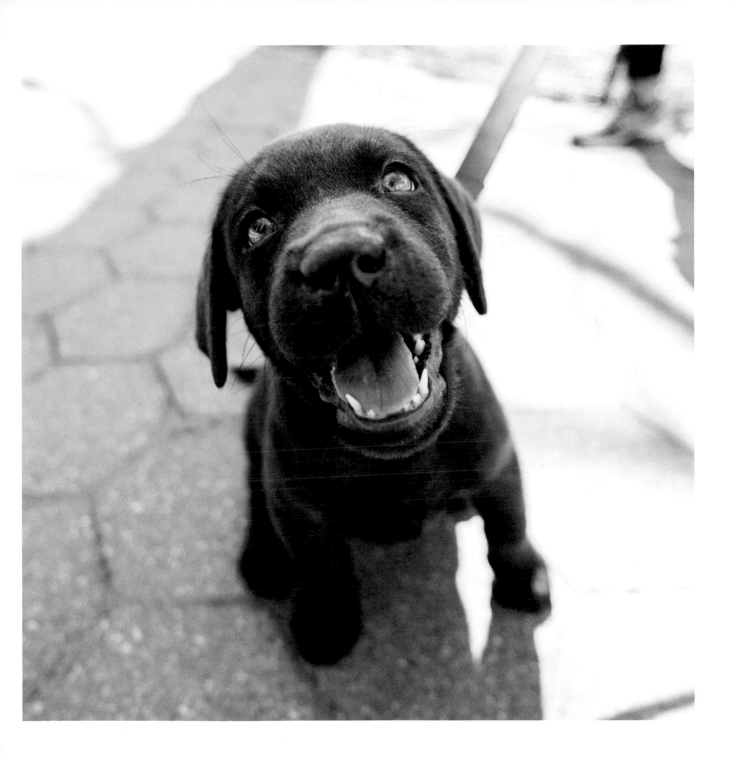

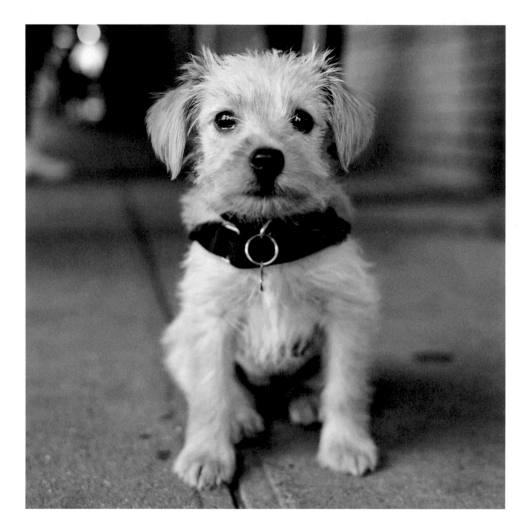

Addy, *Terrier mix, 10 weeks old*

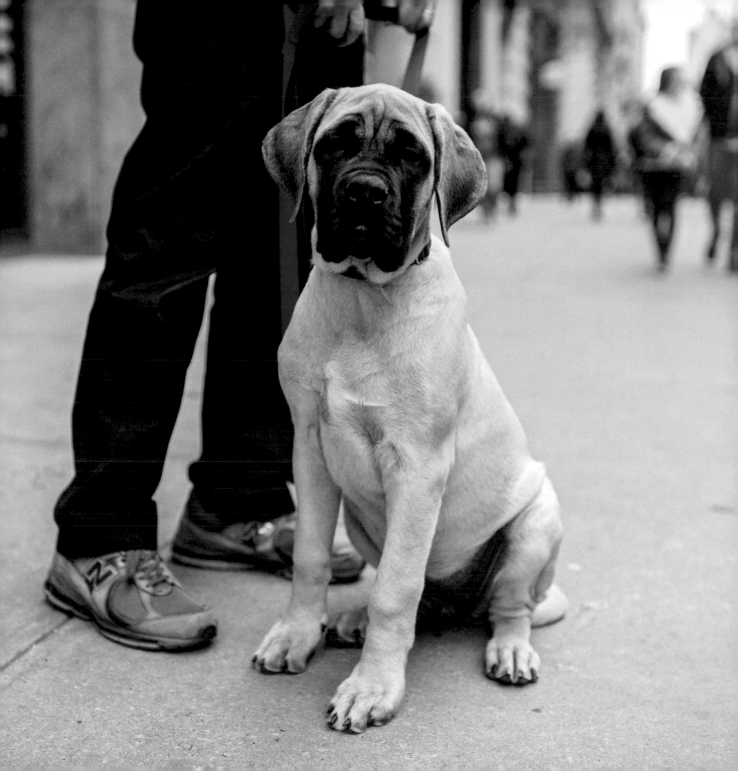

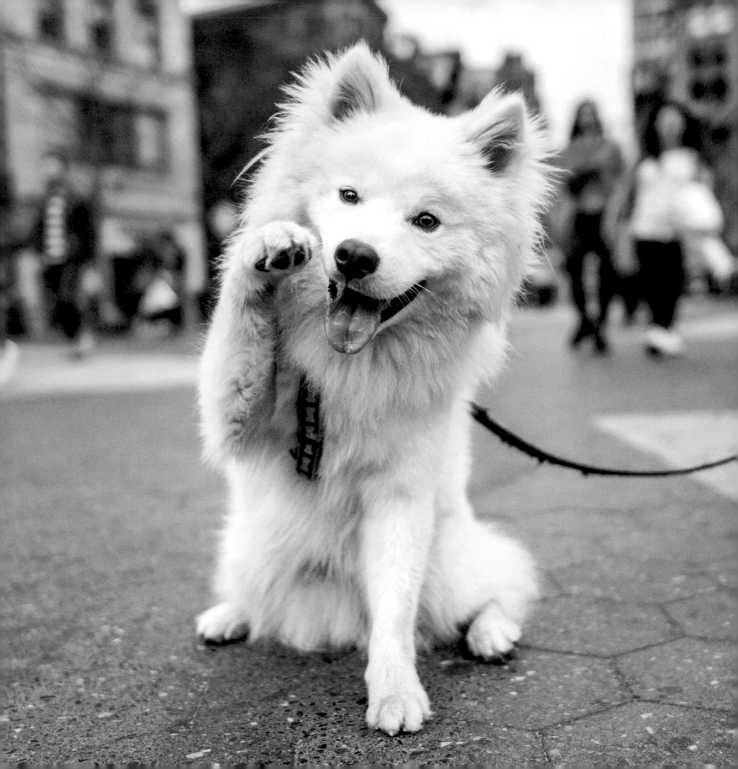

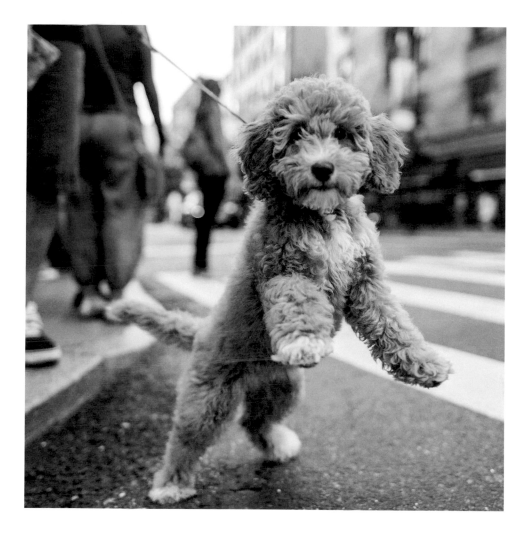

Abigail, *Miniature Labradoodle, 12 weeks old*

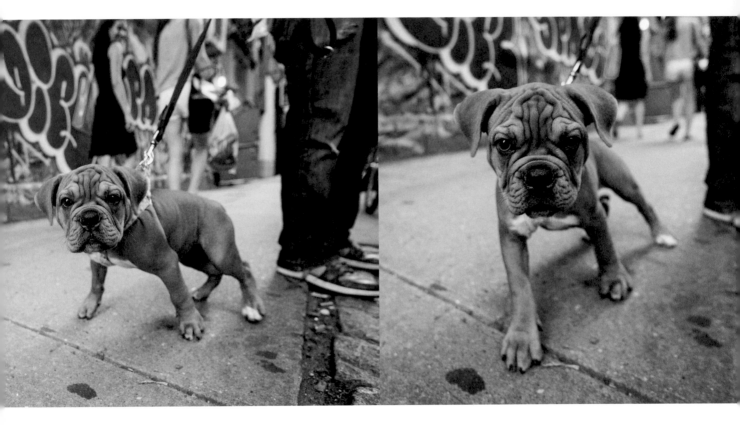

Maddi, *Olde English Bulldogge, 3 months old*

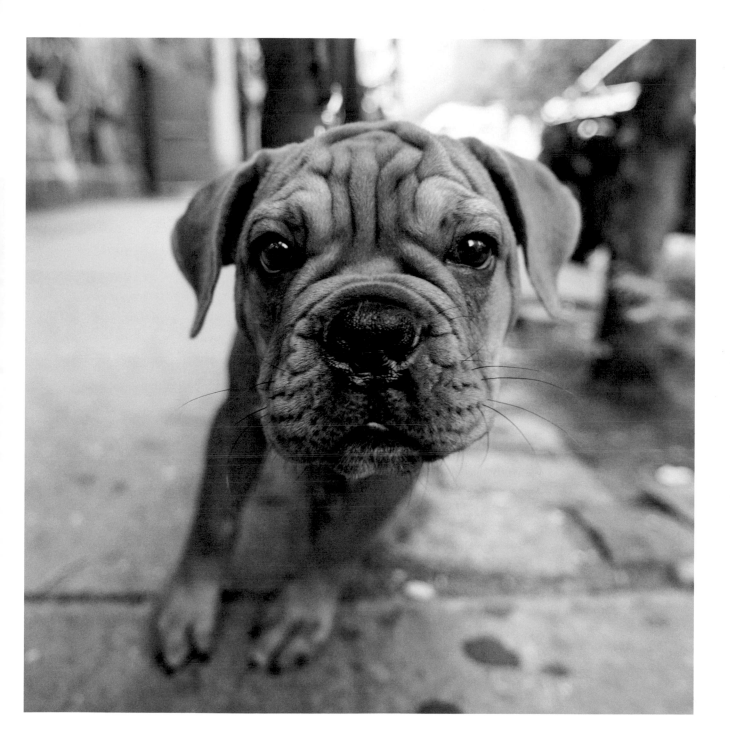

carried away

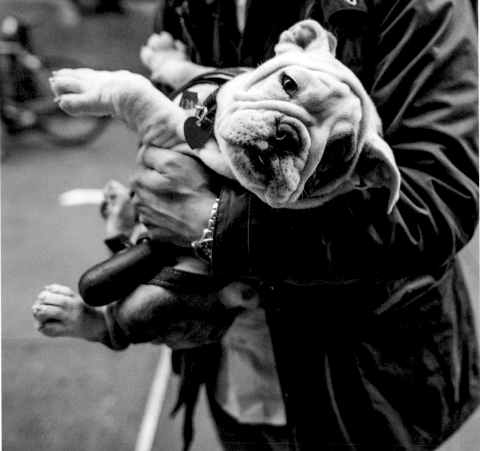

CLOCKWISE,
FROM TOP LEFT

Doukhobor,
Shetland Sheepdog,
12 weeks old

Finn,
Miniature Dalmatian,
5 months old

Daenerys Targaryen,
Miniature Australian Shepherd,
11 weeks old

Winnie,
Dachshund,
16 weeks old

« **Nala,** *English Bulldog,*
4 months old

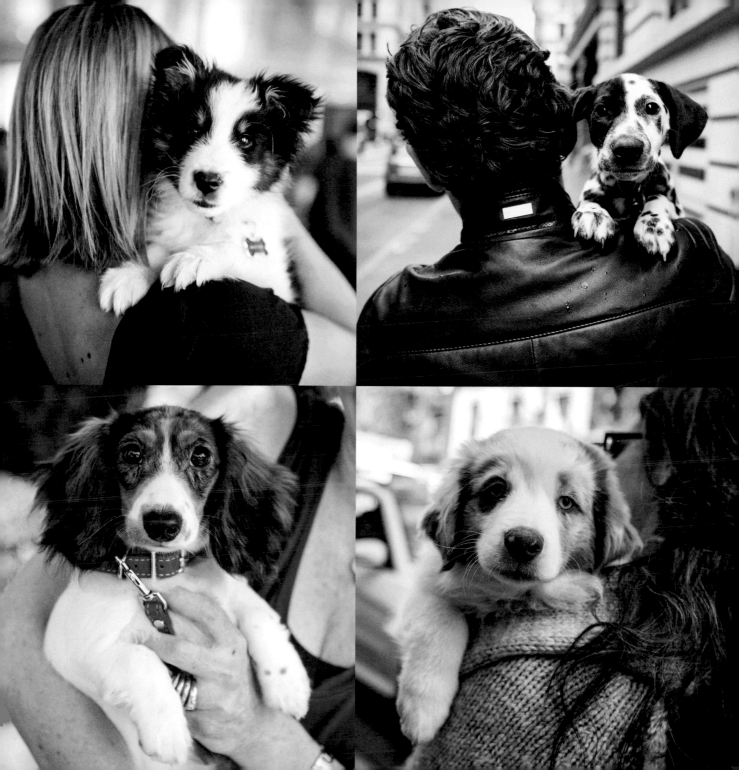

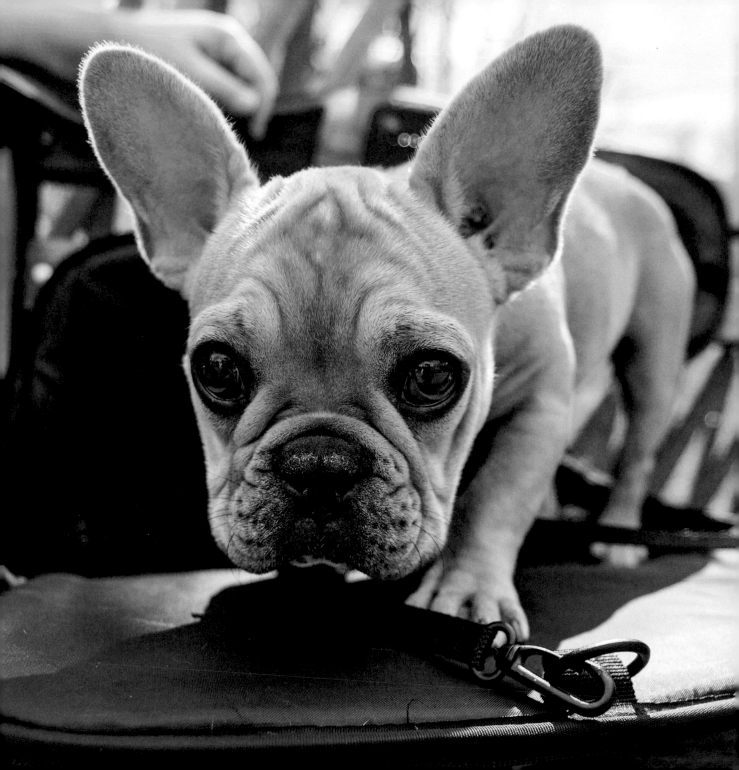

then

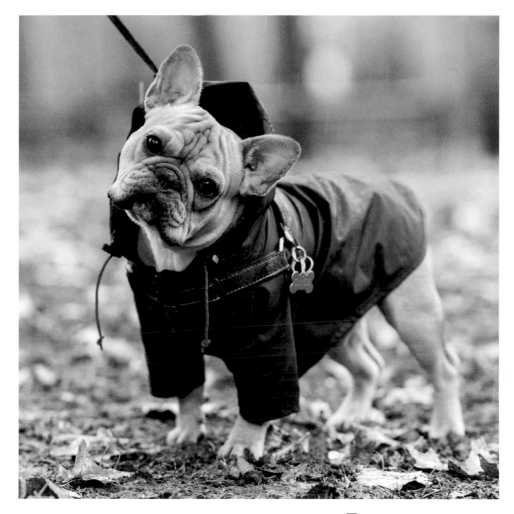

and now

11 months old

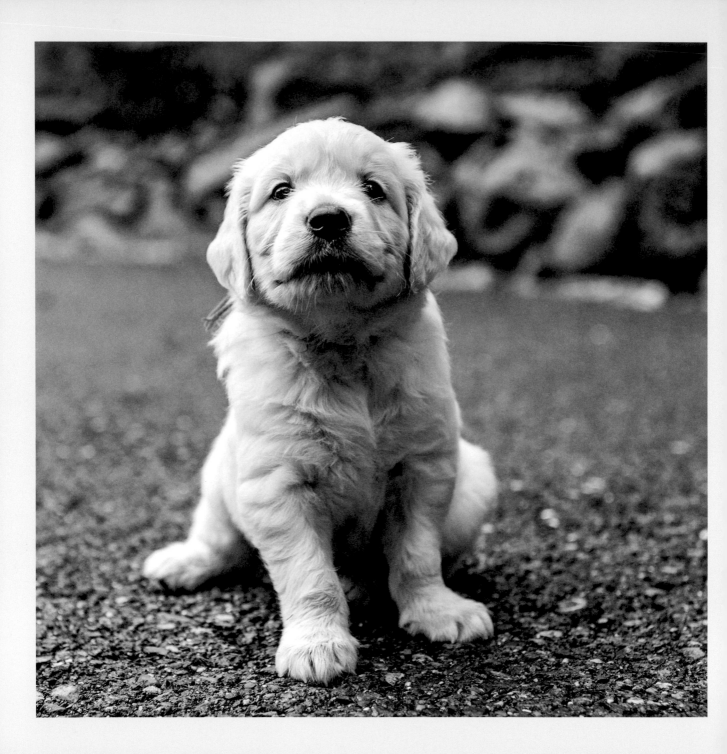

golden retrievers

Golden Retrievers have a way of putting most people in a good mood. After having photographed more than 25,000 dogs, I can confidently say that Goldens take the award for smiliest pups. They have a kind, playful, "How can I please you?" energy that makes them excellent family pets and therapy dogs (and terrible guard dogs). Golden Retrievers have become extremely popular over the years and are often the dog of choice in advertising campaigns. However, as a result of their popularity, like other breeds that become popular (think Dalmatians after the movie *101 Dalmatians* was rereleased), some irresponsible breeders try to meet demand by overbreeding dogs with little concern for the health of the dogs or the breed in general. Thus the breed now has a higher-than-average incidence of cancer and hip dysplasia. If you're planning on welcoming a Golden Retriever puppy into your home, which is a very special position to be in, do your research to find a reputable breeder who can provide a detailed pedigree with health scores. At Icewind Farm, in Phillipsburg, New Jersey, they breed a "cream"-colored line of Golden Retrievers, from dogs brought to the United States from Europe, to increase genetic diversity, reducing certain health risks for a dog over its life span.

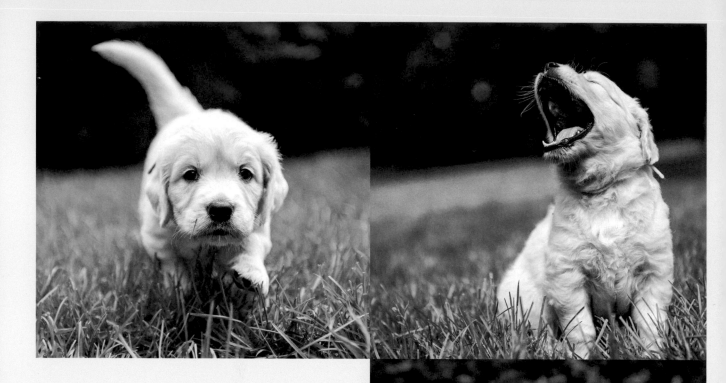

Golden Retrievers' coats can range from a light cream color, as seen here, to a deep mahogany that looks almost red.

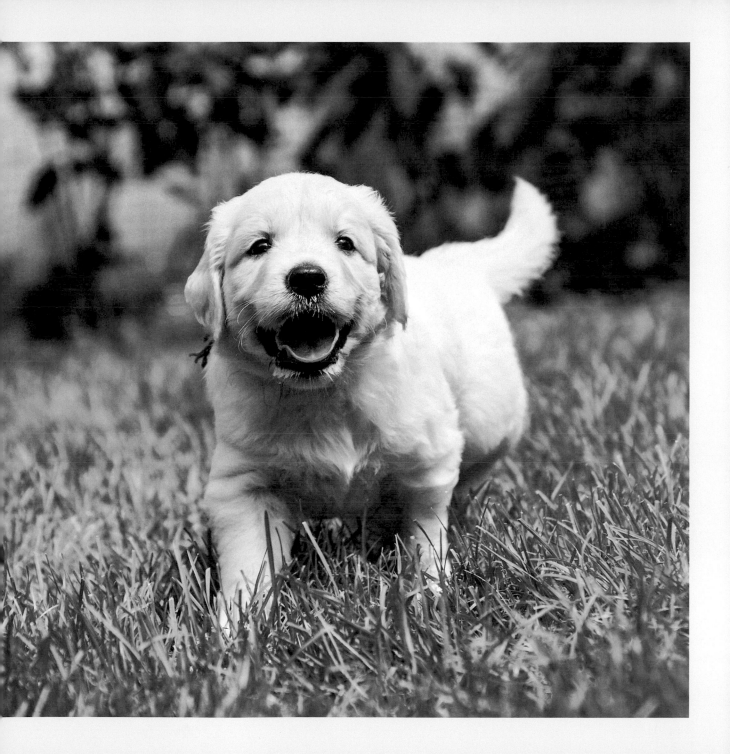

Puppy kisses are adorable, but also important for their emotional and social development.

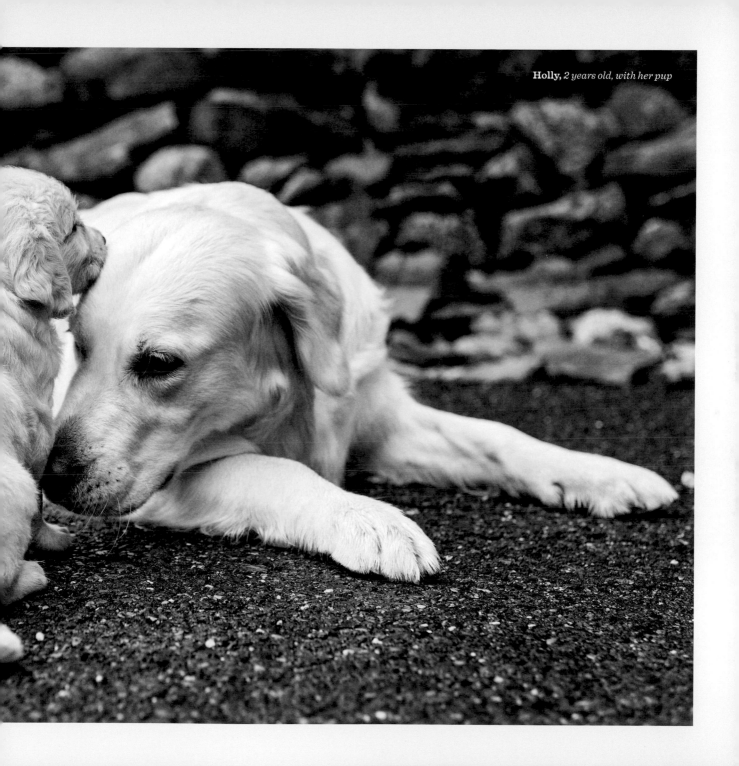

Holly, *2 years old, with her pup*

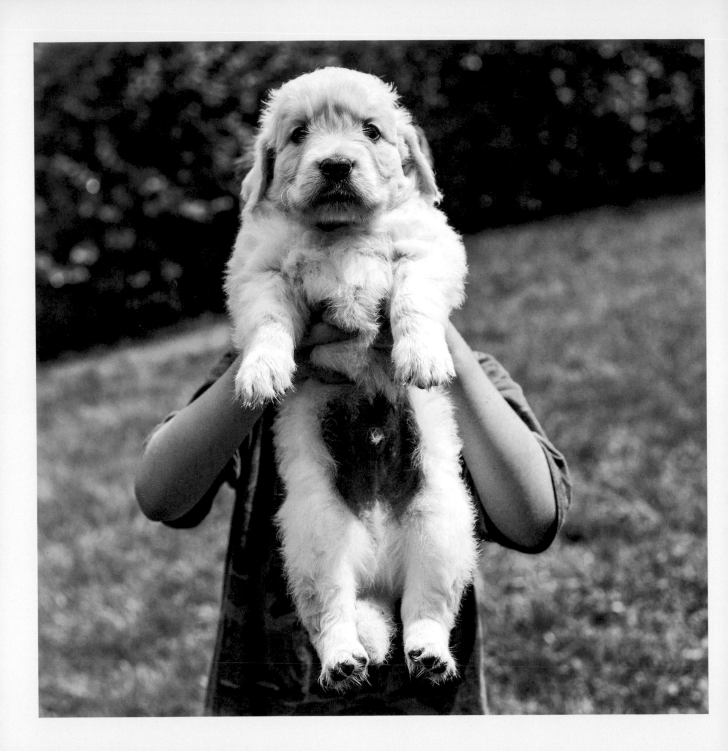

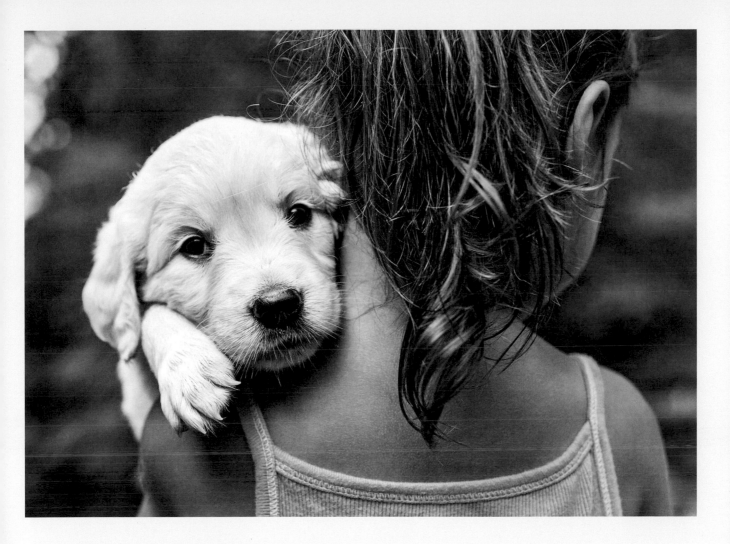

The handling of dogs at an early age, especially by children, provides key neurological stimulation for the dogs and prepares them to be in a house that might have young kids.

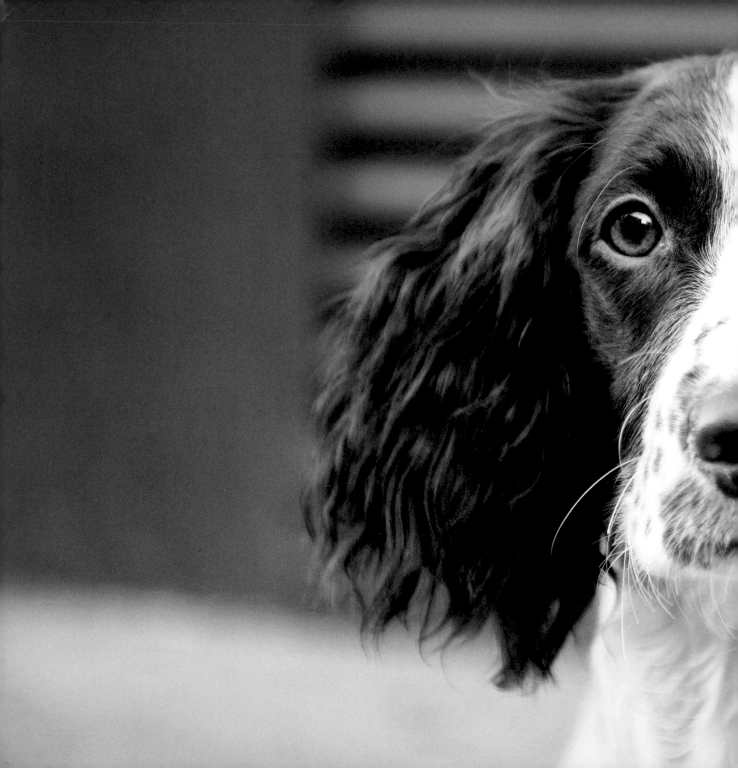

Slim, *English Springer Spaniel, 10 months old*

paws

CLOCKWISE,
FROM TOP LEFT

Lucky,
Chow Chow,
9 months old

Ike,
Great Dane,
4 months old

Boxer,
8 weeks old

Libby,
Wheaten Terrier,
3 months old

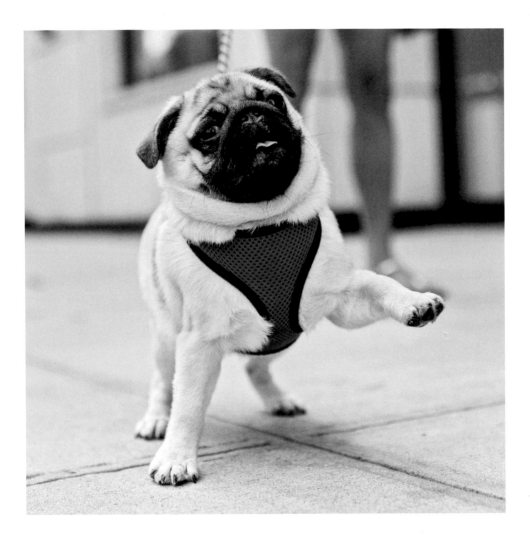

《 **Philippa,** *Pug,*
5 months old

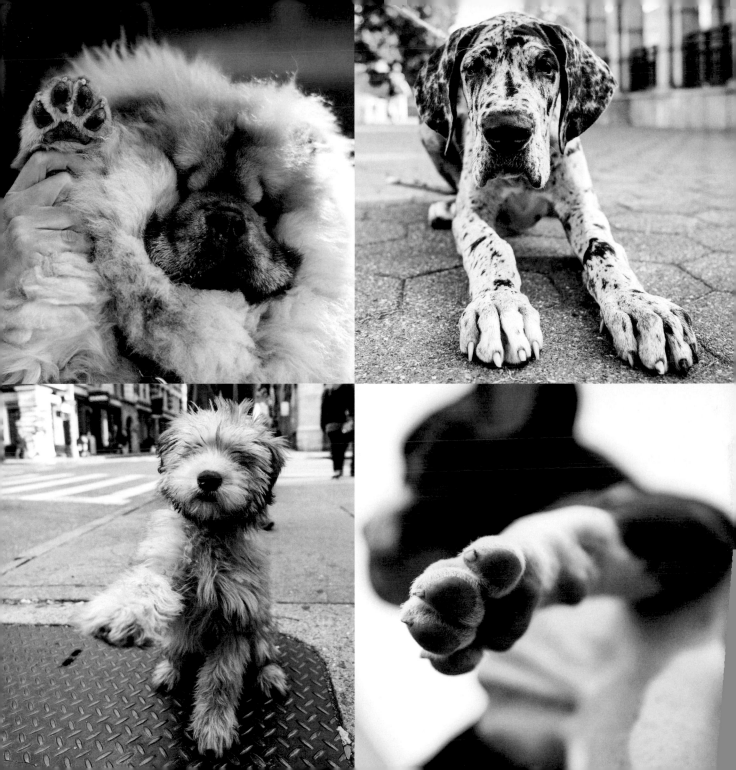

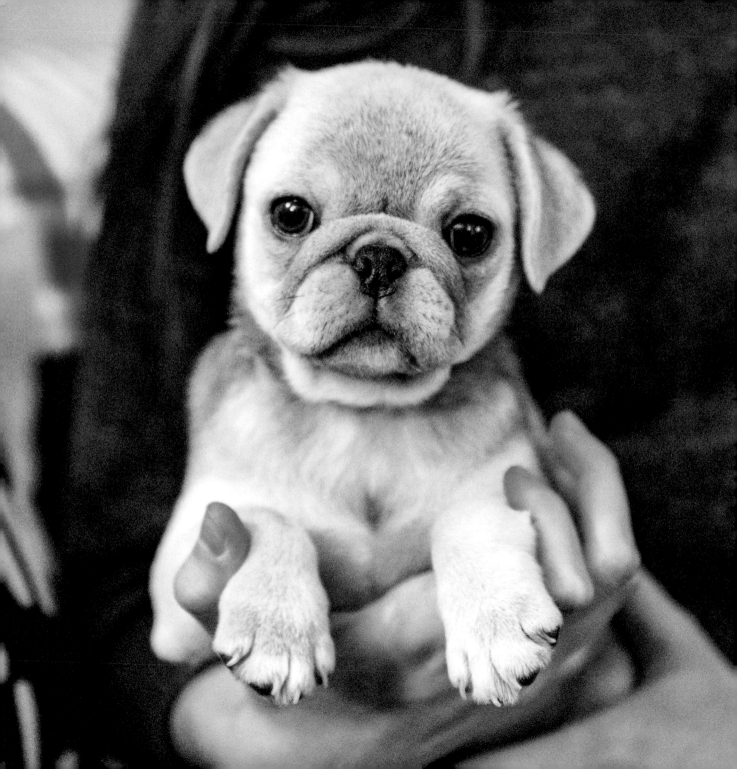

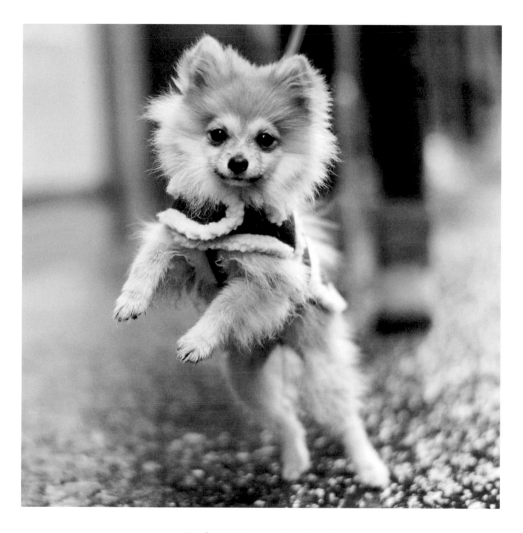

Bamba, *Pomeranian, 4 months old*

"She likes chewing paper towels and chasing the vacuum."

pairs

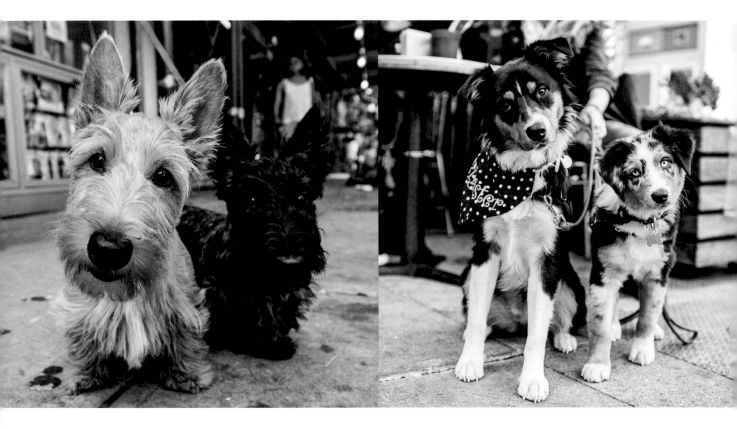

Isobel and **Agnes,** *Scottish Terriers,*
5 months old

Jackson and **Moose,** *Australian Shepherds,*
10 months old and 10 weeks old

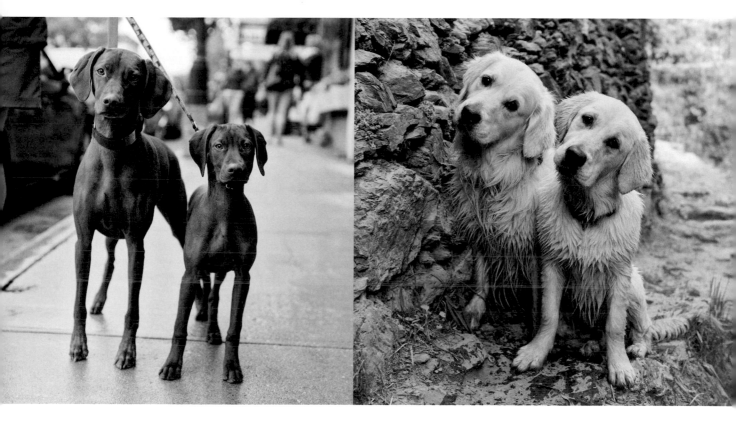

Gracie and **Olive,** *Vizslas,*
4 years old and 4 months old

Lucky and **Bianco,** *Golden Retrievers,*
3 years old and 6 months old

puppy care

Leo has gained a pound since his first vet visit. He will be approximately 12 pounds when he's fully grown.

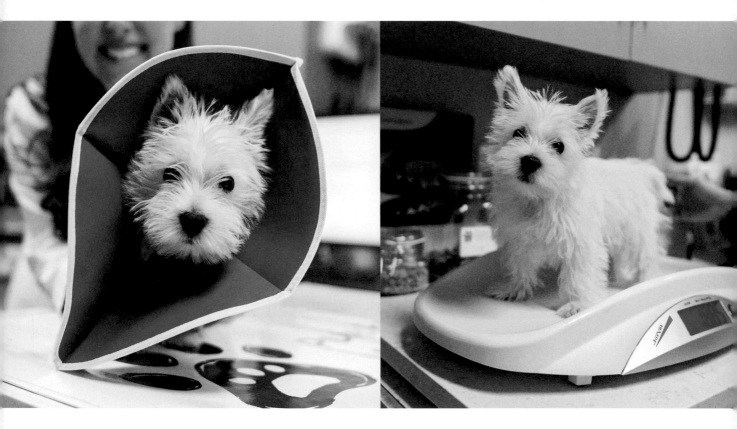

Leo, *West Highland White Terrier, 11 weeks old*

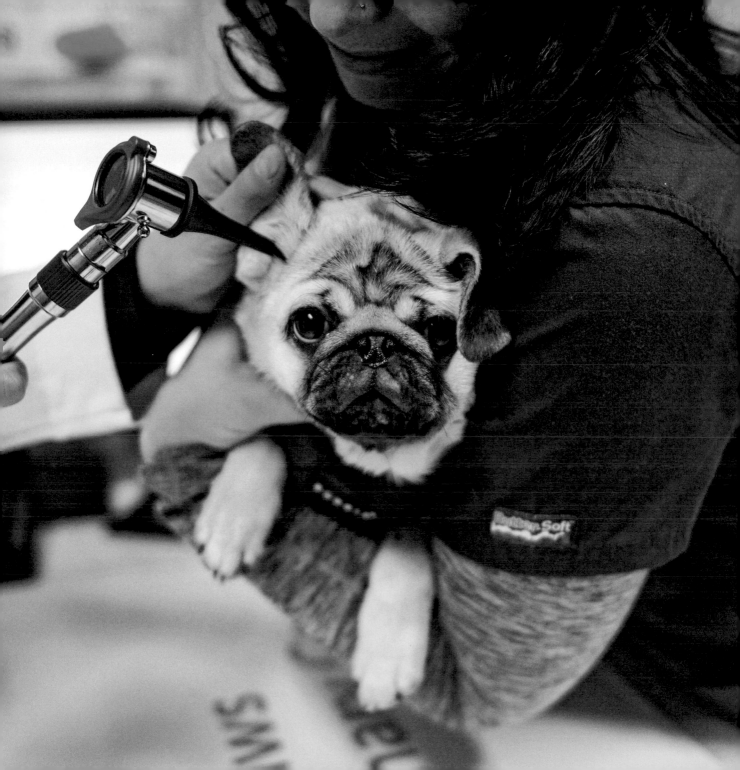

Eamon, *Kuvasz, 13 weeks old*

Cleo, *mix, 3 months old*

seppala siberian huskies

This special breed of sled dog originated in Siberia and was developed in the early 1900s by a revered sled dog musher named Leonhard Seppala. Unlike the more common American Siberian Husky, which most people are familiar with, Seppalas are bred for their ability to pull sleds long distances and endure cold environments. They're the athletes of the dog world. The huskies I typically see are from show lines: dogs bred to conform to a visual and physical body standard (versus a working-dog performance standard). Show lines of Siberian Huskies have developed a distinct look: a clover-shaped mask of fur around their eyes, smaller ears, wider heads, and bushier tails. Seppalas have taller ears and less distinctive markings, and are generally leaner; they're a rare and unique breed preserved by people with a passion for sledding dogs. This breeder at Cold Mountain Siberians builds his own custom land sleds and runs his pups 10 at a time for 30 miles or more a day when they're training.

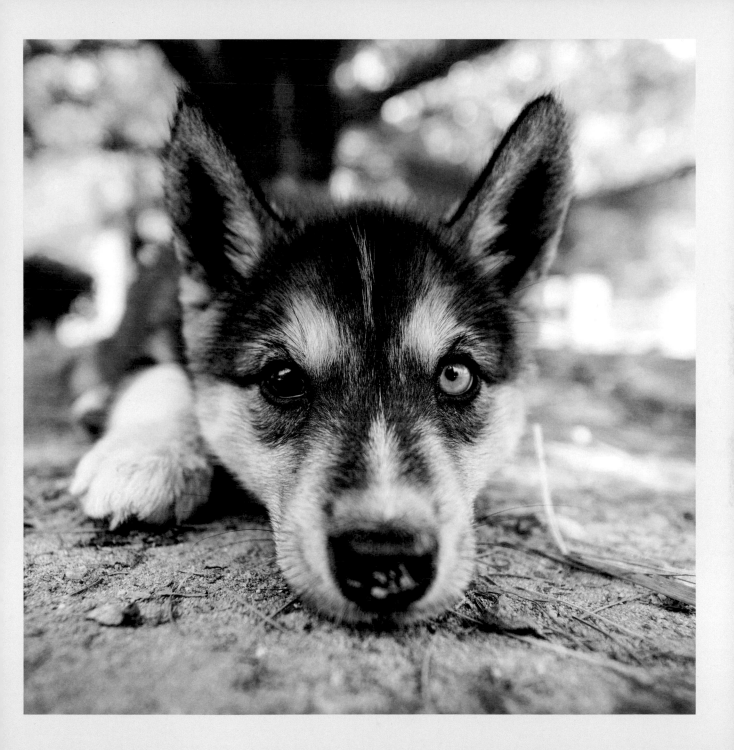

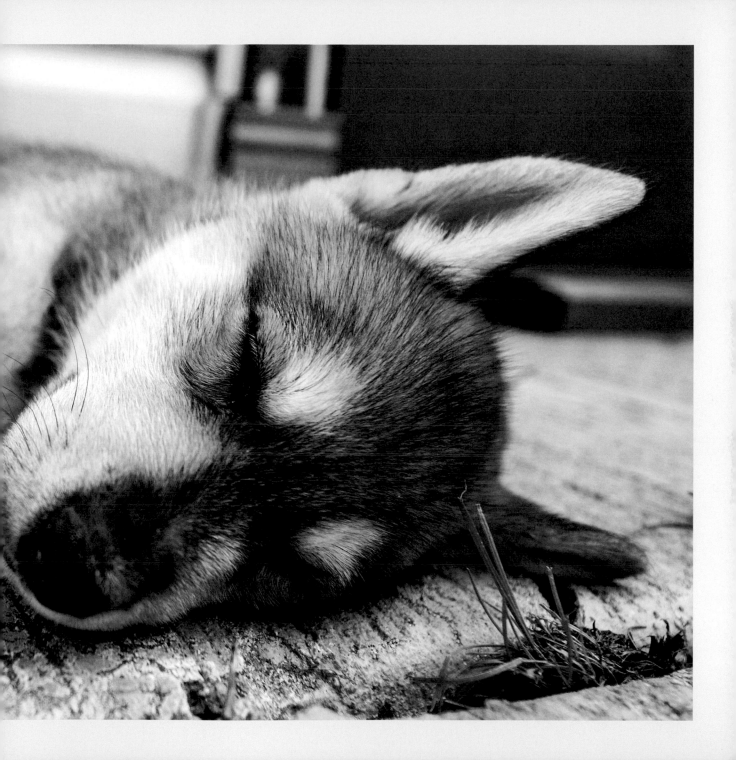

The puppies spend as much time as possible outdoors; they're raised close to nature so they learn to tolerate any weather condition. The breeder also built them subterranean den structures to mimic the type of sleeping environment wolves seek out.

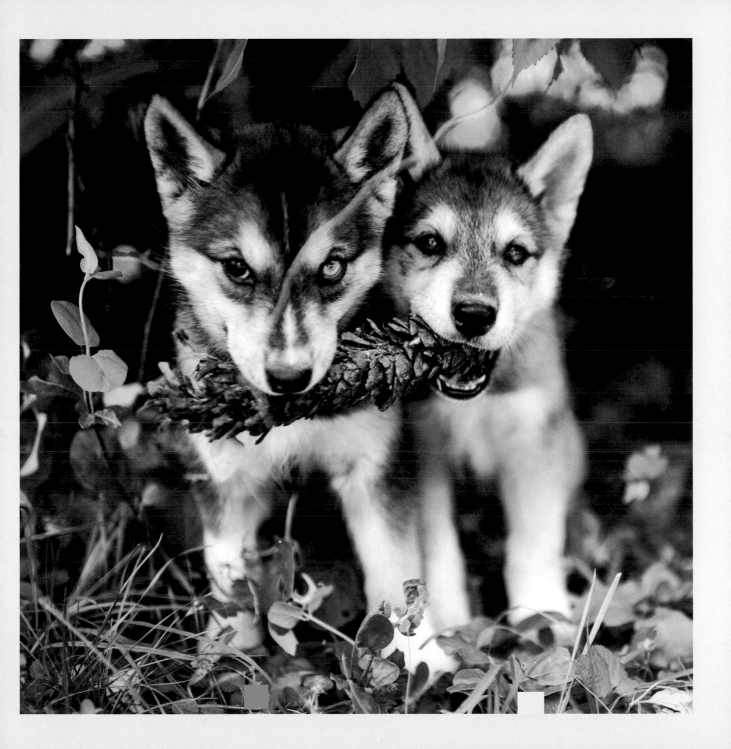

The way littermates play

with one another sets an important precedent for their future interactions with other dogs and humans. Here we see an example of puppies learning "bite inhibition." Puppies start to roughhouse at 4 to 6 weeks of age, and they love biting and nipping at each other. In biting each other, they learn to modulate their bite strength; if they bite too hard, their playmate will cry and playtime will stop. This early conditioned learning ensures that as they grow up, the dogs know their own strength and don't harm other dogs or people.

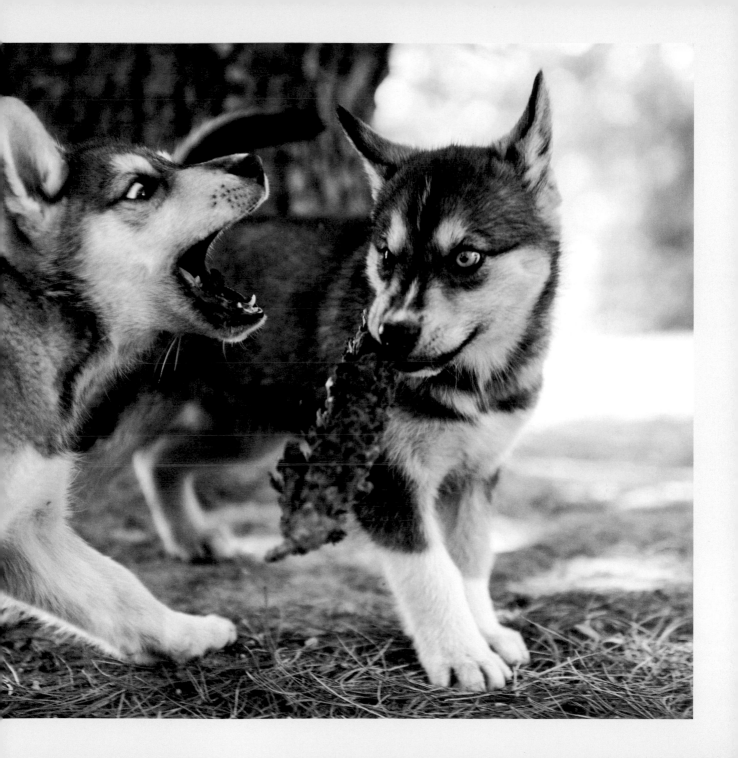

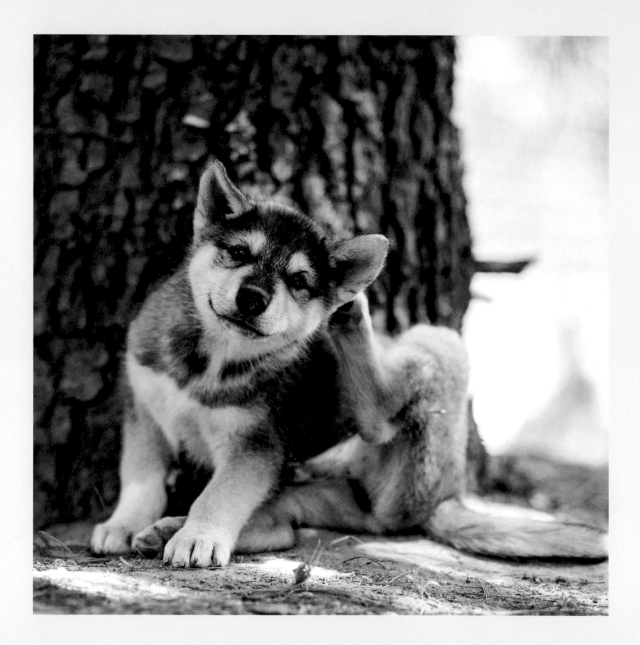

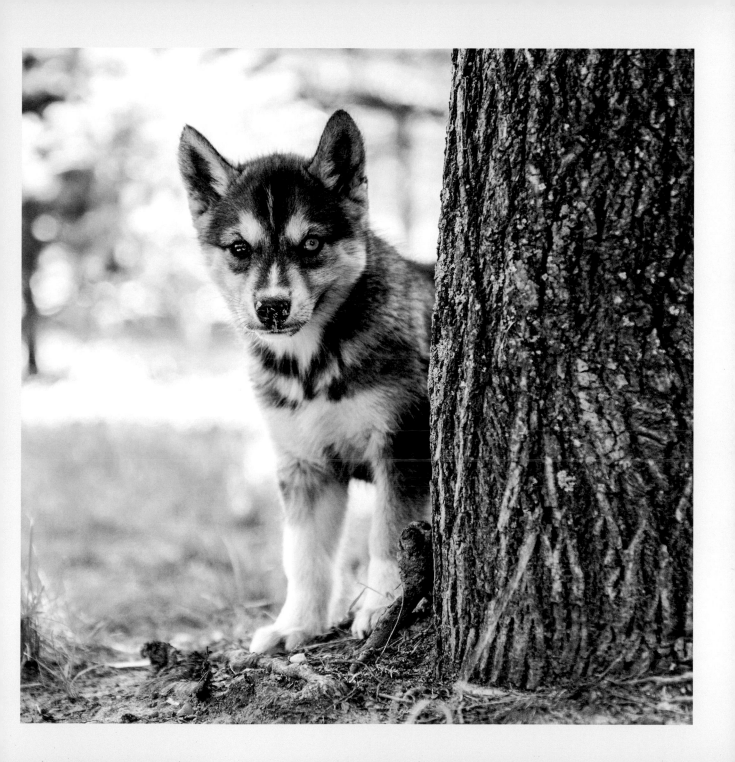

At 1 or 2 years of age, the puppies start training with the dogsled team. It becomes apparent after two or three weeks of training whether a dog has potential. Lead dogs have to be smart and able to handle the pressure of having dogs run behind them. Both sexes are considered equally for a position on the team. When a female dog is in heat, she can still run, but the breeder will mask the odor with a coating of Vicks VapoRub on her backside.

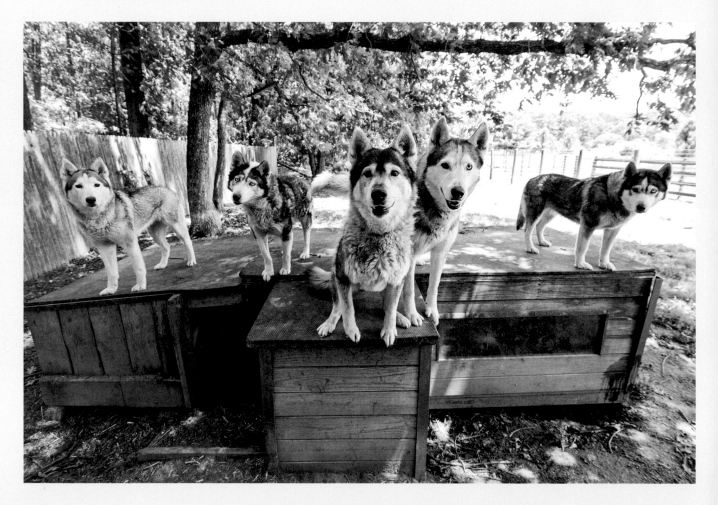

Kiki, **Cricket**, **Whisper**, **Danielle**, and **Denali**

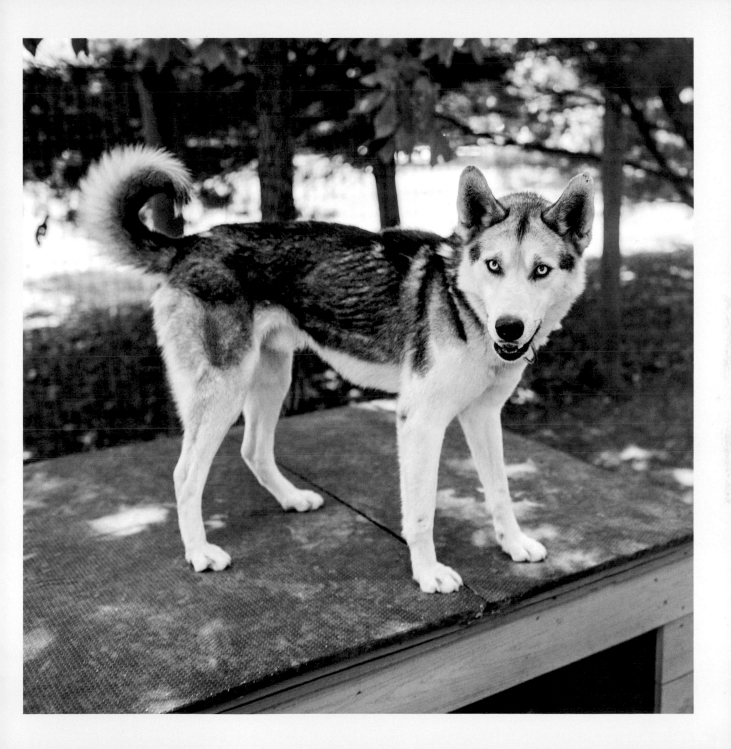

Ziggy, *Dachshund, 3 months old*

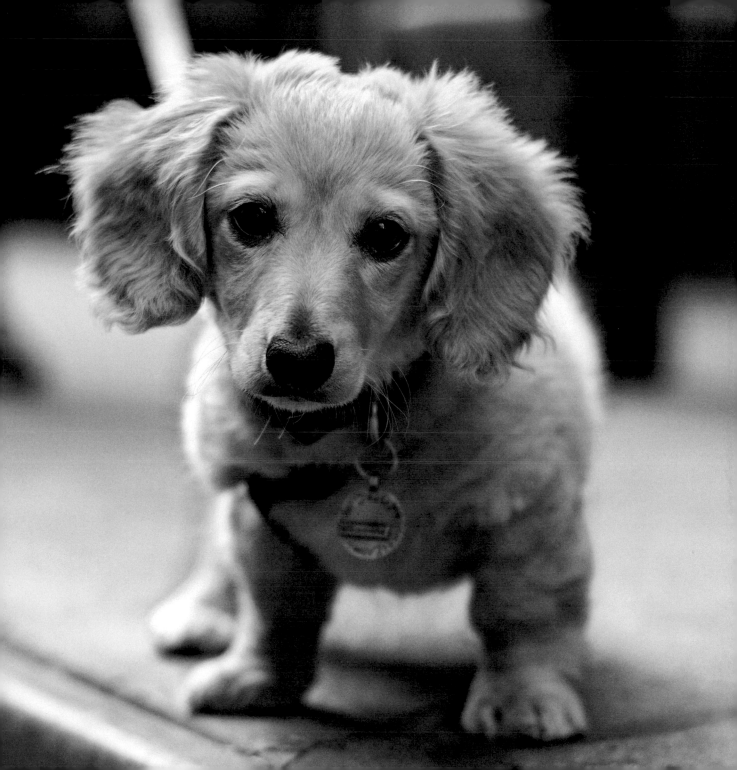

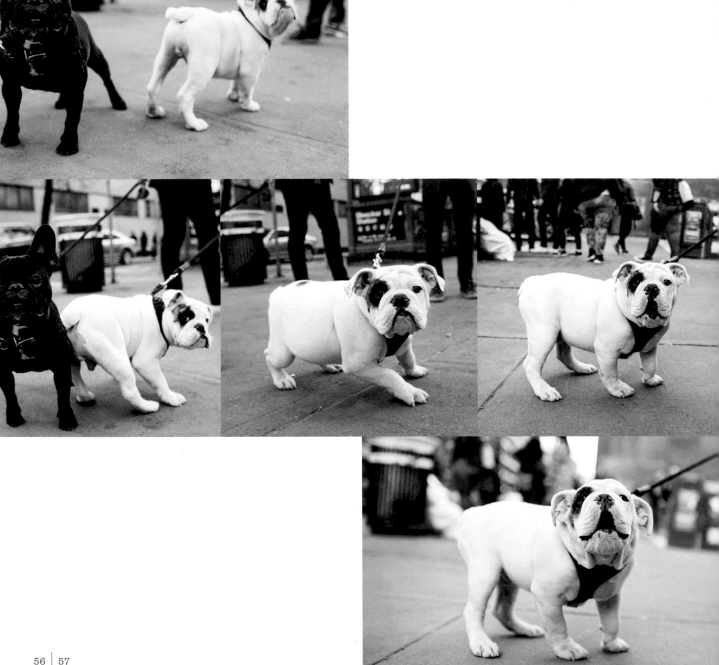

« **Oscar,** *French Bulldog, 5 years old,* and
Oscar, *English Bulldog, 4 months old*

getting the shot

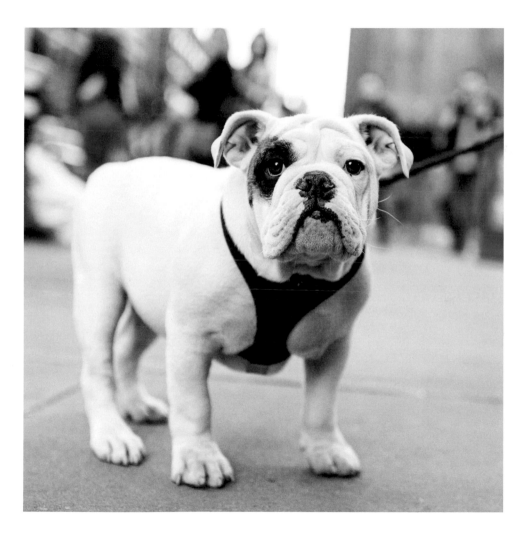

It can take twenty or more frames to capture the right moment.

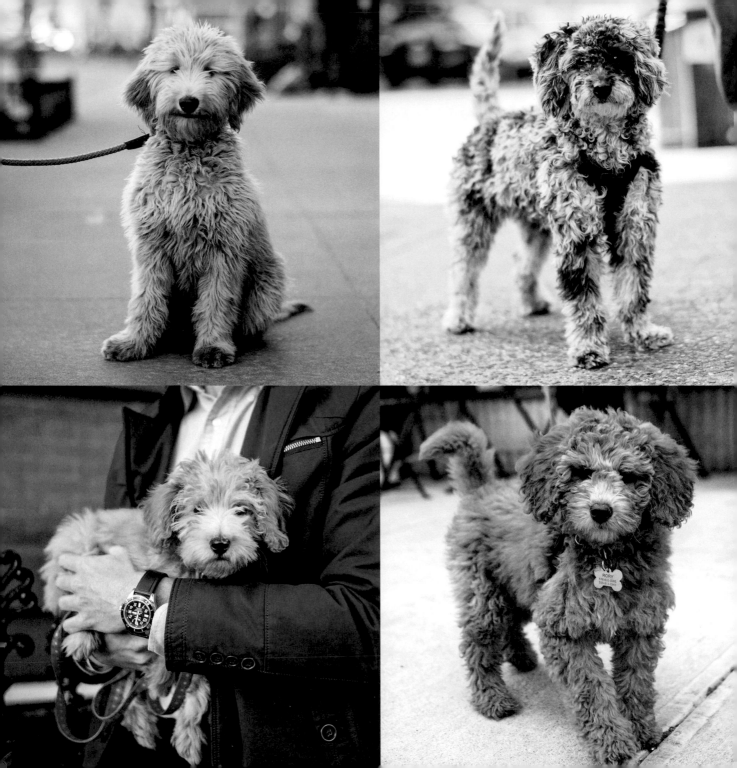

CLOCKWISE,
FROM TOP LEFT

Henrietta,
Goldendoodle,
5 months old

Lula,
Australian Labradoodle,
10 months old

Rory,
Miniature Goldendoodle,
3 months old

Bleecker,
Miniature Goldendoodle,
3 months old

doodles

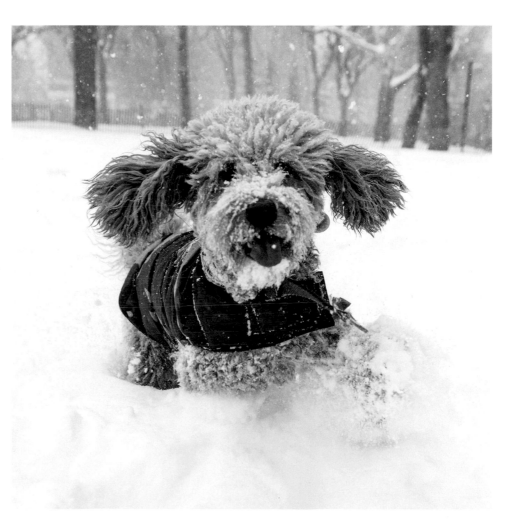

Medford, »
Miniature Goldendoodle,
11 months old

portable pups

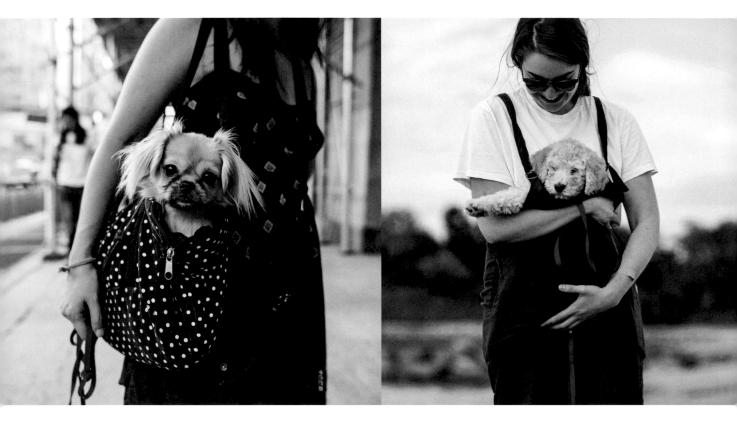

Suki, *Tibetan Spaniel, 10 months old*

Babka, *Standard Poodle, 8 weeks old*

Chance, »
Labrador Retriever mix,
3 months old

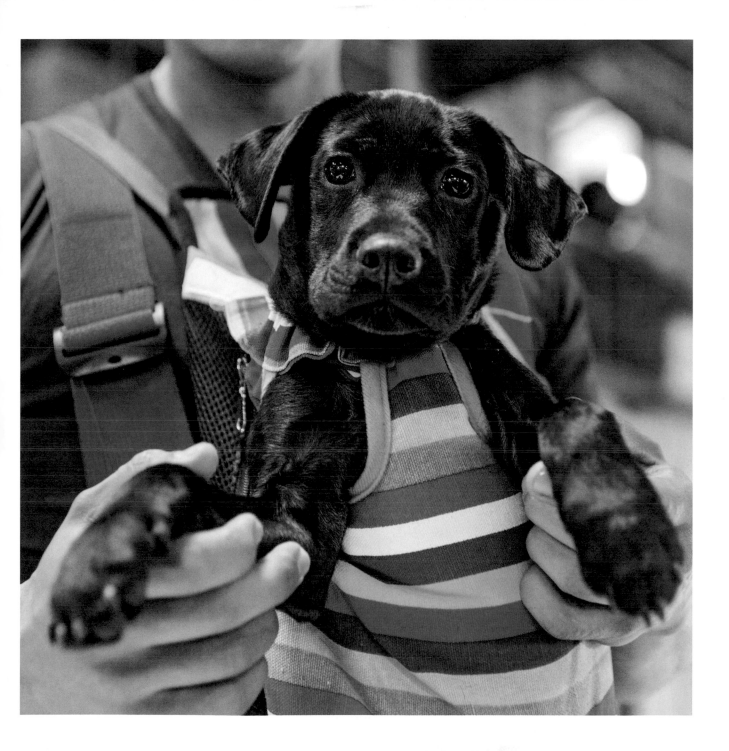

shiba inu

The Shiba Inu, to me, is the cat of the dog world: stubborn, independent, foxlike in appearance, and with the tendency to clean itself. Most owners I've met share a similar sentiment. The smallest of the six Spitz breeds descended from Japan, the Shiba Inu was originally bred to hunt small game and be deft in the mountains. At Icewind Farm, in Phillipsburg, New Jersey, I got to see these wily little guys in action; it was a small litter of just three pups.

Shibas are one of the oldest breeds of domestic dogs and are genetically similar to their wolf ancestors. Shibas also have a distinct noise they make when they're scared or stressed—an almost humanlike wail or scream. Be prepared to hear it when you give your Shiba pup a bath.

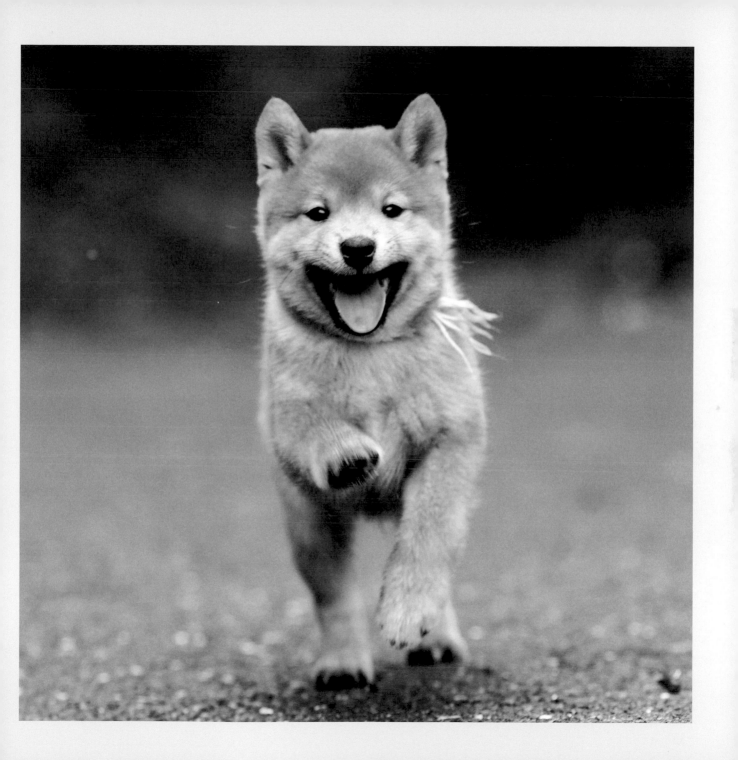

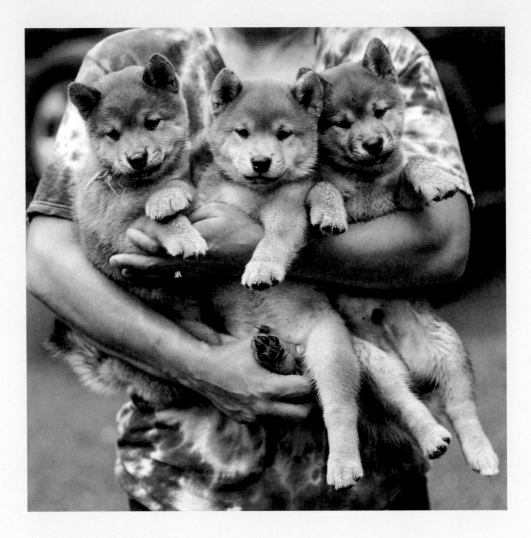

The Shiba Inu is easily housebroken, but a Shiba's owner must be a firm leader, as these dogs are extremely intelligent and will take charge if given the chance.

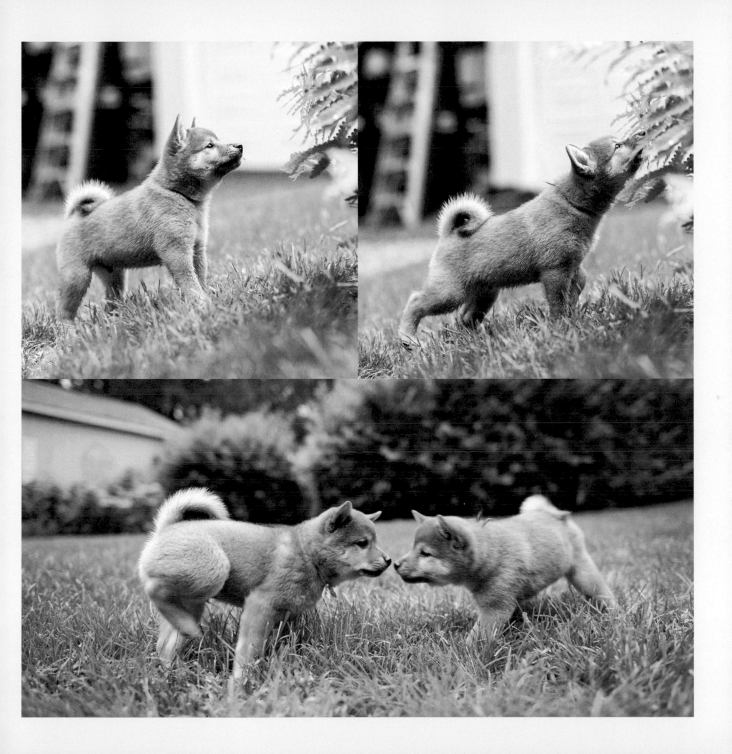

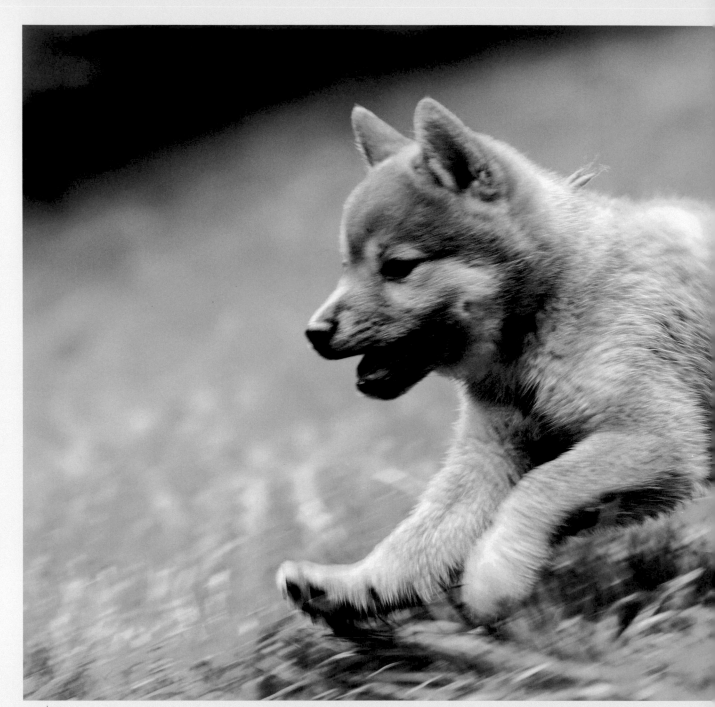

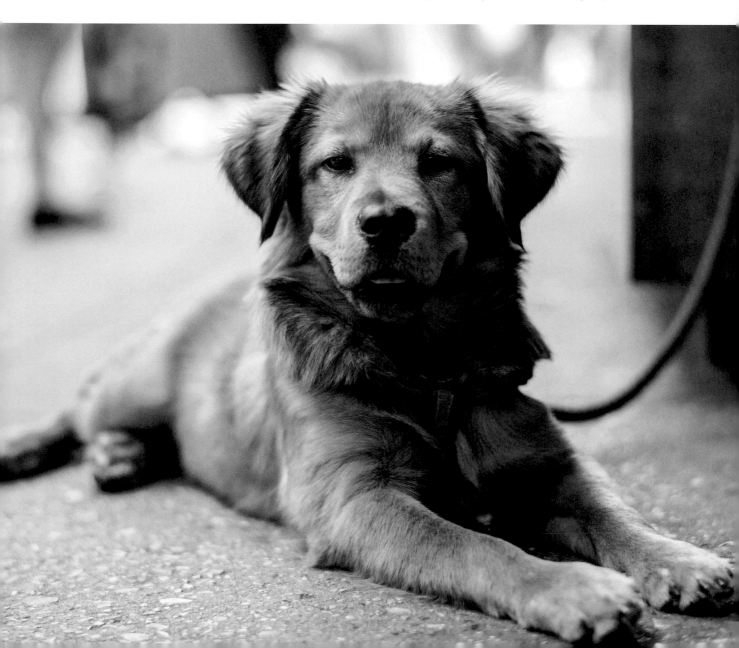

then

Henry, *Chow Chow/Australian Cattle Dog mix, 7 months old*

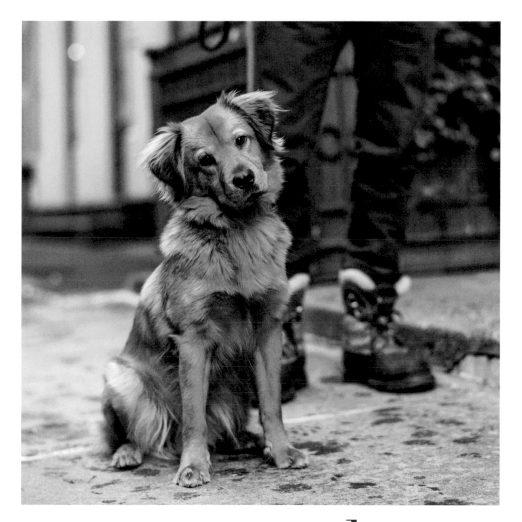

and now

1 year old

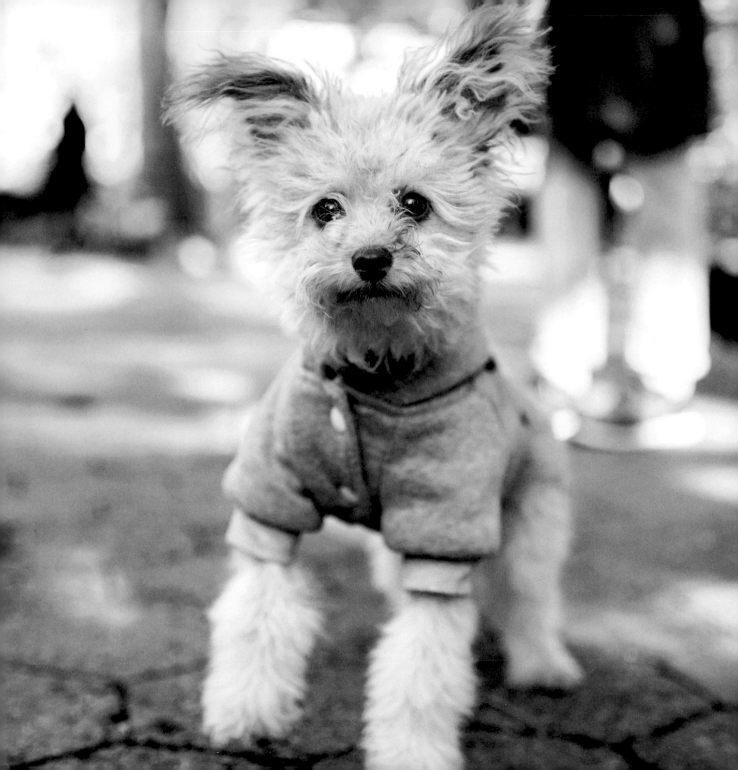

Isabella, *Maltipoo, 8 months old*

"When I'm mad at her, she'll hide in a suitcase."

CLOCKWISE,
FROM TOP LEFT

Norman,
English Bulldog,
12 weeks old

Uni,
Ori Pei,
10 months old

Betty,
English Bulldog,
4 months old

Bacon,
Ori Pei,
6 months old

wrinkles

Duncan, *Shar Pei,* »
11 months old

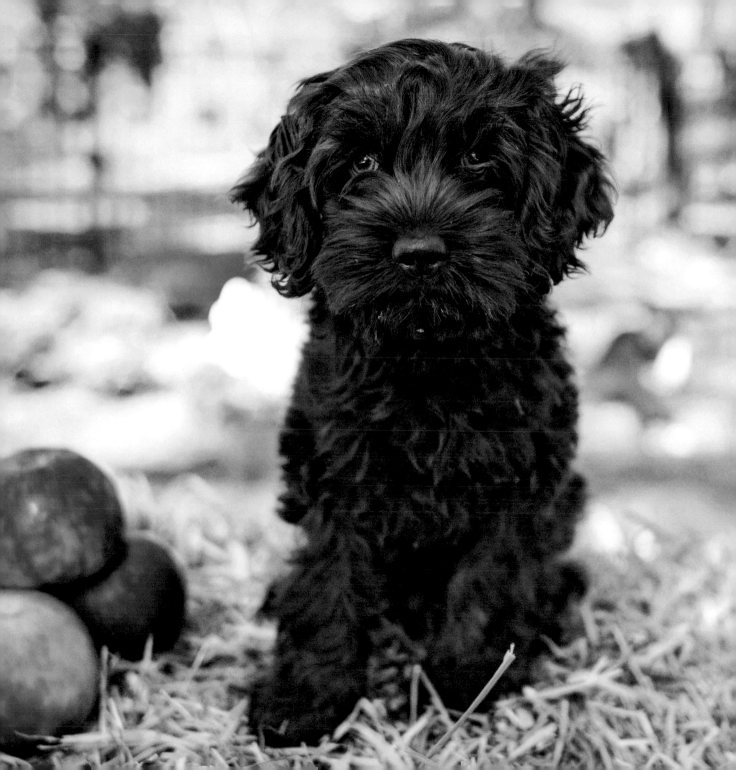

Charlie, *Siberian Husky, 6 months old,* »
and **Rory,** *Tibetan Spaniel mix*

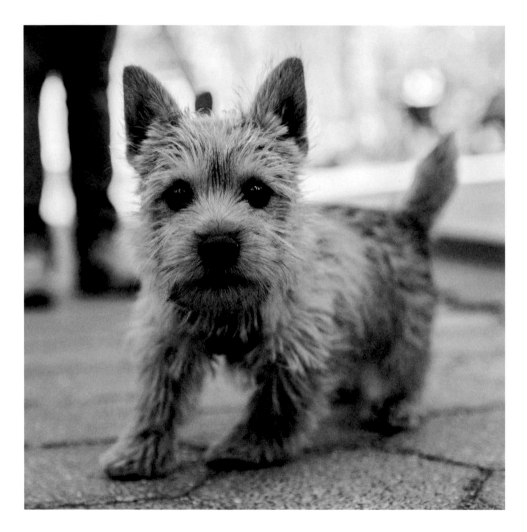

Watson, *Norwich Terrier, 4 months old*

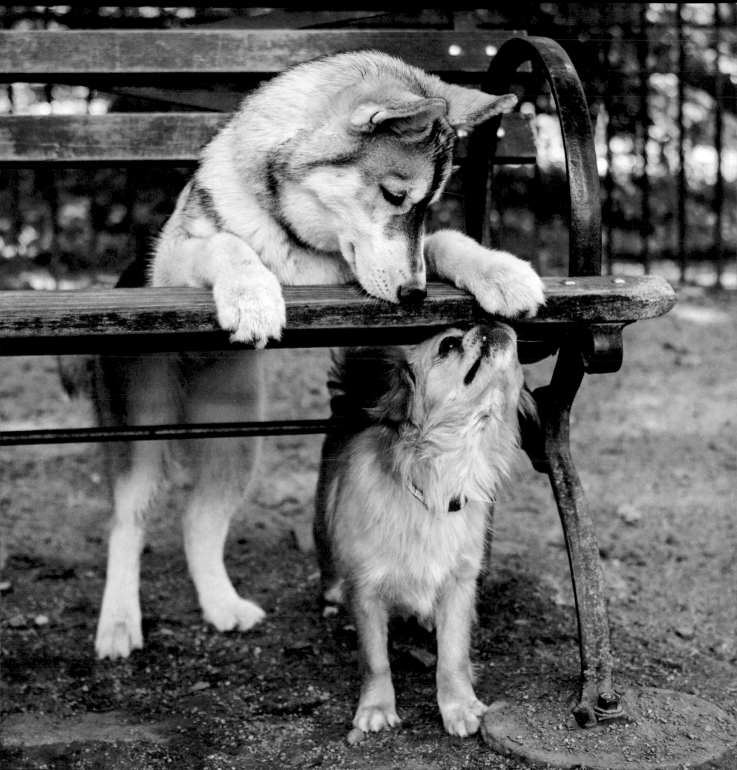

west highland white terriers

Hailing from the West Highlands of Scotland, Westies were bred for the purpose of varminting—hunting mice, rats, squirrels, birds, and other prey. Small in size but with big personalities, Westies think they're ferocious and have a high sense of self-esteem. A Westie knows his opinion and sticks to it. But Westies are also good companion dogs and are often more cheerful than other terriers. Closely related to the Cairn, Scottish, and Skye Terriers, the Westie has a more rounded head shape, a longer skirt of hair along its body, a carrot-shaped tail, and a double coat with hair that is white, stiff, and straight. One breeding tale claims the Westie was born when a Scottish hunter accidentally shot his red Cairn Terrier thinking it was a fox, and so the white-haired variety was bred to be less prone to the same mishap. Westies are a relatively healthy breed, are good with kids, and have become popular as pets around the world.

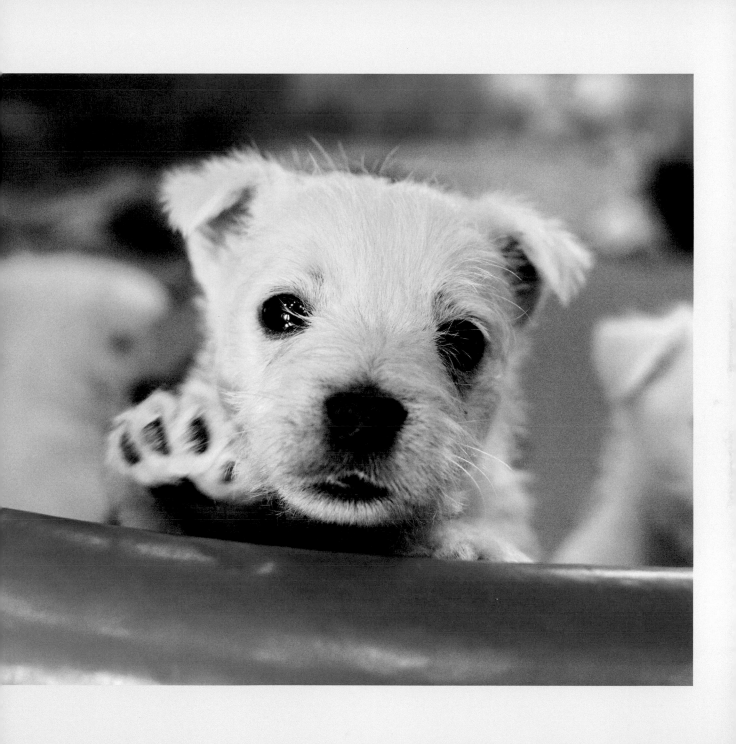

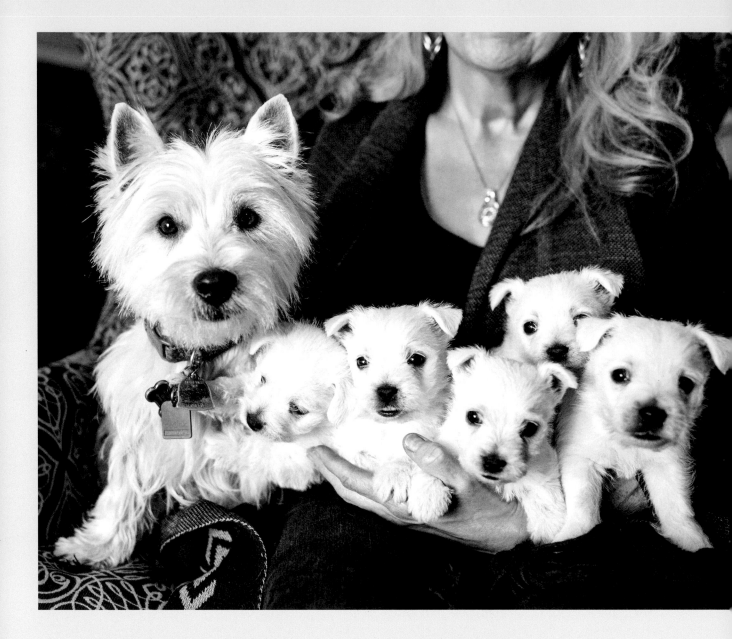

In Lubbock, Texas, Tiana, 2 years old, is learning to be a mother. She will not leave her pups for the first three days of their lives, and she keeps them fed and clean.

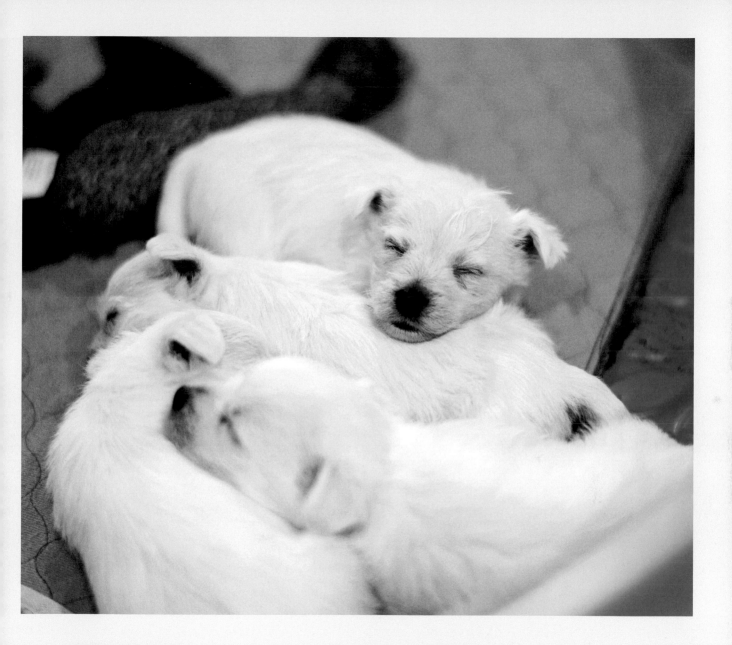

By 5 weeks old, you can tell if the dog is going to be a cuddler or more bossy.
At 6 weeks, they're weaned off their mother's milk and start eating puppy food.

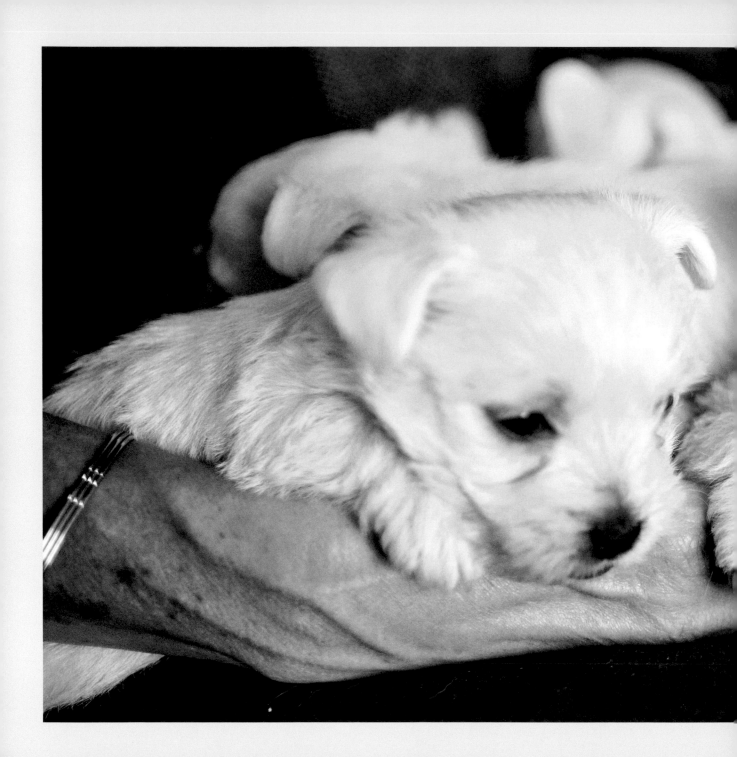

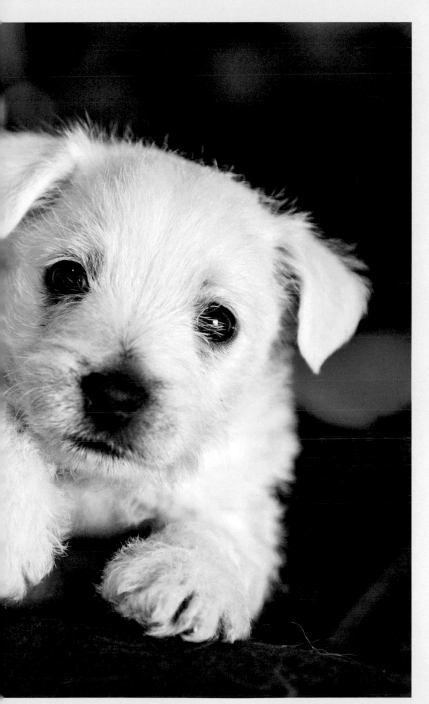

At 7 weeks old, the pups move on to their new families. They usually cry on the first night because they've cuddled with their littermates since birth. The first night is the hardest, but they adjust quickly.

big babies

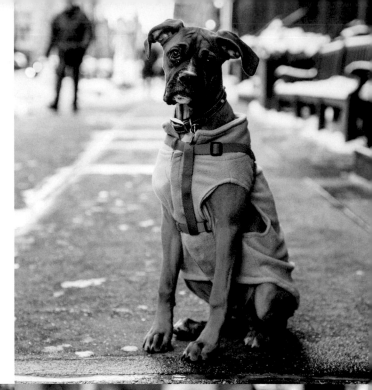

TOP ROW, LEFT TO RIGHT

Walnut, *Boxer,*
5 months old

George, *Bernese*
Mountain Dog,
4 months old

Hopper, *Weimaraner,*
3 months old

BOTTOM ROW, LEFT TO RIGHT

Ike, *Great Dane, 4 months old*

River, *Rhodesian Ridgeback,*
5 months old

Sascha, *Leonberger,*
4 months old

Malyuta, *Siberian Husky,*
3 months old

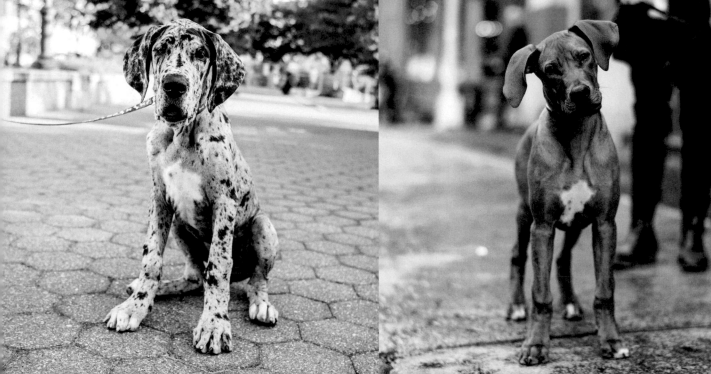

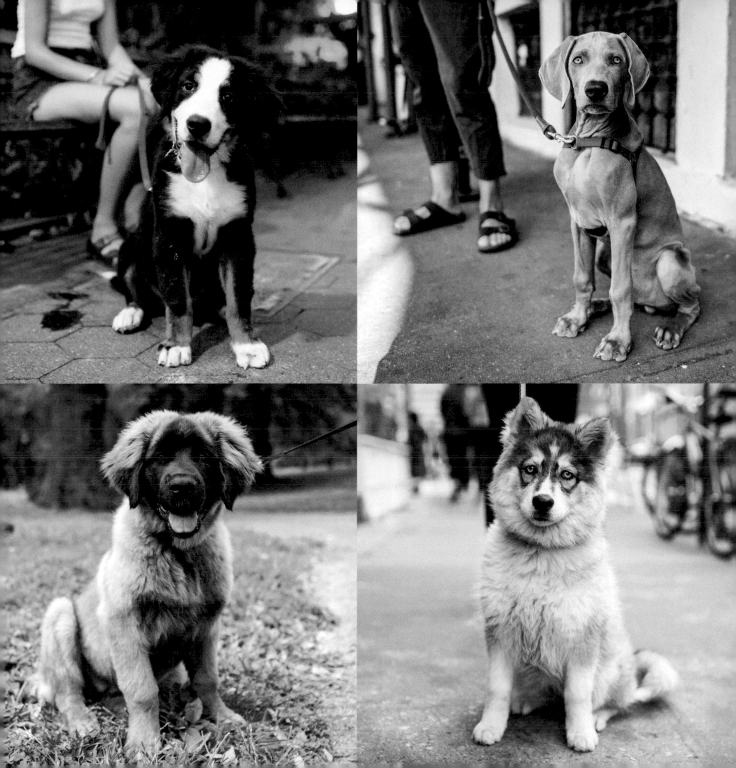

« **Breckenridge,** *Havanese/Pekingese mix, 8 months old*

Chloe, *Keeshond, 4 months old*

then

Winston, *Labrador Retriever, 4 months old*

and now

6 months old »

« **Taco,** *Brussels Griffon, 4 months old*

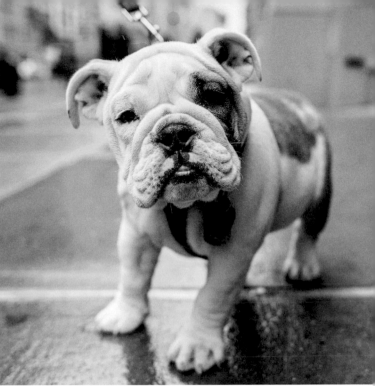

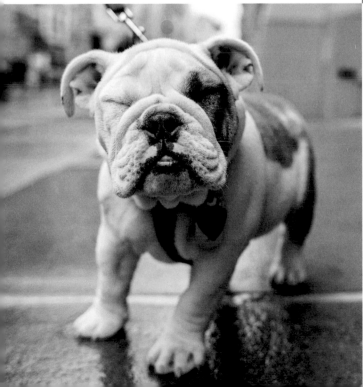

"She's trying to learn to sleep at night, so we don't sleep anymore."

Lily, »
German Shorthaired Pointer,
3 months old

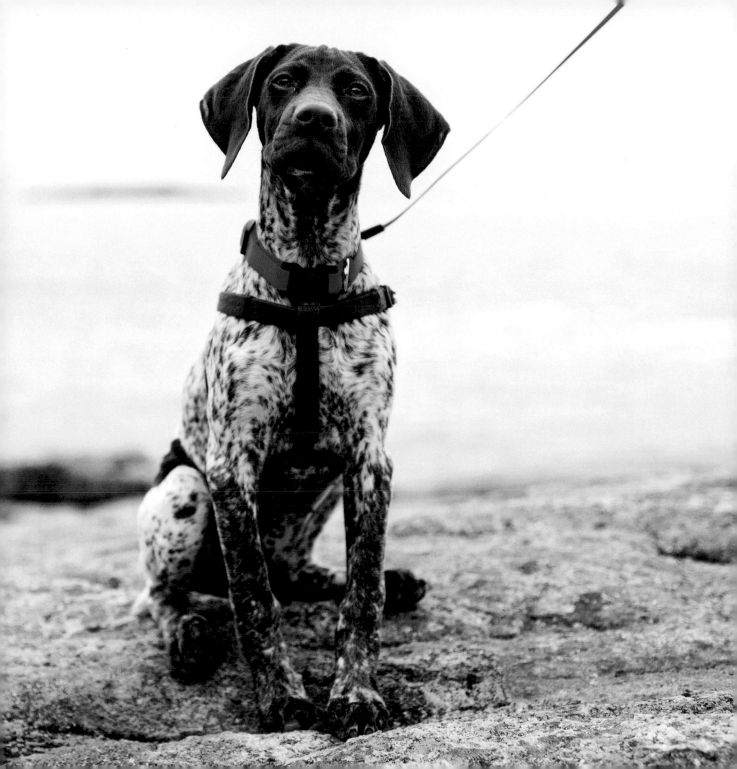

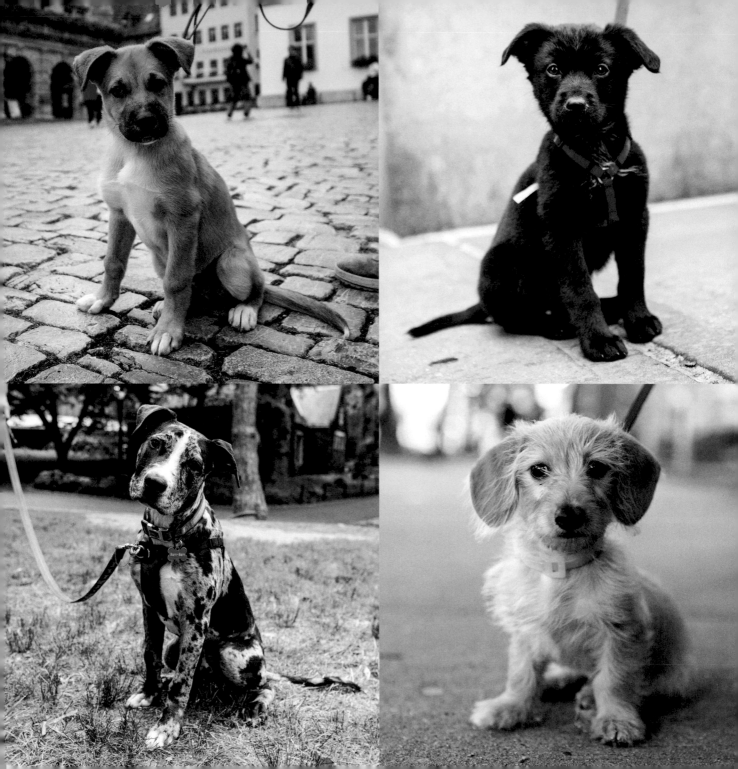

Apollo,
Boxer/Husky mix,
13 weeks old

Zuma,
mix,
9 weeks old

Luna,
Dachshund mix,
3 months old

Bam-Bam,
Catahoula/Pit Bull mix,
5 months old

little mutts

Sequoia, *mix,* »
3 months old

seeing eye dogs

A working guide dog is a fascinating thing to see in action—especially in a bustling place like New York City. As a team, a blind person and his guide dog can freely cross streets, climb stairs, ride public transportation, and more, doing the everyday things we take for granted, like eating at restaurants and shopping for groceries. Guide dogs, unlike most other service dogs, have to have a mind of their own. For example, if a car is coming down the road and the owner says, "Forward," the dog has to disregard the command—this is called intelligent disobedience. And while most dogs might pull toward food on the ground or another dog they see, a guide dog has to keep its composure. The dog has a very important job to do, and it can't be distracted by things its owner may be unaware of. Lastly, and of equal importance, a guide dog is a companion and social aid to his owner. I've heard from many blind people that since they switched from a white cane to a guide dog, their lives have become more fulfilling, and strangers don't treat them like they're outcasts.

Using German Shepherds, Labrador Retrievers, Golden Retrievers, and Labrador/Golden crosses, The Seeing Eye, located in Morristown, New Jersey, raises and trains puppies to help the blind and visually impaired live independent lives.

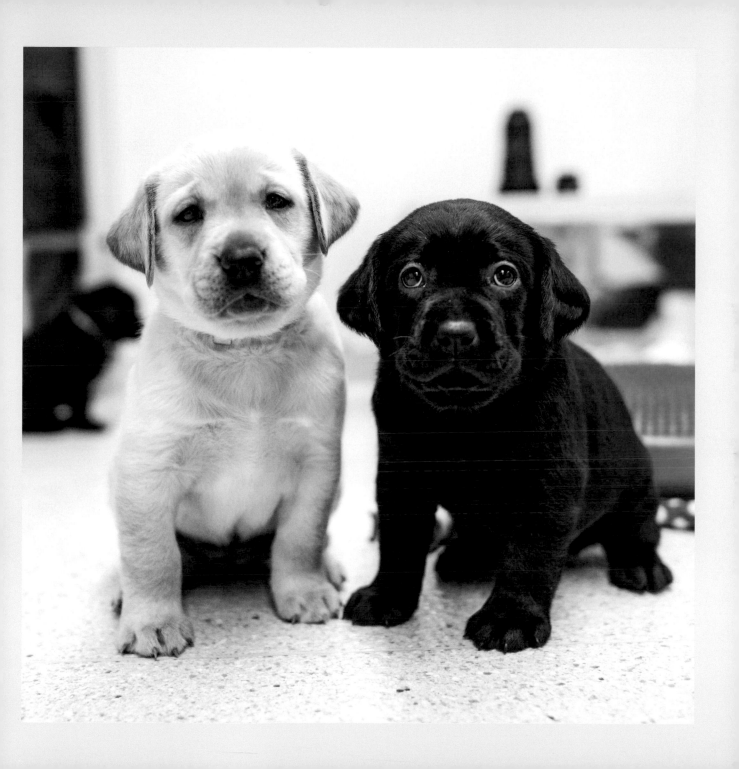

The whelping center at The Seeing Eye has a full-time geneticist on staff to create a breeding program to produce dogs with the most desirable characteristics for a working dog. The dogs are bred to be gentle, well socialized, and healthy so they can live a long life and work well with their owners.

A small child's pool lined with towels is used to keep the mom and her pups in a contained, protected, and warm environment for the first few weeks of the pups' lives.

August Wayland, »
Labrador Retriever, 2 years old, with her pups

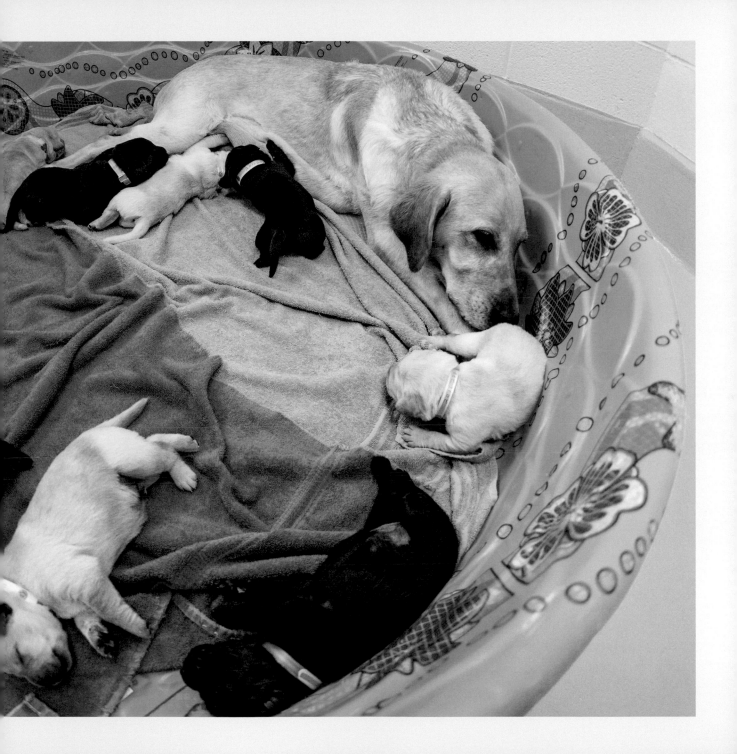

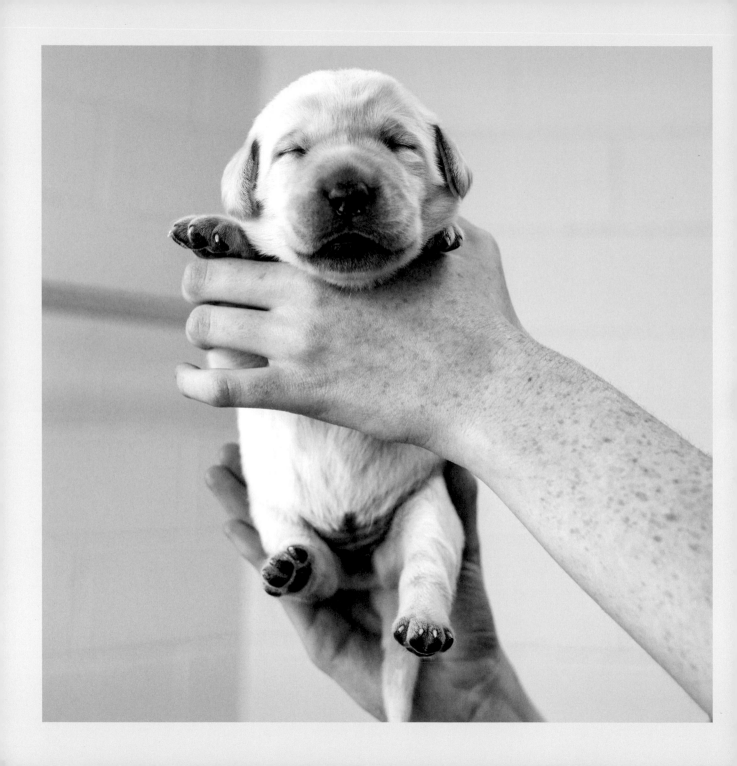

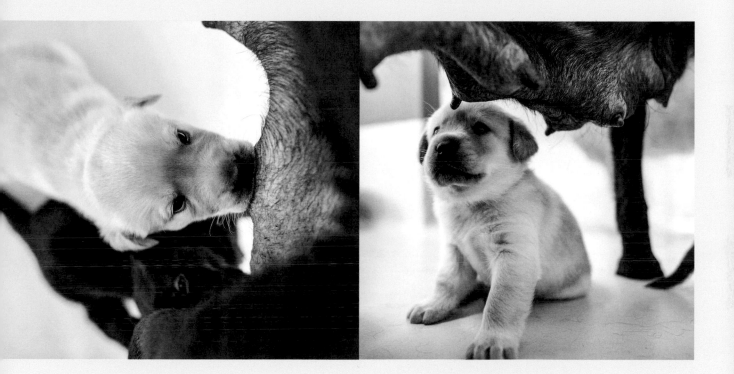

The pups nurse several times a day; the mom appreciates the nursing because it relaxes her and relieves pressure.

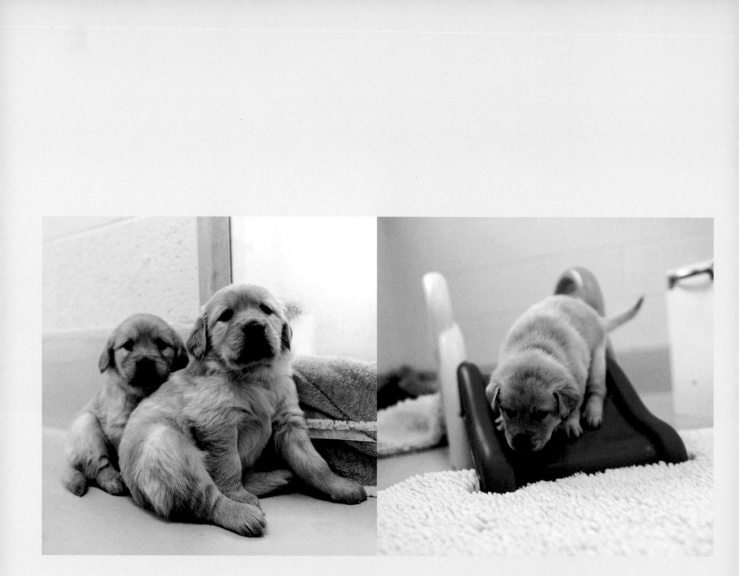

Puppies visit the playroom every day starting when they're 4 weeks old and stay until they're 7 weeks old. They think they're just there to play, but everything is a learning experience. Mirrors, sounds, toys, and playground equipment are employed to get them used to different stimuli. A cube with objects hanging down teaches them to look up. A slide teaches them how to navigate different obstacles.

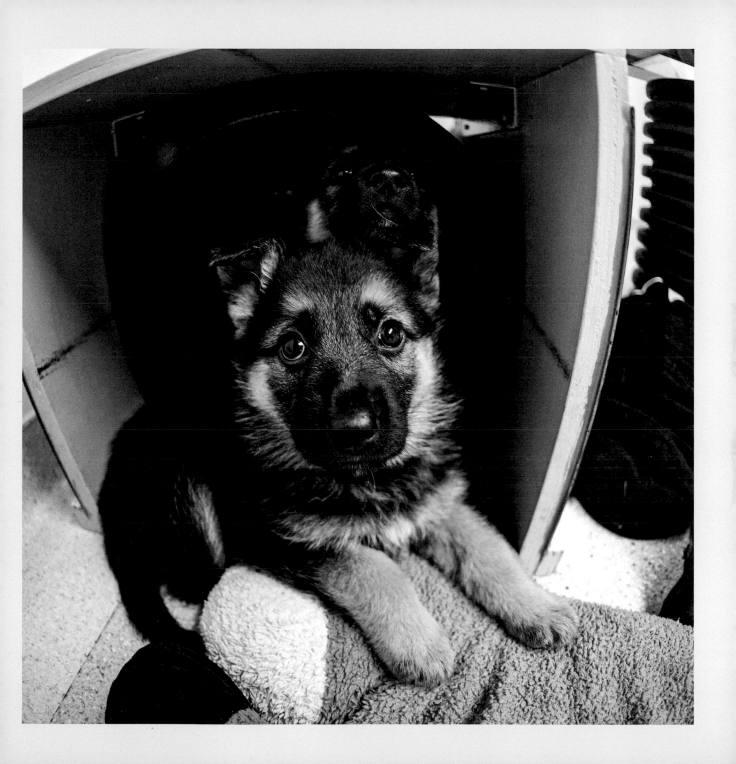

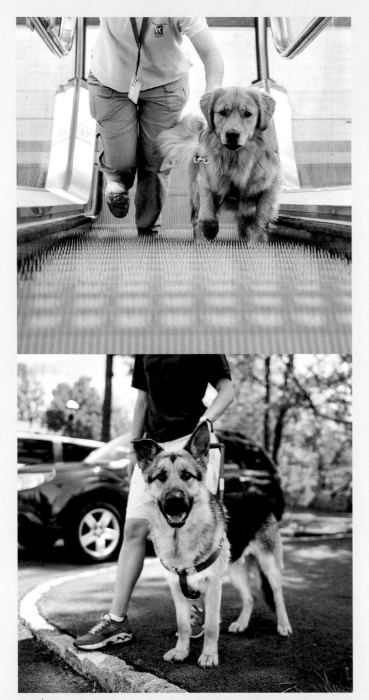

At 2 years old, these dogs are nearing the end of the training program. They're faced with real-world obstacles like escalators, crosswalks, and other distractions. They'll soon meet their new owners, so they need to learn how to stay focused.

Matching a dog to a person is part screening process, part magic. The human candidate has to be physically and mentally independent, which shows he is able to handle a dog. A person's size, personality, gender, location, and walking speed are all considered. A match isn't based on breed preference alone; there has to be chemistry. A blind person's relationship with his dog is much more than that of an owner and a pet—it gives him complete independence.

Elroy, *German Shepherd;* **Falcon, »** *Golden Retriever;* **Dove,** *Labrador Retriever, all 2 years old*

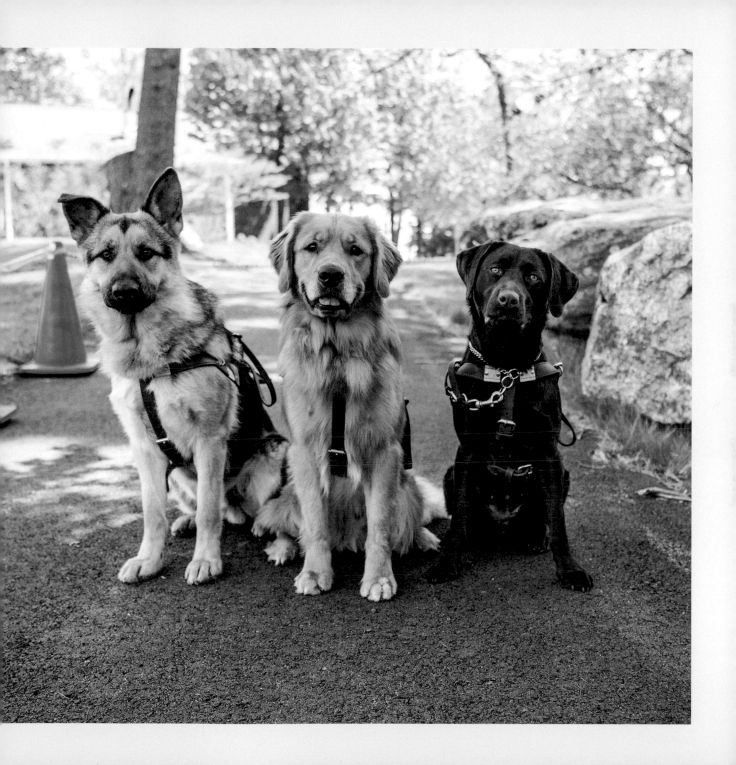

Lloyd Burlingame is blind and relies on Al, a Seeing Eye dog, to be his steady companion. Lloyd is 81 years old and says that being with Al is giving him the time of his life. "We listen to lectures about Beethoven together. When we walk around, he offers me a menu of places to go, including the pharmacy and the grocery store. Al is as smart as any Rhodes scholar, as agile as any Harlem Globetrotter, and has the charm of Cary Grant."

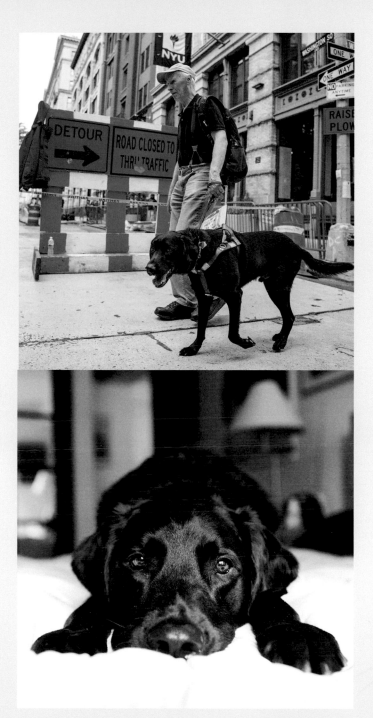

Hoku,
mix,
11 months

Taser,
Bernese Mountain Dog,
10 weeks old

Blaize,
Miniature
Australian Shepherd,
6 months old

Gixxer,
Shepherd mix,
8 months old

travel buddies

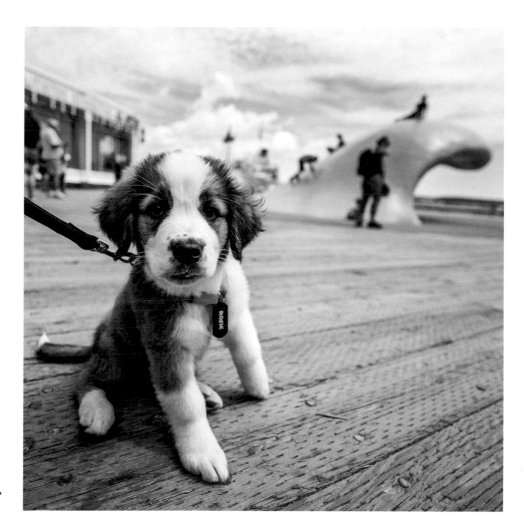

Rosie, *St. Bernard,* »
9 weeks old

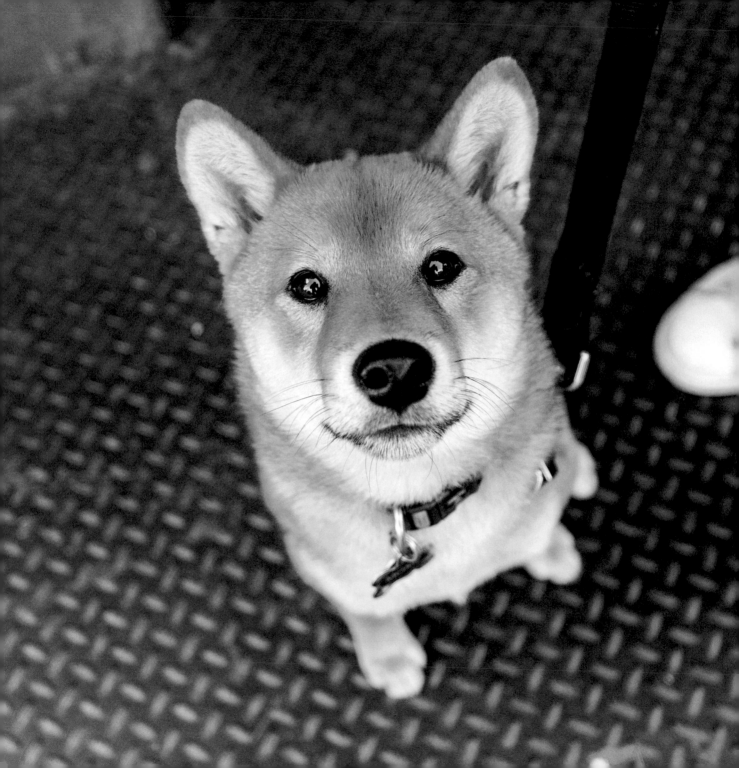

"He has a thing for people in shorts. When he sees someone's hairy legs, he'll walk up and lick them. Even a stranger."

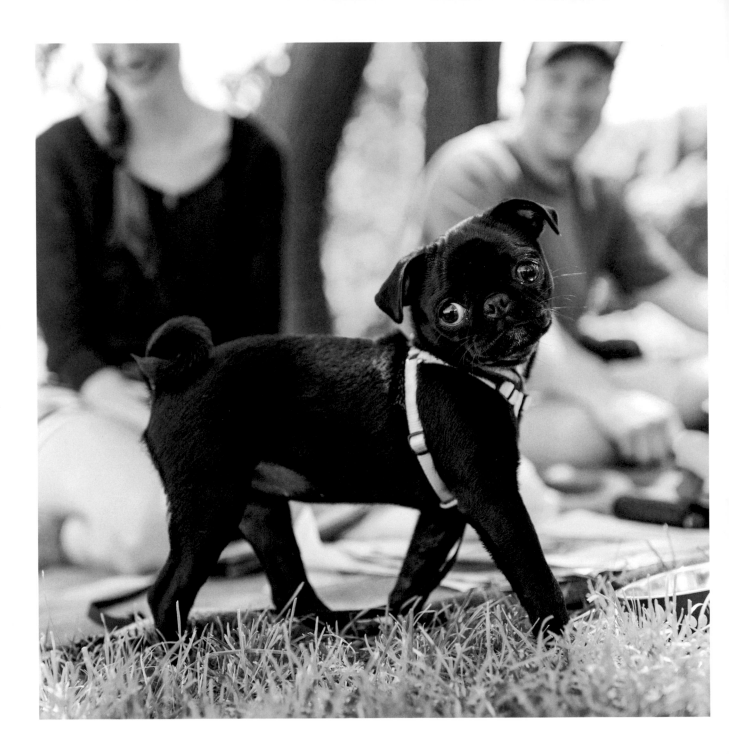

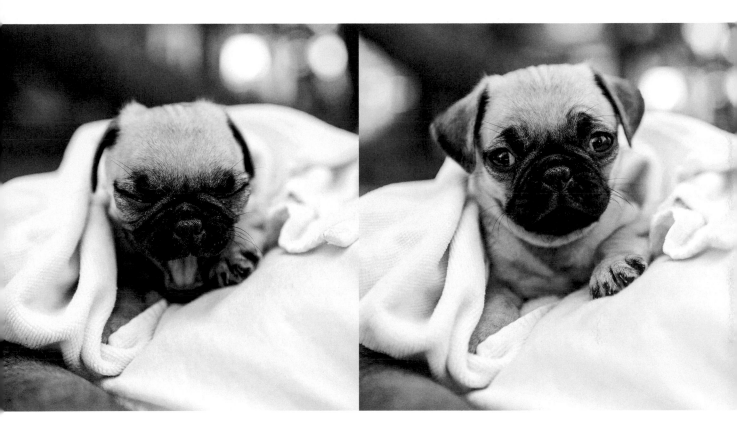

Bougie, *Pug, 7 weeks old*

puppy care

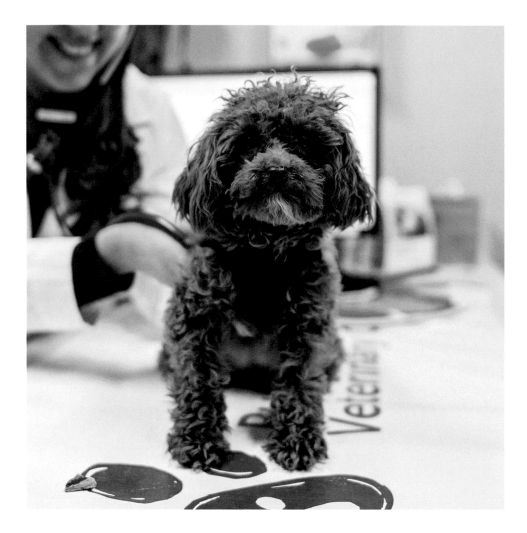

<< **Elsa,** *Toy Poodle,*
8 weeks old

The veterinarian makes sure Elsa's ears are clear and normal and her pupils are functioning properly. She has a baby tooth that hasn't come out yet.

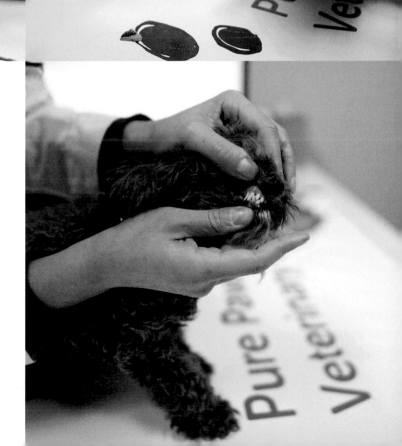

border collies

You'll never see a dog more committed to its job than a highly trained Border Collie with its flock of sheep. Their unwavering focus makes them extremely difficult to photograph. If you could listen to a Border Collie's inner voice, it would be something like this: "SHEEP. SHEEP. STAY THERE, SHEEP. NO, YOU GET BACK HERE, SHEEP. SUCH GREAT SHEEP. I LOVE SHEEP."

If I'm lucky, I'll get a Border Collie to look at the camera for a fleeting moment. I visited shepherd Joe Joyce of Joyce Country Sheepdogs in the beautiful hills of Connemara, Ireland, to meet his collies and his herd. Along the long, narrow roads approaching our destination, I saw several sheep wandering in the road with a Border Collie close by and knew I had come to the right place.

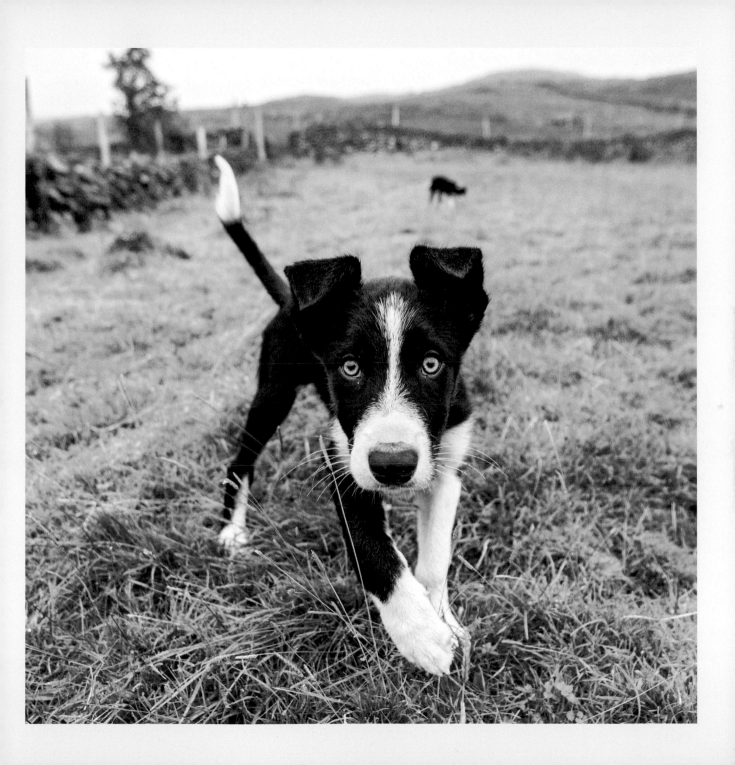

Bob, *5 months old*

Joyce won't sell a dog he's bred to a family unless the dog is going to be working. This is out of respect for the dog, who is happiest when active and doing a job.

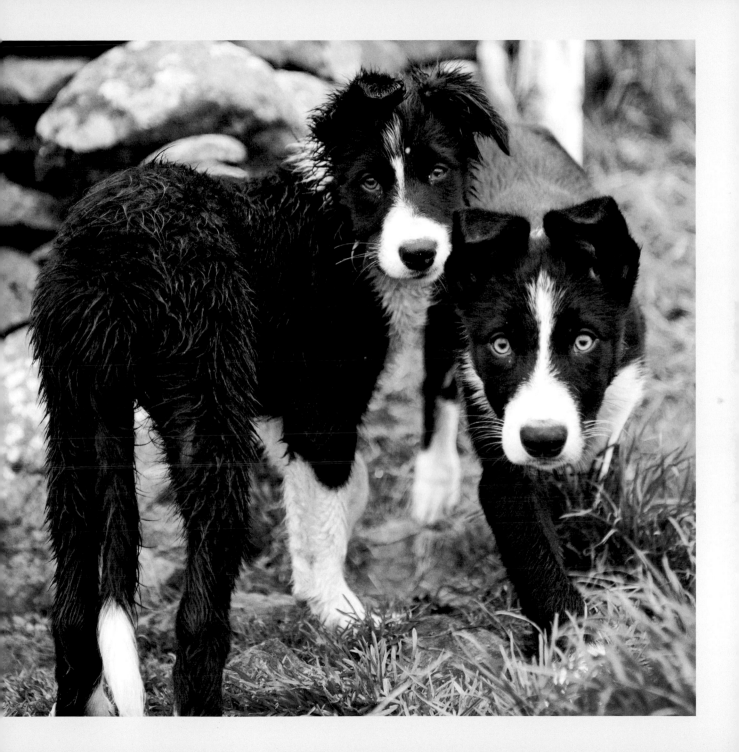

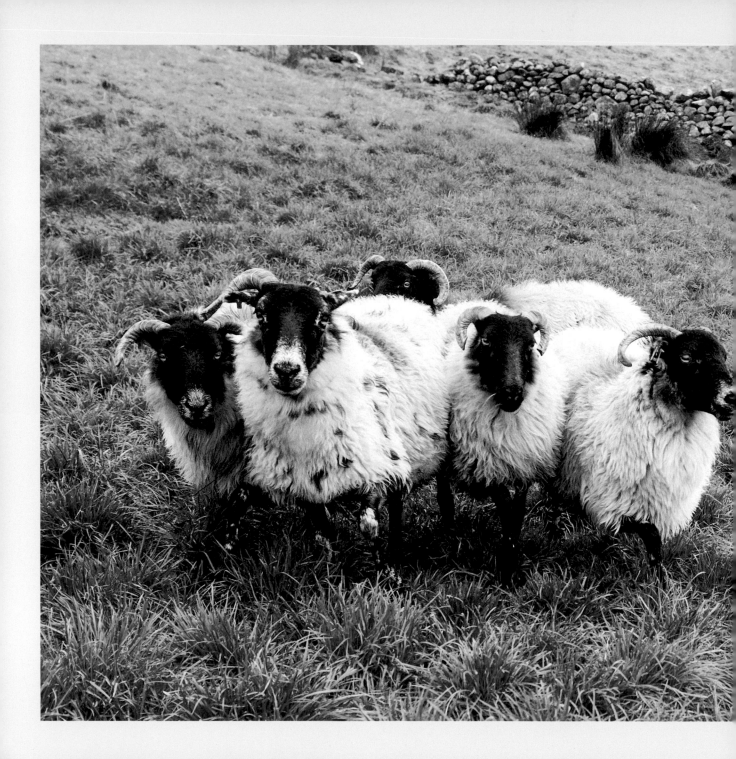

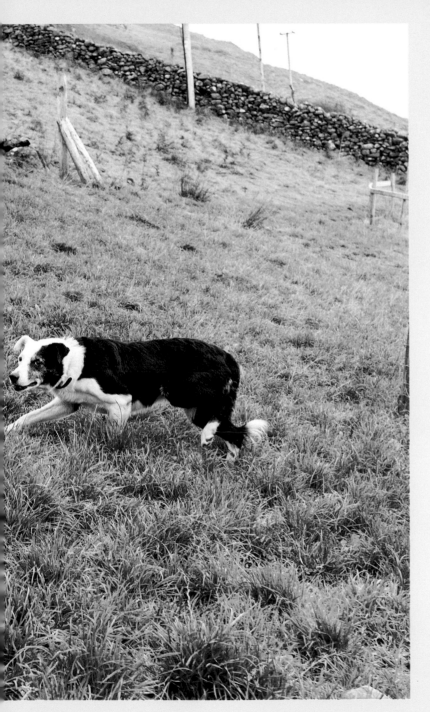

There are approximately

1,500 sheep split among five farmers along these two mountains, so a herding dog is a must to collect the sheep. Two dogs working together will collect between 200 and 300 sheep when they need to be brought back to the farm for shearing, bathing, or breeding.

Starting at 12 months old, the dogs learn four main commands. To go left, the shepherd says "Come by," to go right "Keep away," to stop "Lie down," and to come "Back to me." The hardest command to teach the dogs is to put the sheep back to pasture. Once a dog brings the sheep to the shepherd, it feels counterintuitive for him to release them again—he thinks you want to keep them.

《 **Nell,** *3 years old*

ears

« **Jimmy,** *Basset Hound,*
5 months old

head tilts

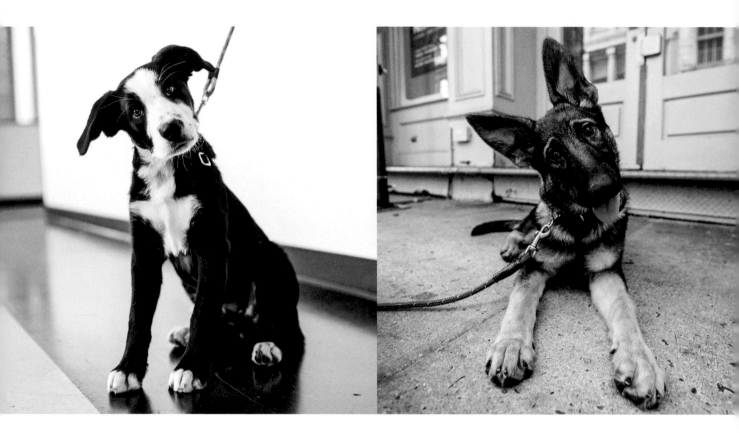

THIS PAGE, LEFT TO RIGHT

Watson, *Border Collie/Bernese Mountain Dog mix, 4 months old*

Brooklyn, *German Shepherd, 4 months old*

OPPOSITE, CLOCKWISE FROM TOP LEFT

Mojo, *Jack Russell Terrier, 4 months old*

Dr. Watson, *Pembroke Welsh Corgi, 8 months old*

Lazer, *Pug, 3 months old*

Oscar, *Boxer, 4 months old*

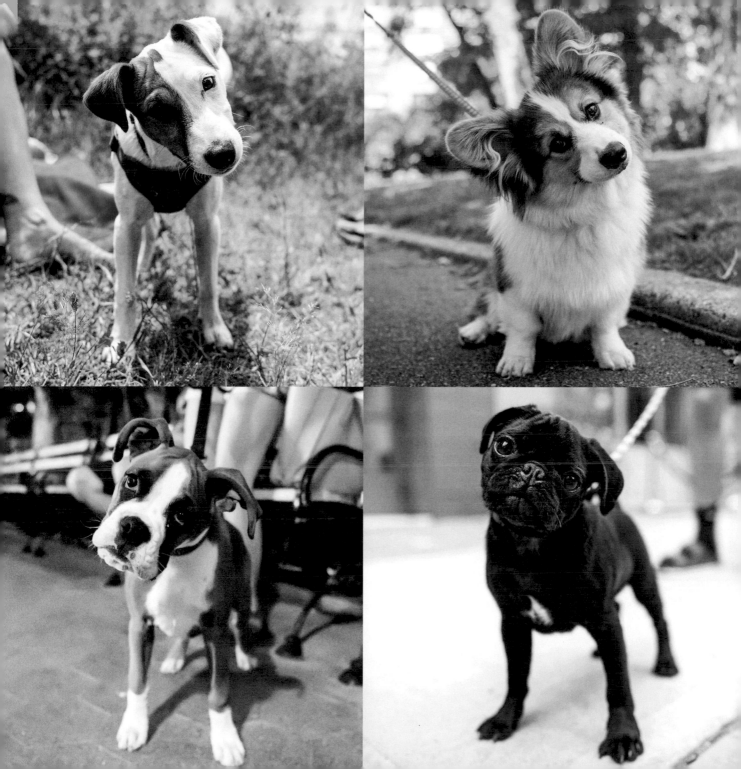

The Prince, *Cavachon, 3 months old*

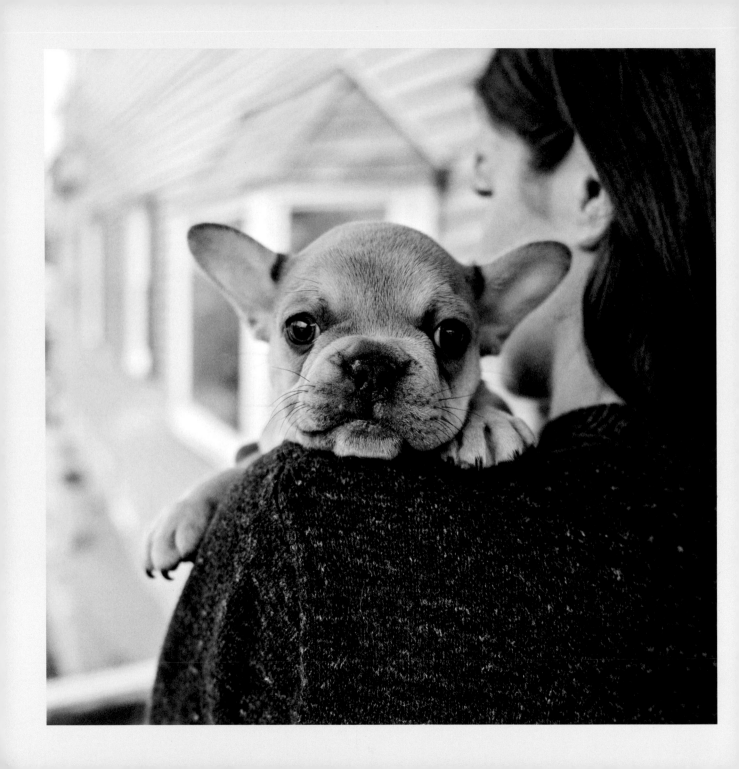

french bulldogs

Developed in the early 1900s in England and France, French Bulldogs were created by crossing English Bulldogs, Pugs, and Terriers, resulting in a small dog with big eyes and "bat ears." On an average day of shooting in New York City, I'll cross paths with about 10 French Bulldogs; they've become extremely popular as city dogs, and for good reason—they're wildly entertaining and the perfect-sized apartment dog. Frenchies don't require much exercise and can't handle extreme temperatures, so they're usually happiest hanging out inside with you. Frenchies are also terrible swimmers, so if you take them to the beach or pool, make sure they're wearing a life jacket.

Most French Bulldogs are unable to mate or give birth naturally due to anatomical and physiological challenges. Most litters are therefore conceived by artificial insemination and born via cesarean. Human intervention is needed to keep this breed thriving.

Part of the French Bulldog's appeal is their scrunched-up (brachycephalic) face; I think they look a little bit like a human baby. Frenchies come in four official colors: brindle, fawn, white, and brindle and white, though you'll see Frenchies in other color variations, like black and tan.

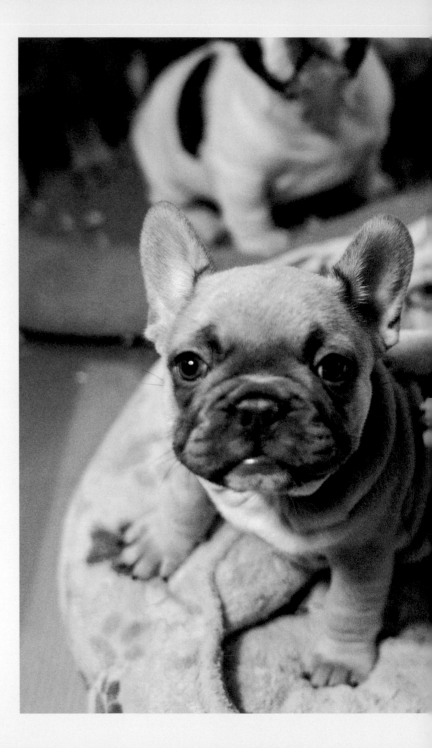

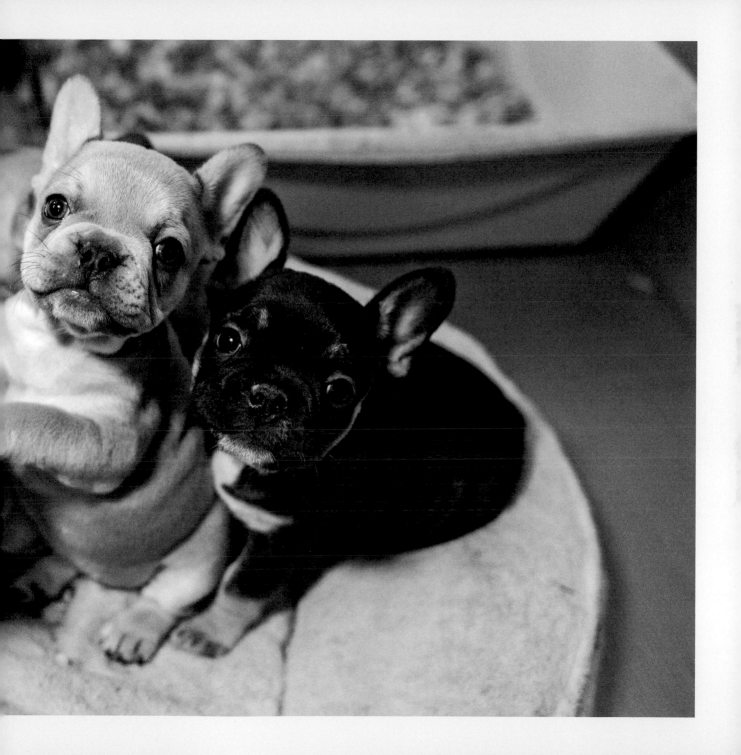

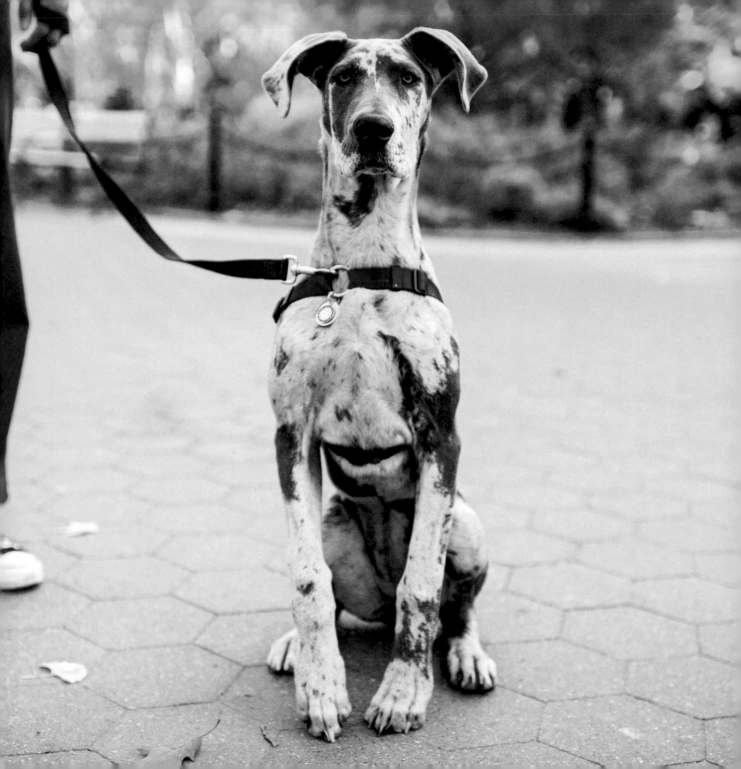

then

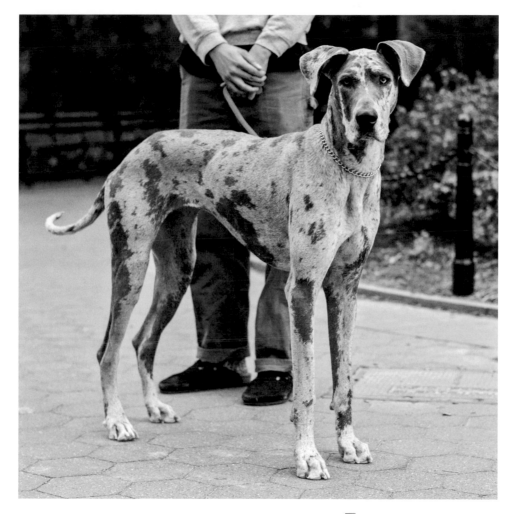

and now

16 months old

Turner, *Jack Russell Terrier, 12 weeks old*

"He lies
down
and goes
'on strike'
if he sees a
nice patch
of grass to
roll in or
if he just
wants to rest
in the sun."

Tuggy, *Golden Retriever, 14 weeks old*

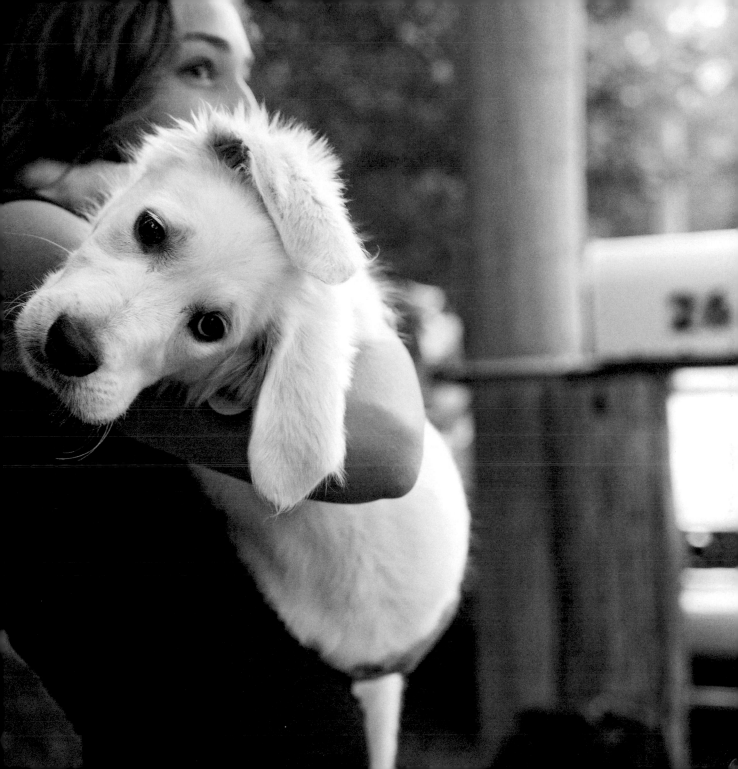

little mutts

CLOCKWISE,
FROM TOP LEFT

Mabel,
*Cavalier King Charles
Spaniel/Pug mix,
5 months old*

Caramel,
*Jack Russell Terrier mix,
7 months old*

Nacho,
*Labrador Retriever mix,
3 months old*

Tica, *mix,
13 weeks old*

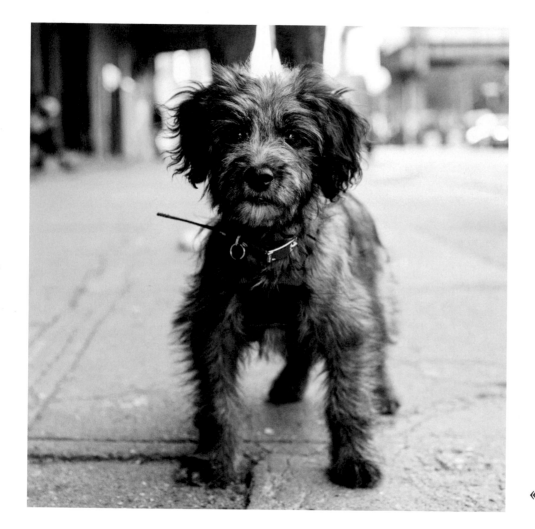

« **Rooney,** *Terrier mix,
3 months old*

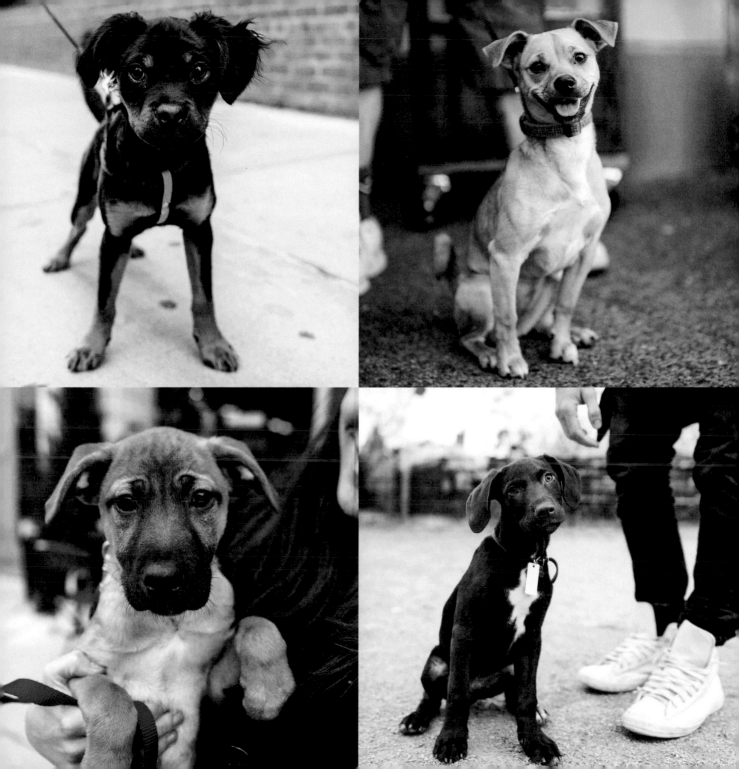

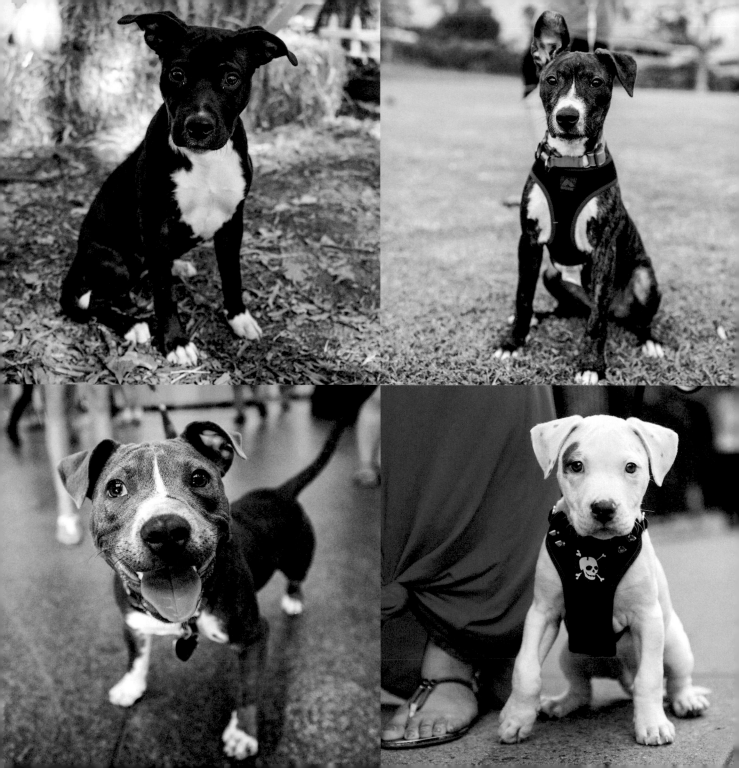

Xocjitl,
Pit Bull mix,
4 months old

India,
Pit Bull mix,
5 months old

Klaus, *Pit Bull,*
9 weeks old

Checkers,
Pit Bull,
4 months old

pit bulls

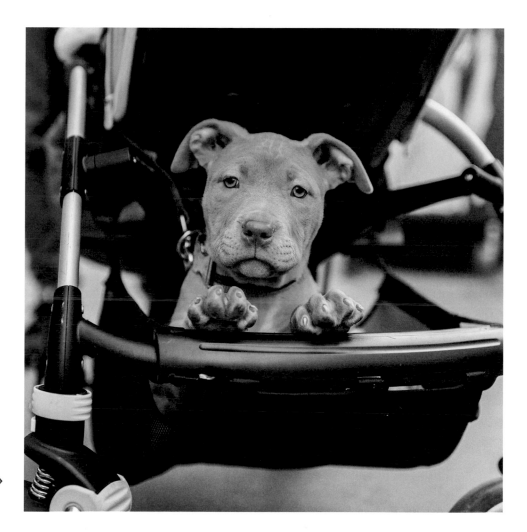

Nova, »
Pit Bull,
2 months old

bernese
mountain dogs

Bernese Mountain Dogs are classic gentle giants. With their tricolored coats and extra-friendly attitude, it's no wonder these guys have become so popular as family pets and therapy dogs. Originally bred to herd cattle and pull carts (called drafting) in the Alps near the canton of Bern, Switzerland, these dogs love being outdoors and having a job to do. They are a personal favorite breed of mine, and when I see one on the street, 9 times out of 10 I'm running over to get a photograph. These guys don't know their size and will do everything in their power to "hug" me. They can weigh up to 120 pounds as adults and unfortunately do not have a long life span—they're considered a "heartbreak breed"—but oh, how they live! Despite having traveled through Switzerland twice and never actually seen a *Bernese* Bernese Mountain Dog, I found a great breeder in eastern Pennsylvania who had more than eight adult dogs of her own. It's always a good sign for a breeder to have happy adult dogs for the puppies to engage with in those first few impressionable weeks. One funny detail about this visit involved manure—horseshit. I went out into the field to get some action shots, and the only thing the dogs were concerned with was gorging themselves on the ice-cold horse poop scattered around, which apparently is a normal, healthy behavior for pups. Could this be the dog version of the Paleo diet?

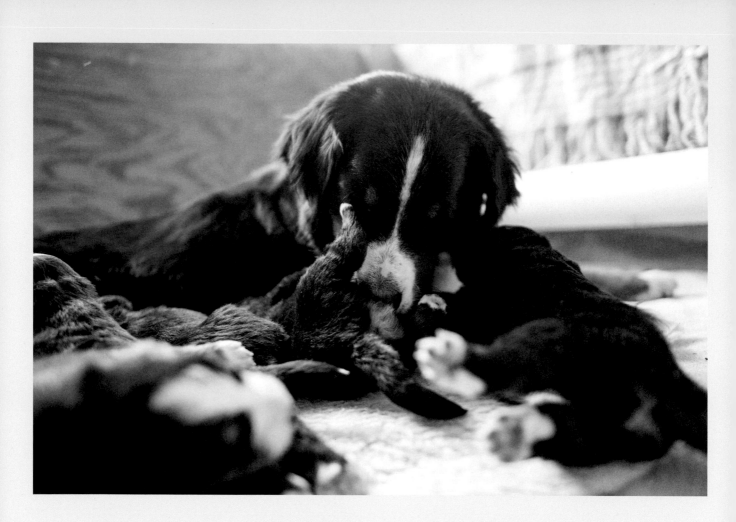

A happy mom means happy puppies. Puppies are incredibly impressionable during their first 16 weeks of life. Having a mother who likes to nurse and tend to her puppies makes a huge difference for a dog's life and personality down the road. Notice also the foam around the whelping box that helps prevent the mother from accidentally rolling over and smothering a pup in a corner. Could you imagine keeping track of eight kids at once?!

Sarah, *4 years old,* »
with her pups

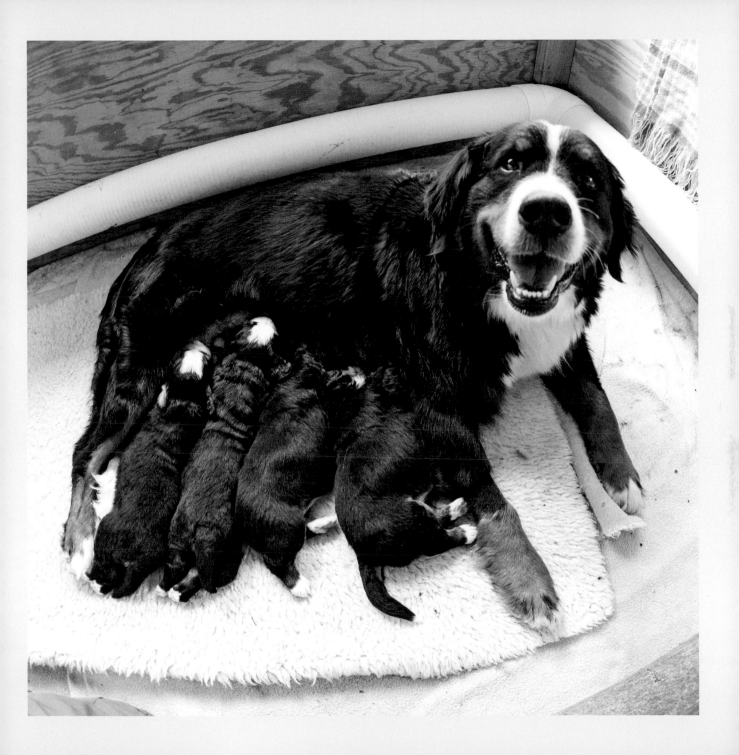

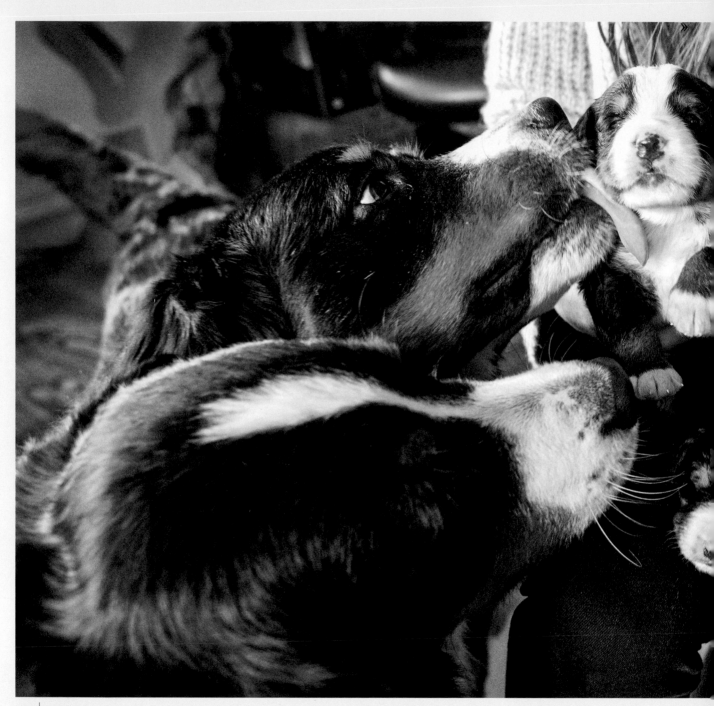

Louie, *9 years old;* **Rosie,** *1 year old;* and **Penny,** *2 years old, with the pups*

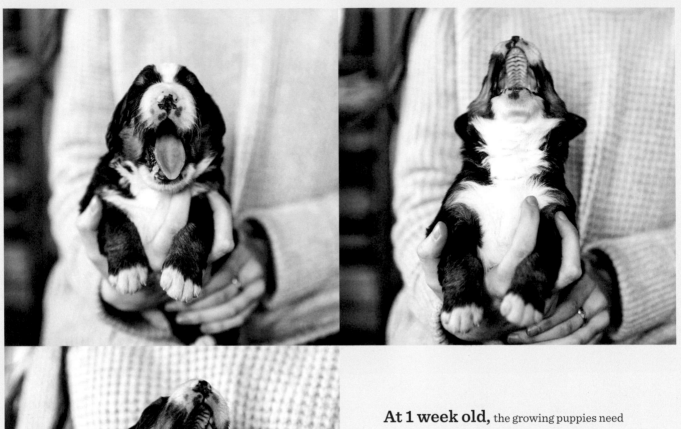

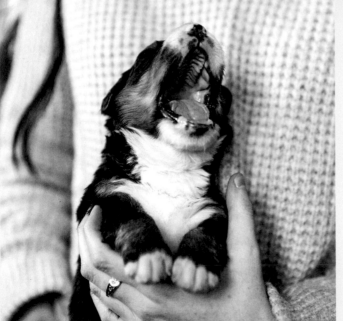

At 1 week old, the growing puppies need to sleep more than 20 hours a day. The rest of the time they spend nursing on their mother's milk. Whenever the mom comes to lie down in the whelping box to feed her puppies, the pups instinctively wiggle over to find a teat, despite being blind with their eyes closed and mostly deaf for the first one to two weeks of life. Competing with their littermates for milk is part of the social-development process for young pups.

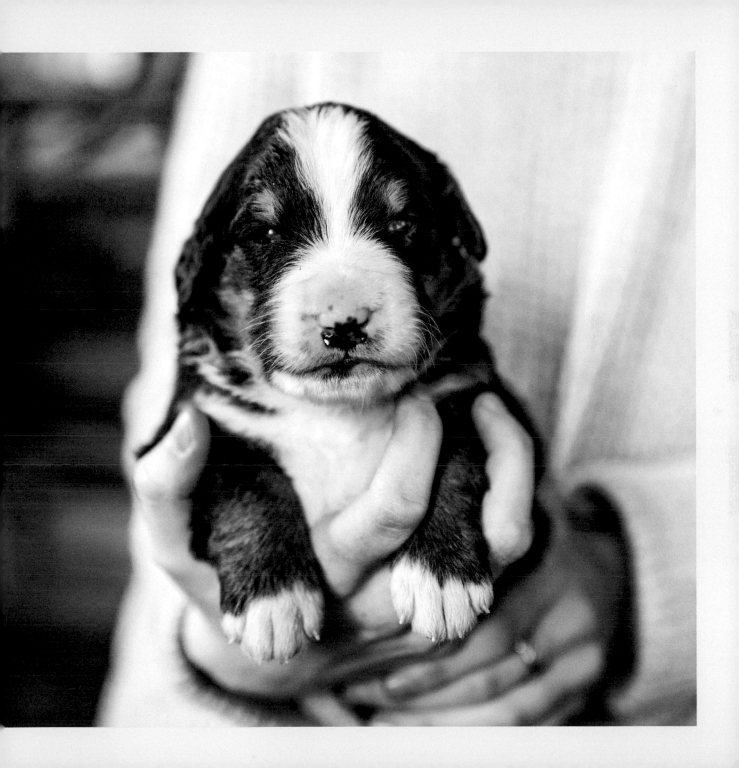

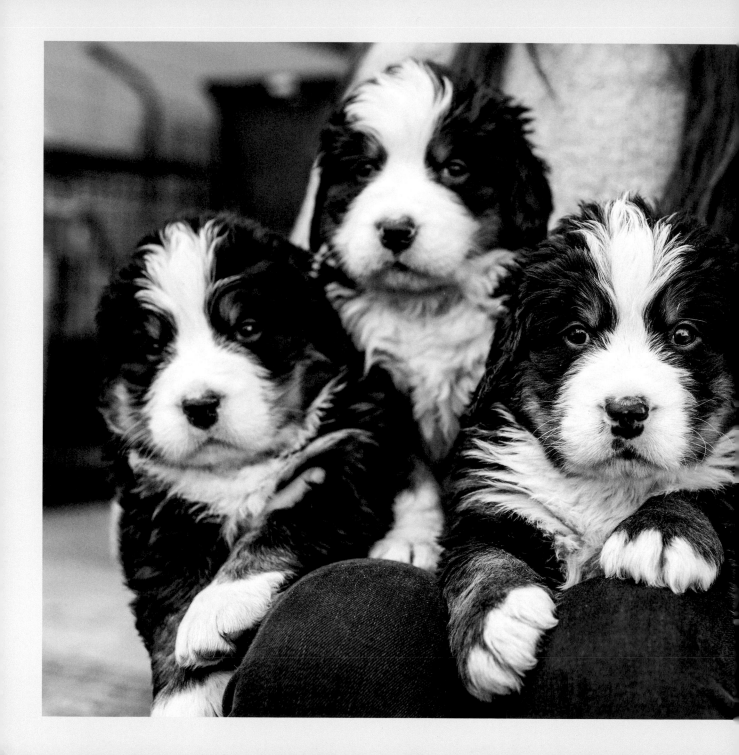

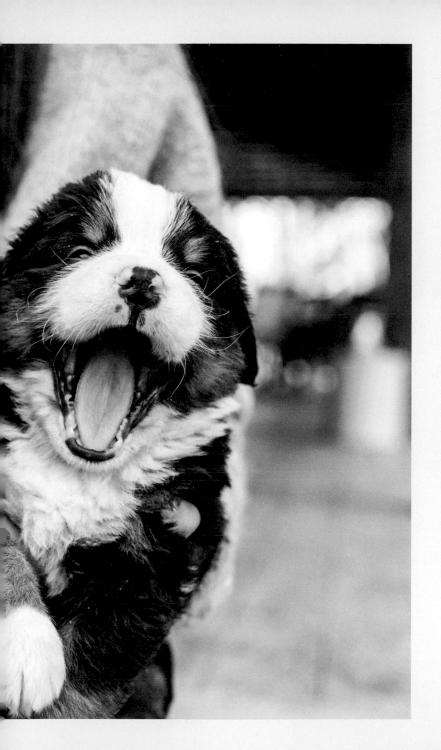

At 4 weeks old, the puppies are gaining more independence. They're still nursing, but it's around this time that they start to eat solid food.

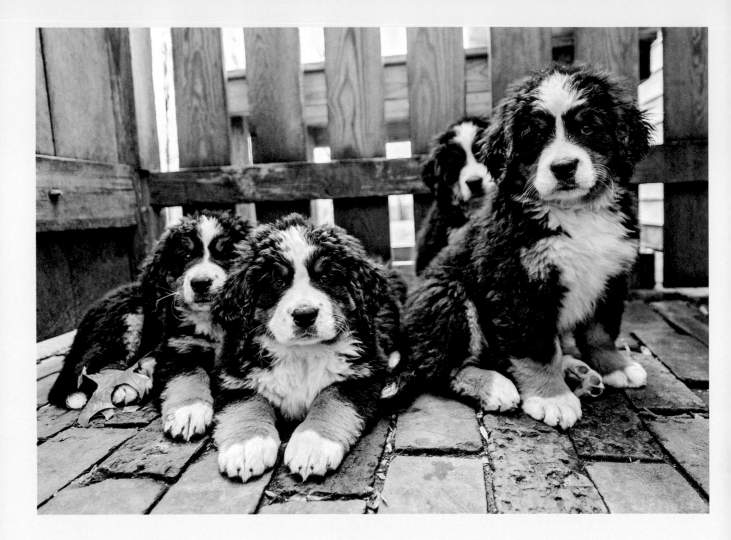

At 8 weeks old, the dogs' personalities are beginning to show. They are playful and full of energy. They've gained weight, and their fur is getting fluffier. These pups will go home to their new families any day now.

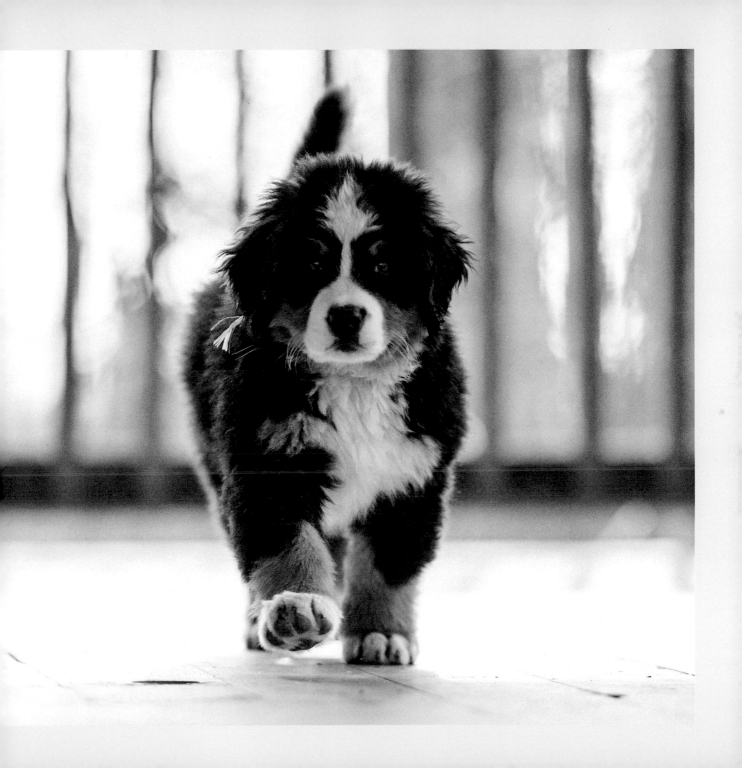

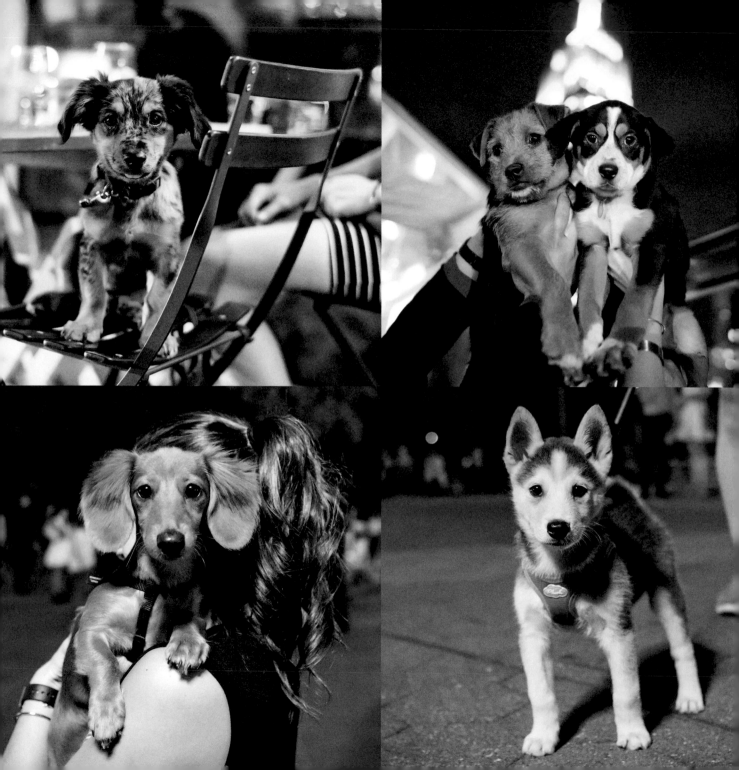

Buzz,
mix, 3 months old

Tara and **Isabella,**
Terrier mixes,
10 weeks old

Hemsi,
Miniature Husky,
11 weeks old

Ruby,
Dachshund,
5 months old

night life

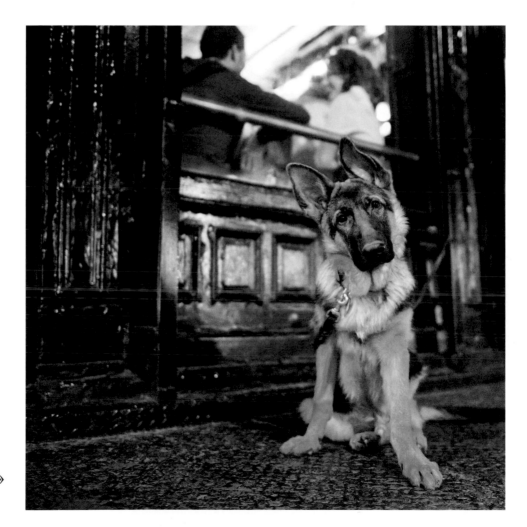

Gandhi, »
German Shepherd,
5 months old

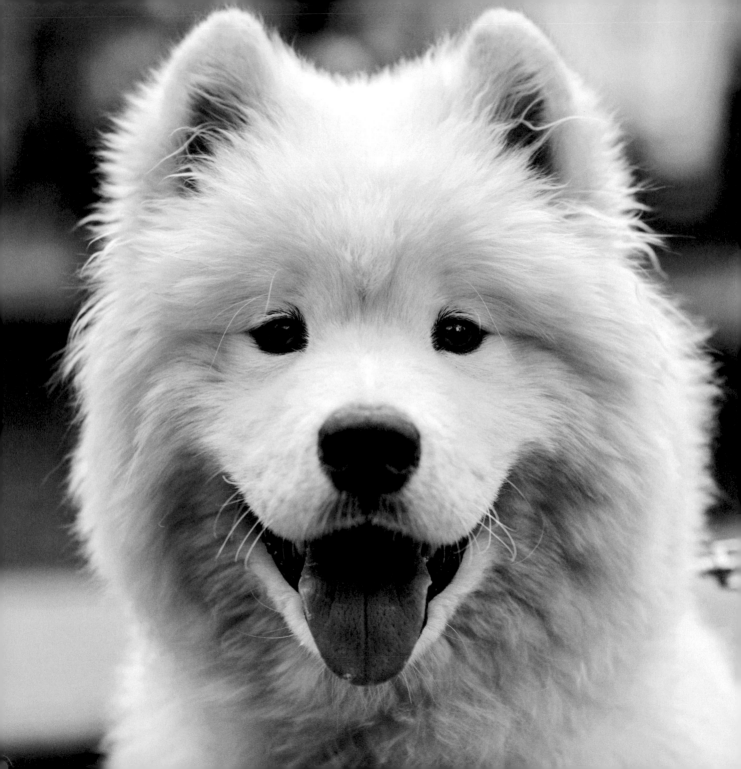

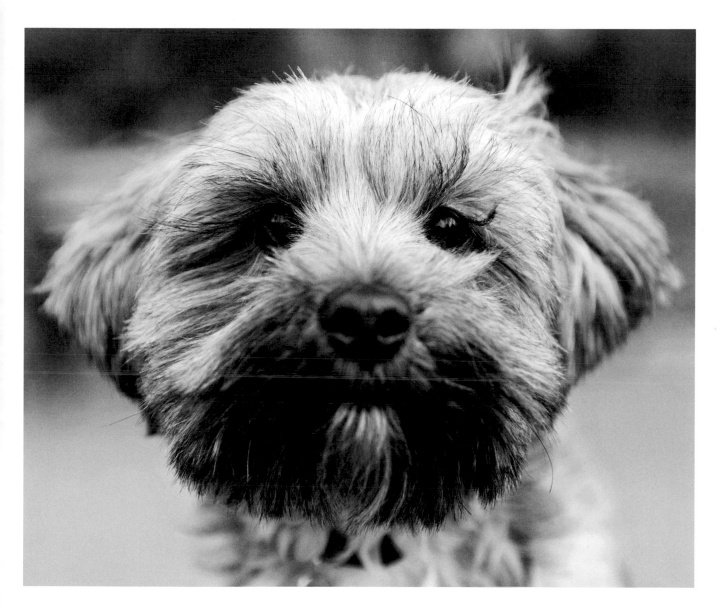

Max, *Shih Tzu/Terrier mix, 11 months old*

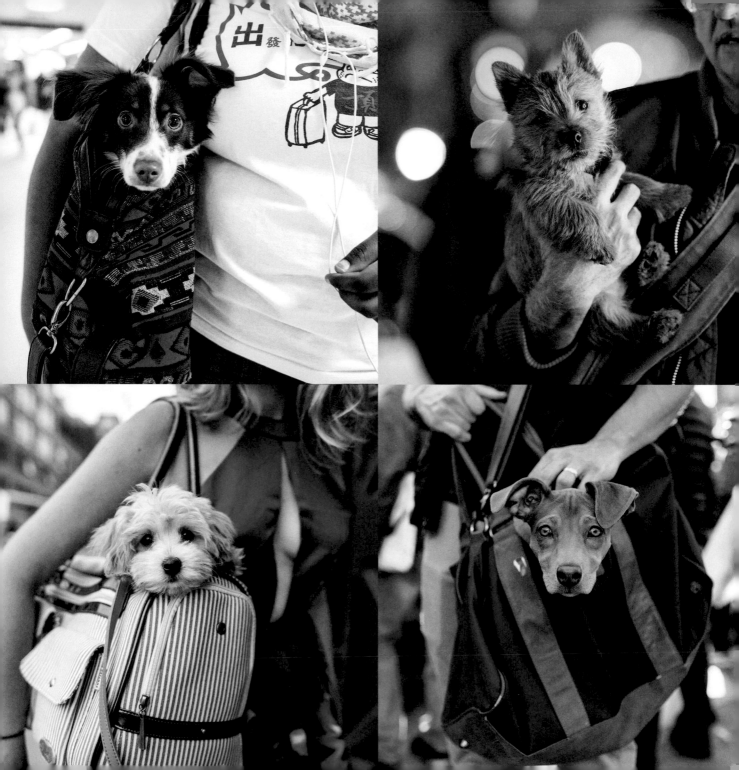

CLOCKWISE,
FROM TOP LEFT

Kaoru,
Australian Shepherd,
6 months old

Marcel,
Norwich Terrier,
16 weeks old

Sansa,
Chihuahua/Pit Bull mix,
15 weeks old

Khroutan,
Maltipoo,
3 months old

portable pups

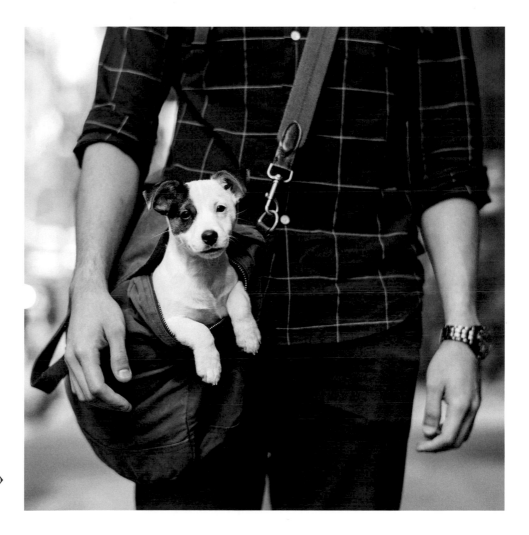

Moji, »
Jack Russell Terrier,
11 weeks old

Luna, *French Bulldog, 5 months old* »

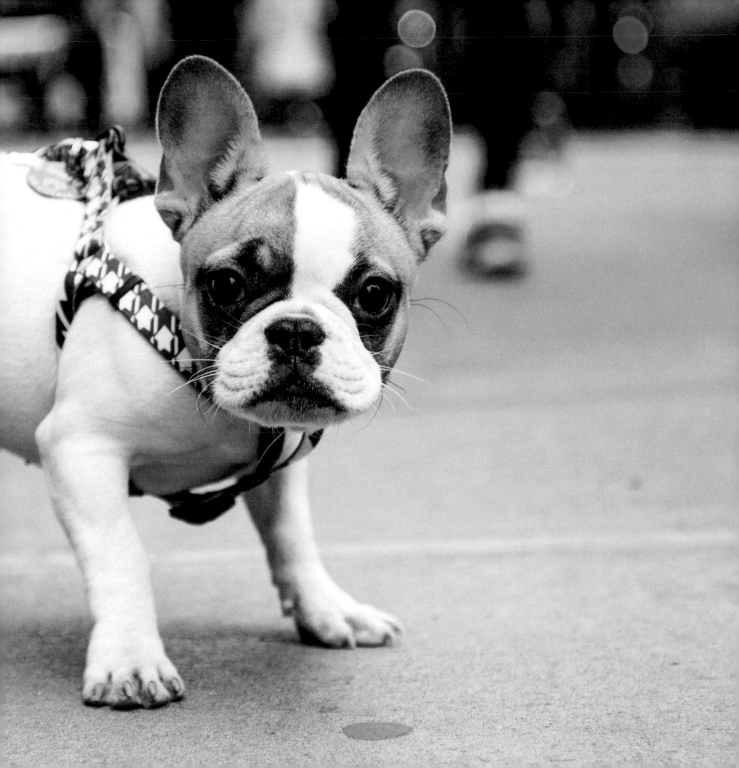

nova scotia duck tolling retrievers

The Nova Scotia Duck Tolling Retriever is an especially unique retriever breed. Whenever I photograph them, they do this unmistakable dance that no other dog does—they rear back on their hind legs, tuck in their front paws, and lunge at me in a playful way. It's charming, and that's a toller's job. Originally called the Little River Duck Dog and developed in Yarmouth, Nova Scotia, this hunting breed can do more than just retrieve fallen fowl. Tollers will prance along the sides of a body of water with their white-tipped tails, mesmerizing ducks or geese and luring them in, just like a fox does. It's an attraction the birds can't resist.

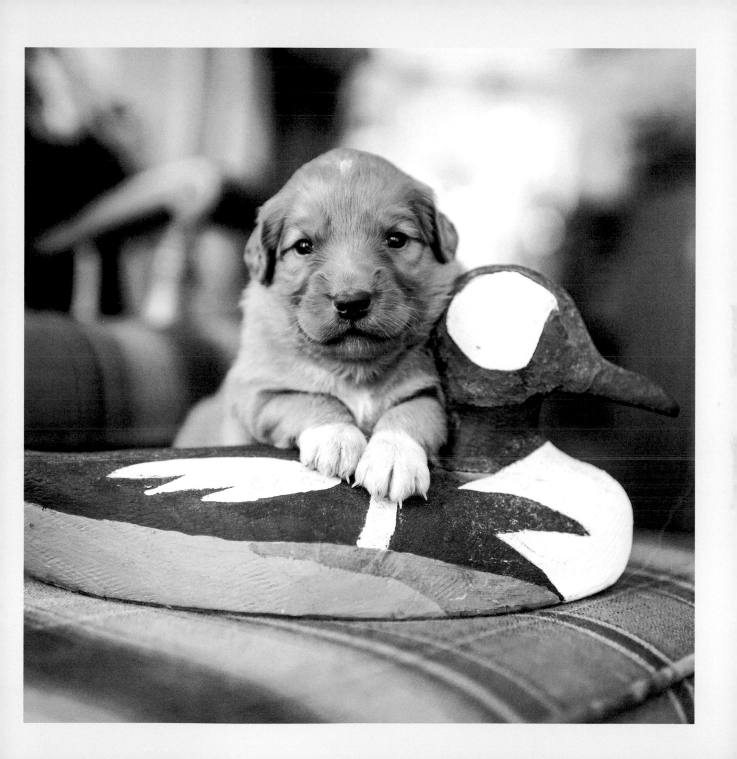

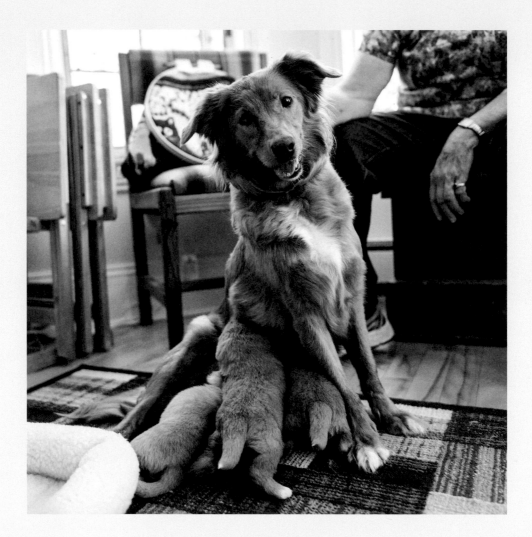

Mocha, *with her pups*

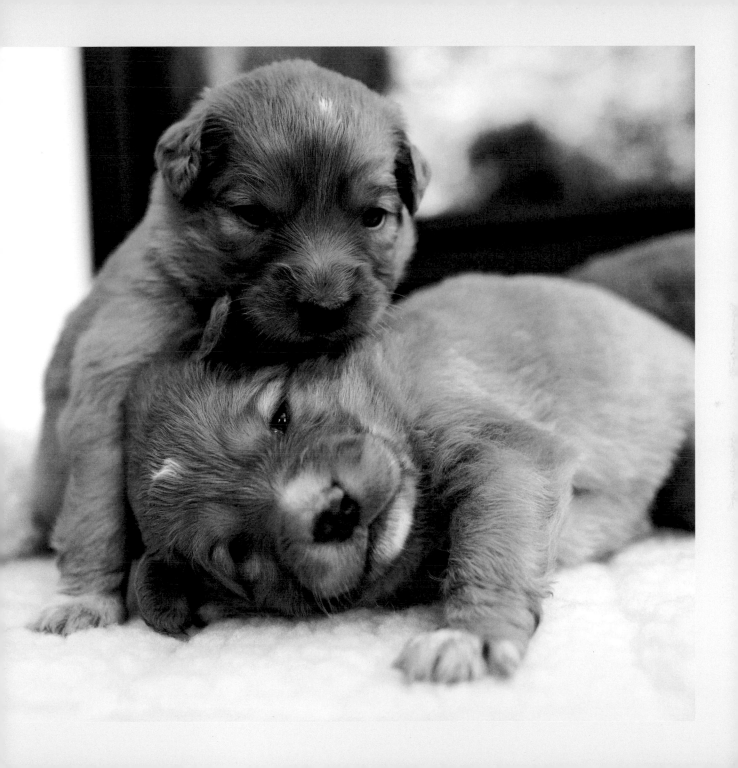

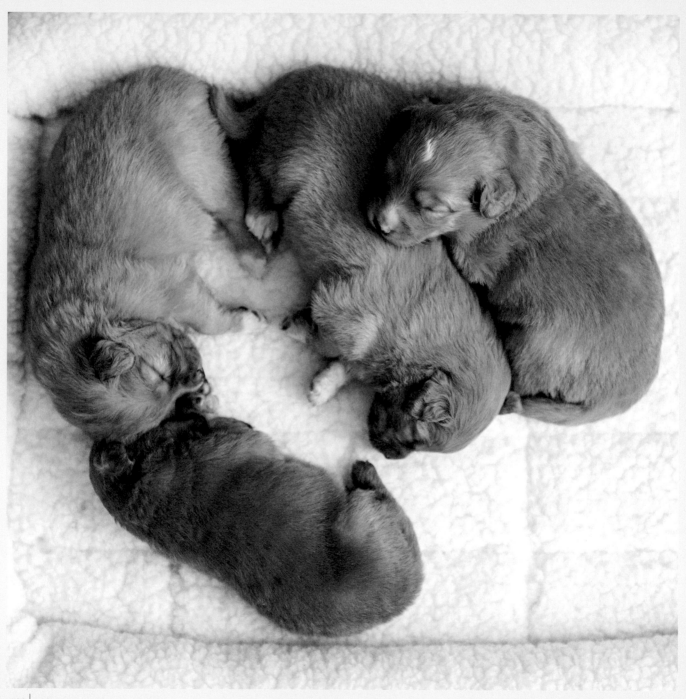

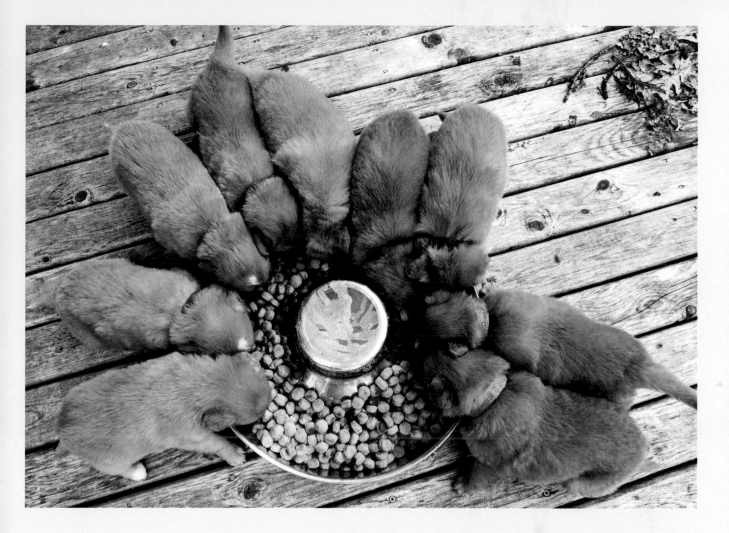

At Redland Kennels, in Mahone Bay, Nova Scotia, they've been breeding tollers for 20 years. They started with two foundation dogs that have lineage to the original Yarmouth breedlines: Harbourlights Salty Dog and Harbourlights Cinnamon Twist. Some of the pups become pets, but they're always placed in active homes where they will be taken paddleboarding, kayaking, or hunting. The breeder is choosy about where the pups go, and nobody gets to pick their puppy. The breeder knows which dog is best for each family.

« *Growing puppies sleep an average of 20 hours per day.*

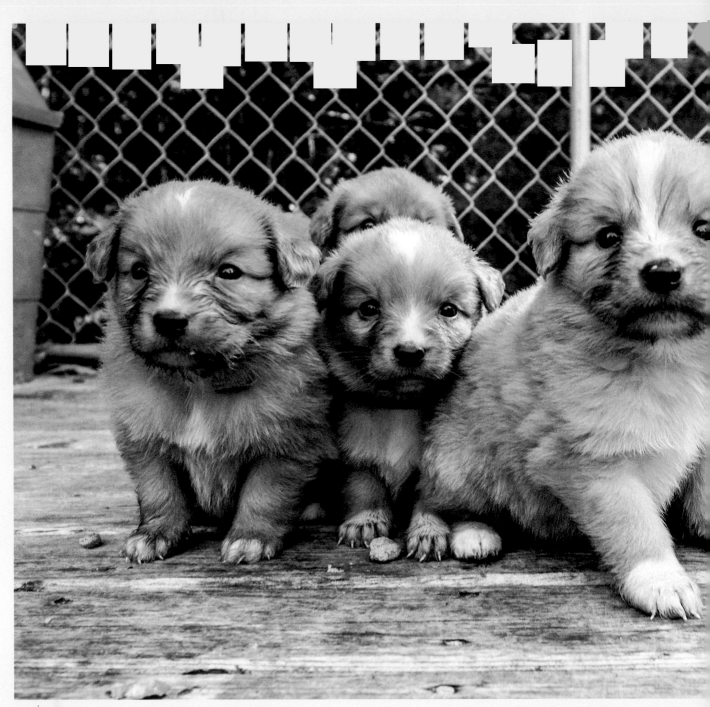

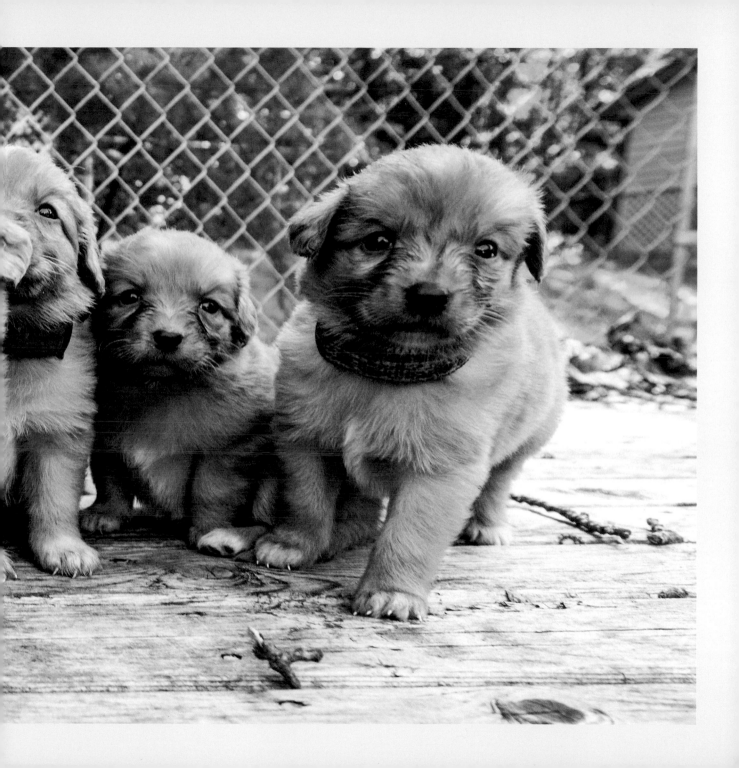

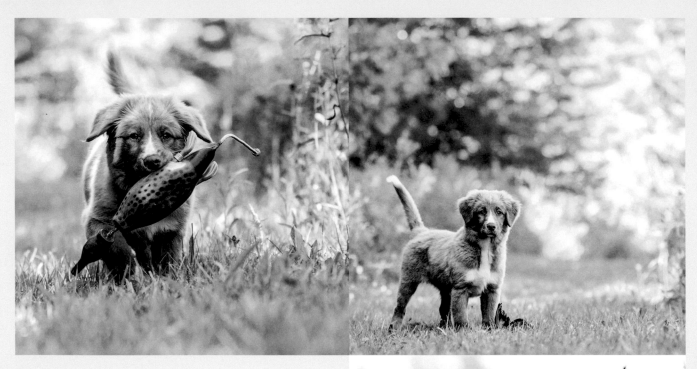

At the Saltydog Kennels,
in Ardoise, Nova Scotia, young pups first practice retrieving and learn basic commands at around 15 weeks old. This is Hannah's first swim and her first bird.

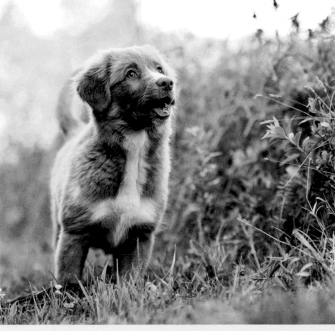

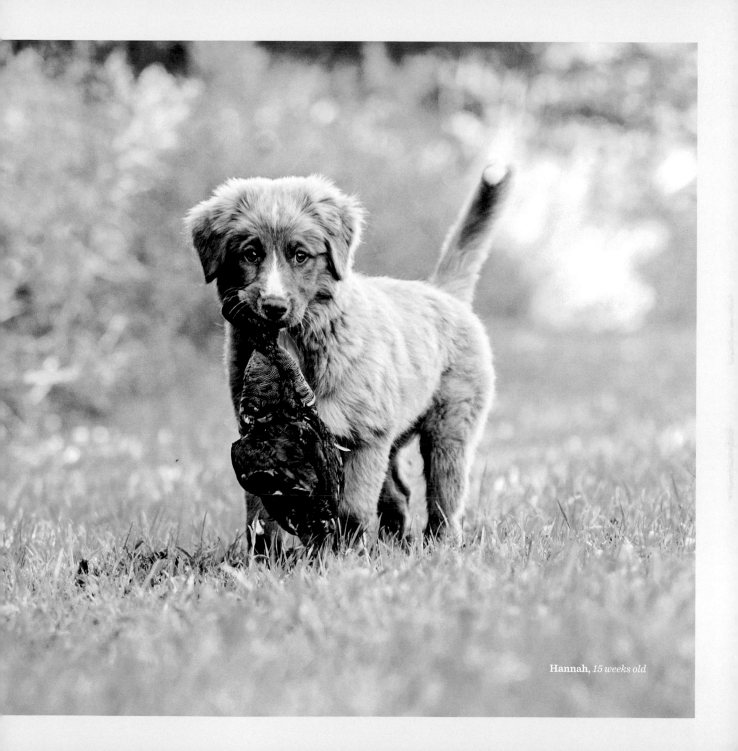

Hannah, *15 weeks old*

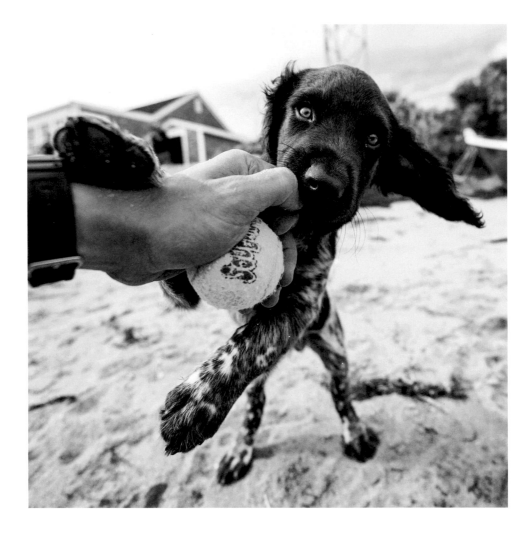

"He always falls asleep when we take him out on the boat."

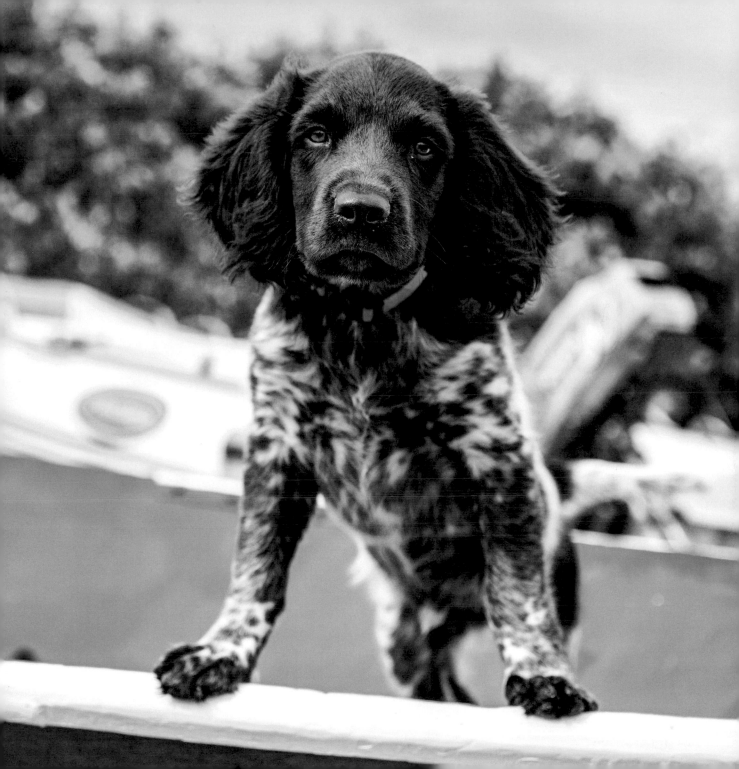

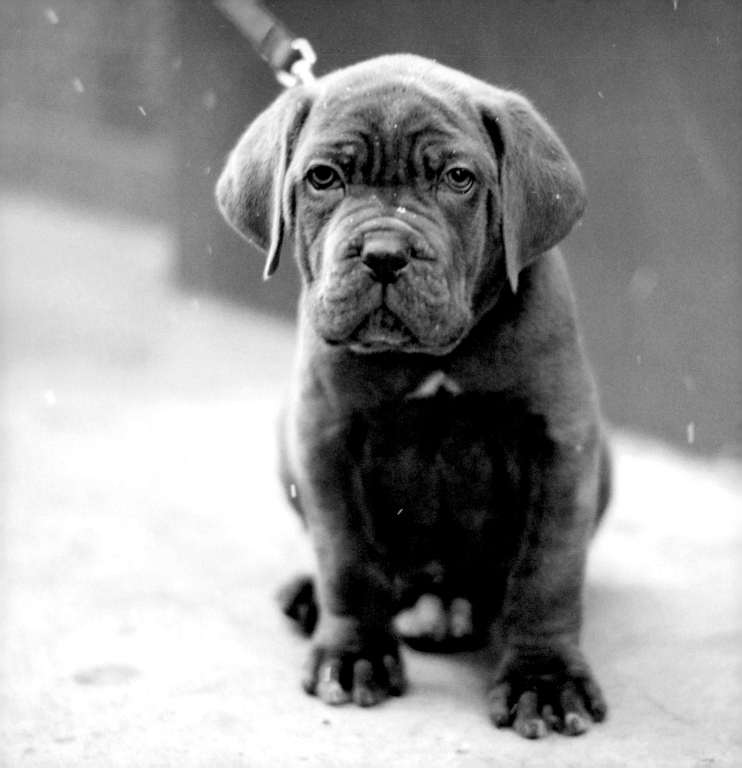

then

《 **Ghost,** *Cane Corso, 3 months old*

and now

2 years old

shelter
pups

Rescuing a dog from a shelter is a noble and rewarding way to find your best friend for life; he will love you for giving him freedom. Rescued dogs sometimes have troubling stories, and the photographs I take of them often show that in their expression. It's an interesting, sometimes sad, and ultimately heartwarming aspect of what I do as The Dogist. Since 2013, when my project began, I've featured more than 150 adoptable dogs from shelters all around the country. These puppies are from the North Shore Animal League America in Port Washington, New York; it's one of the oldest shelter organizations in the United States. North Shore has saved the lives of more than a million dogs, puppies, cats, and kittens from all over the world. To spend time there is to fall in love a hundred times over.

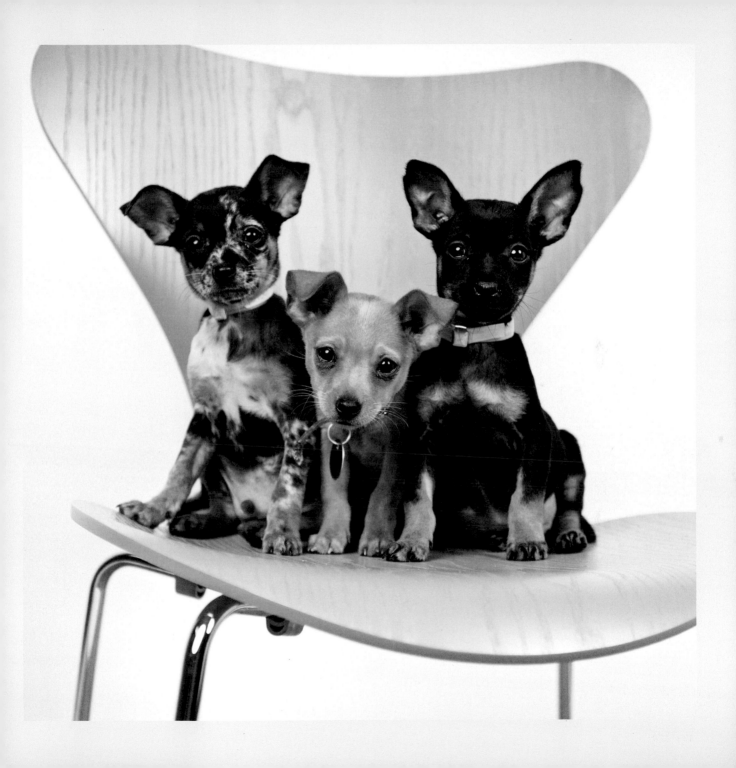

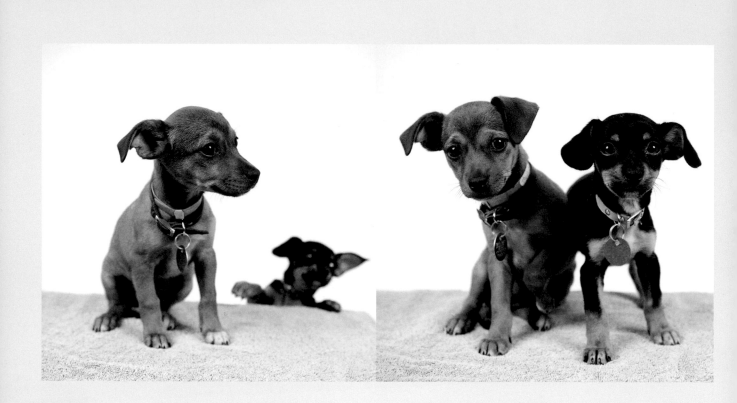

Often, puppies arrive at New York shelters from overcrowded shelters in other parts of the country. Many of the puppies are of mixed breeds and will likely grow up to display a combination of physical and temperamental characteristics from different breeds. This makes the dogs unique and often healthier due to their genetic diversity. For those who prefer purebred dogs, there is often a misconception that shelters don't have them. The truth is, dogs of every sort find themselves without homes for one reason or another: a family wasn't ready for a pet, an owner becomes ill or passes away, a dog whelps a litter of puppies unexpectedly. I believe that if you are looking for a dog—whatever the breed—he or she is probably in a shelter waiting for you.

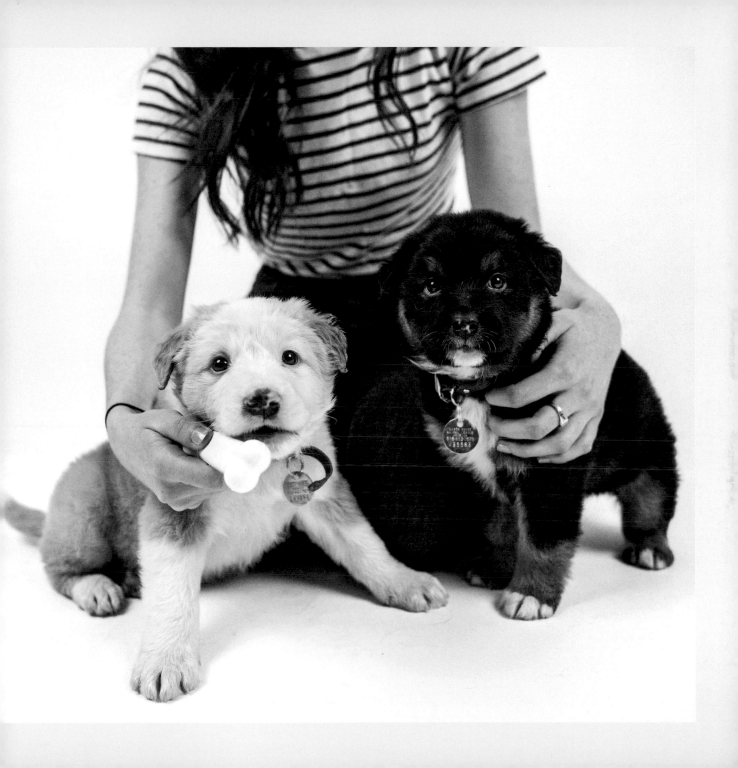

To adopt a pup, you need to demonstrate that you have the time, space, income, and ability to own a dog. You'll be asked questions about your home life: Do you have kids? other pets? outdoor space? Do you own your own home, or if you rent, are dogs allowed? A reference is needed too. I often hear people complain that it's difficult to adopt a dog given a rescue group's adoption criteria, and so the potential owner immediately considers buying a dog. The people who work at shelters are experts who want nothing more than to place dogs in their forever homes. If they do not allow you to adopt one of their dogs, you're probably not yet ready for the responsibility of dog ownership.

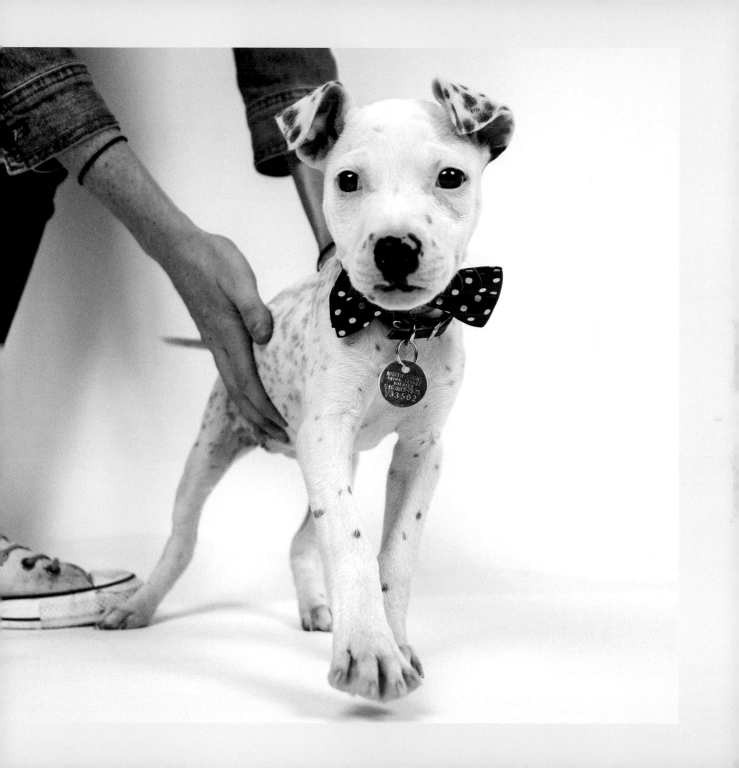

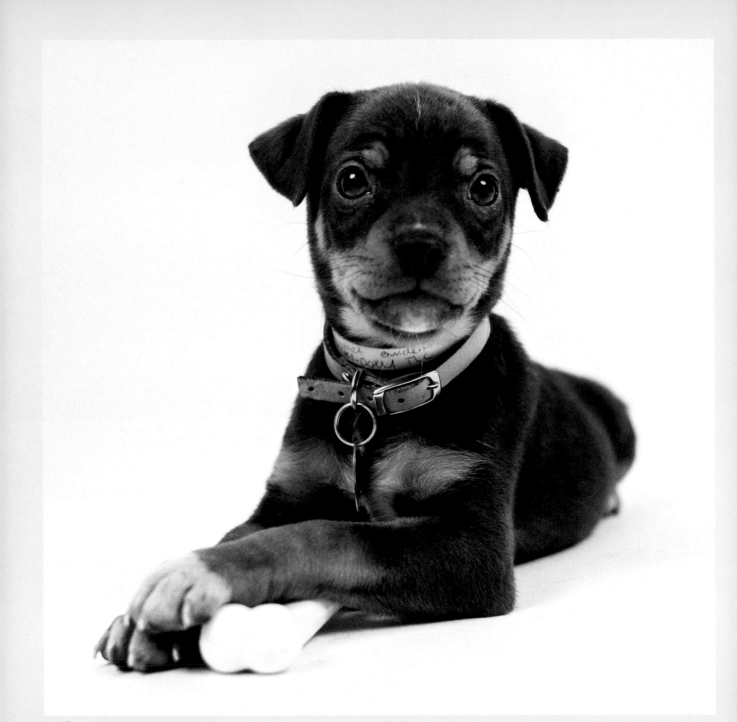

Give a Dog a Bone is a program I created to help tell the story of dogs in shelters. Many of the dogs I see on the streets came from a shelter, so it's important to me to recognize how they got so lucky by spotlighting those who haven't yet. While the puppies featured in this section have all since found homes, which is usually the fortunate case for young puppies, every shelter has special dogs to offer. If you're truly ready for a furry companion, start by visiting your local shelter. You may find your match and make another being very, very happy.

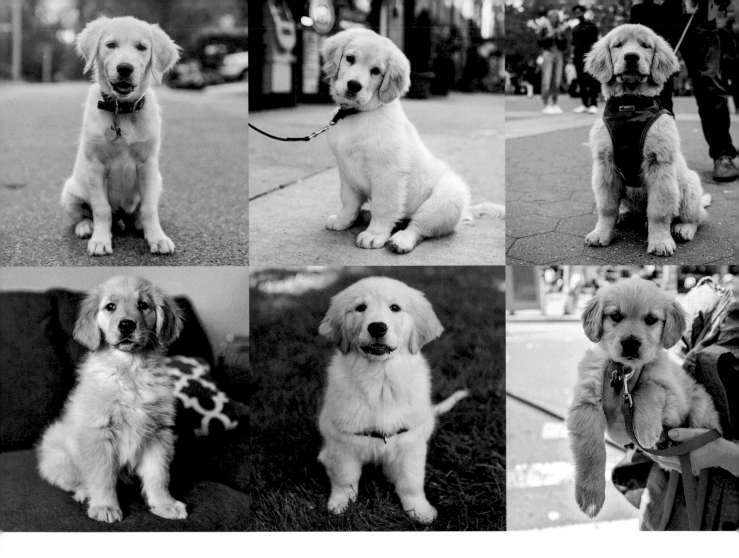

TOP ROW, LEFT TO RIGHT

Tuggy, *Golden Retriever, 14 weeks old*

Fin, *Golden Retriever, 13 weeks old*

Major, *Golden Retriever, 3 months old*

BOTTOM ROW, LEFT TO RIGHT

Max, *Golden Retriever, 8 weeks old*

Lulu, *Golden Retriever, 12 weeks old*

Glee, *Golden Retriever, 9 weeks old*

golden retrievers

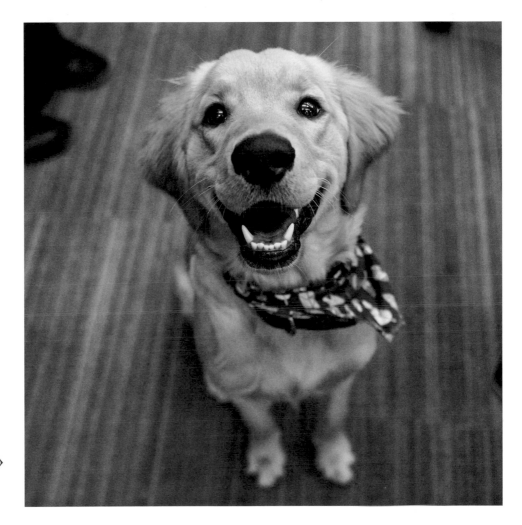

Pazzo, »
*Miniature Golden
Retriever,
7 months old*

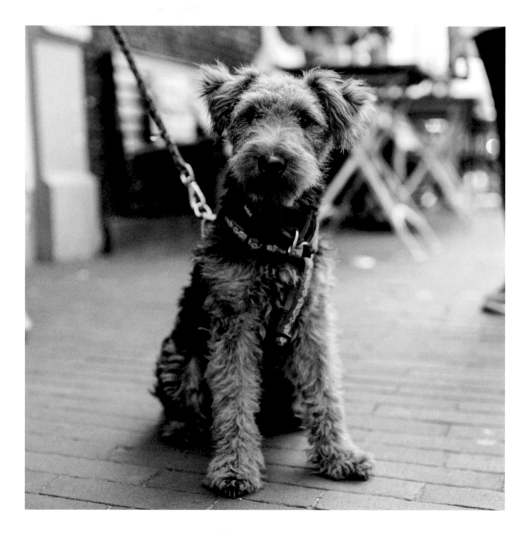

Yoko, *Welsh Terrier, 11 months old*

cones of shame

CLOCKWISE,
FROM TOP LEFT

Tanner,
Pomsky,
9 months old

Florence,
Dachshund,
6 months old

Miss Marble,
Labrador Retriever,
8 months old

Sasha,
German Shorthaired
Pointer,
7 months old

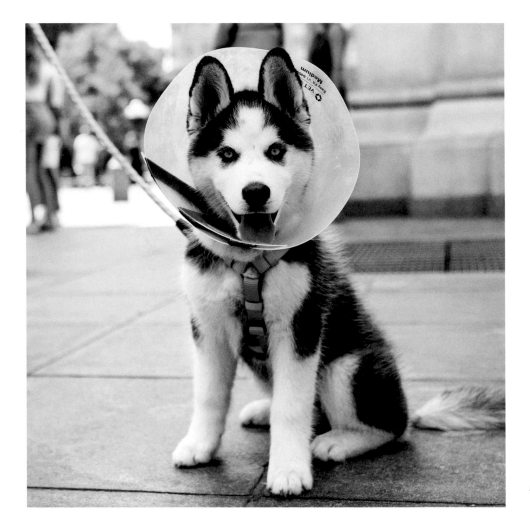

« **Skylie,** *Siberian Husky,*
16 weeks old

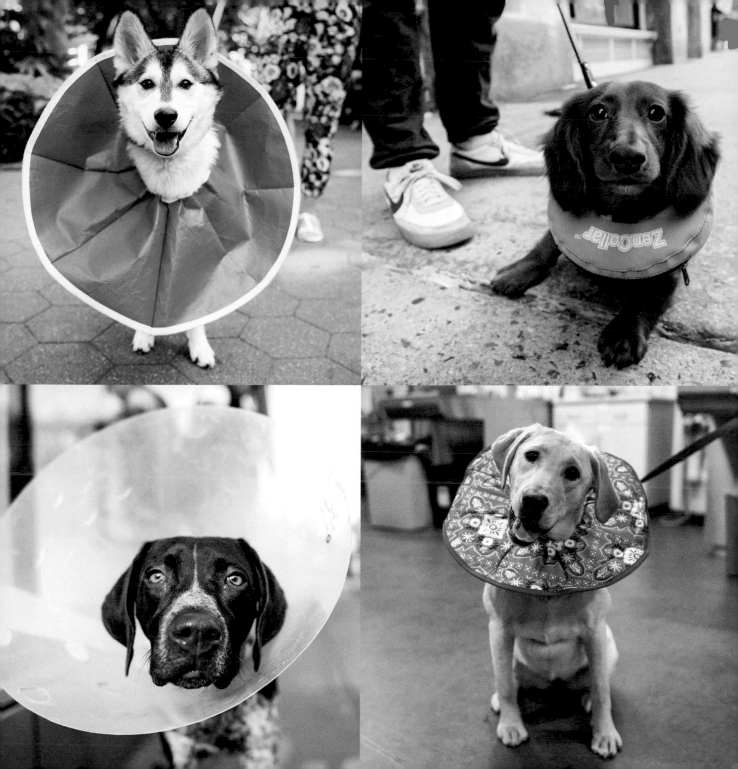

« **Abuli,** *Maltese, 11 months old*

Arya, *Hound mix, 3 months old*

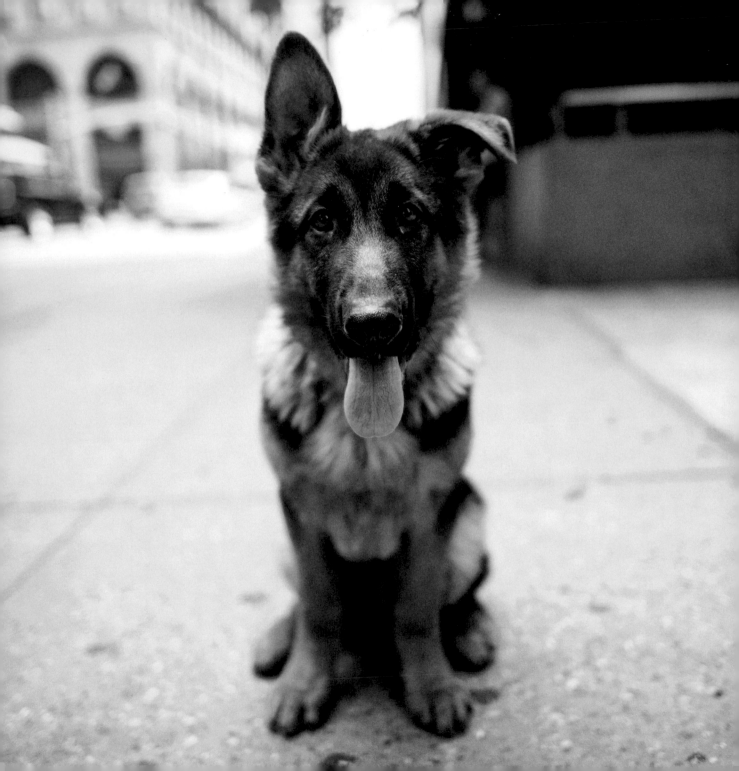

then

« **Bruno,** *German Shepherd, 18 weeks old*

and now

1 year old

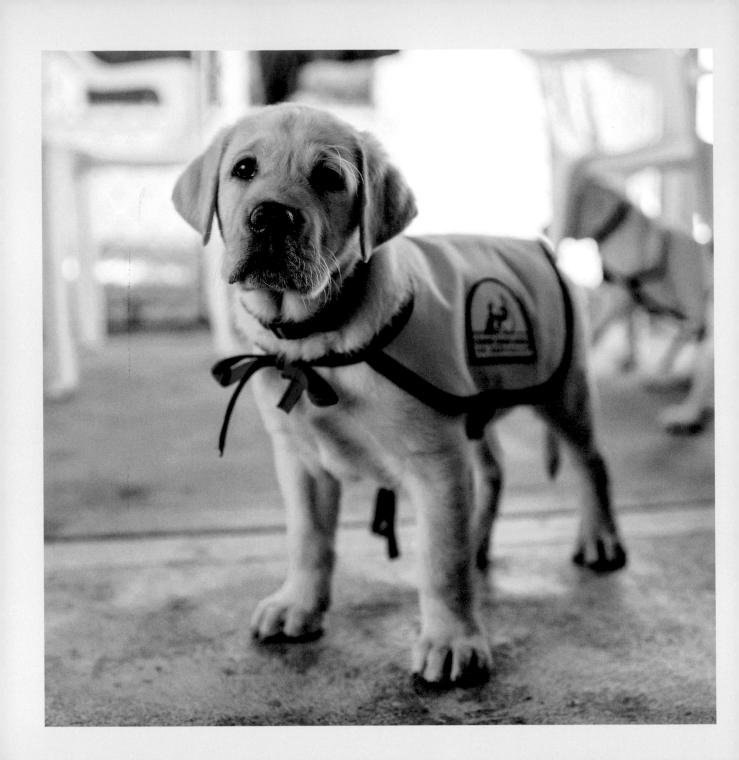

assistance dogs

Canine Companions for Independence (CCI), in Santa Rosa, California, trains both service and facility dogs to help disabled individuals live better lives. They breed Golden Retrievers, Labrador Retrievers, and Golden/Labrador Retriever hybrids with traits to fit a working-dog role perfectly. Service dogs are trained to help people with 65 different types of disabilities, ranging from hearing impairment, autism, back injuries, and developmental delays to paralysis. They also train facility dogs to work in special-education classrooms, health-care facilities, and courthouses. At 8 weeks old, the puppies are paired with a puppy raiser who will rear them for the first year of life. Each dog will learn the same 25 to 39 basic commands from their puppy raisers. When they return to CCI at $1\frac{1}{2}$ years of age, they're taught more specialized commands tailored to the person they will be assisting.

Only 50 percent of the dogs that enter formal training at CCI will graduate from the program. A working service dog has to have a strong work ethic and good focus. Furthermore, to become a hearing assistance dog (or a guide dog), the dog must be able to think on its own if a command shouldn't be followed; this concept is called intelligent disobedience. Not all dogs possess this level of skill and focus, and those that don't graduate may become "skilled companion" dogs or get adopted by a family to simply be the family pet.

These breeds are naturally kind and loving toward people, and being handled by the staff helps the pups further prepare for interacting with humans. They'll leave the whelping center at 8 weeks old to move in with their puppy raisers for the first year or so.

The puppies are transported in a cart to get them acclimated to being in a moving vehicle (it's also a practical way to move them from one place to another). A working dog can't get spooked by the sensation of a car or develop motion sickness when it's on the job, after all.

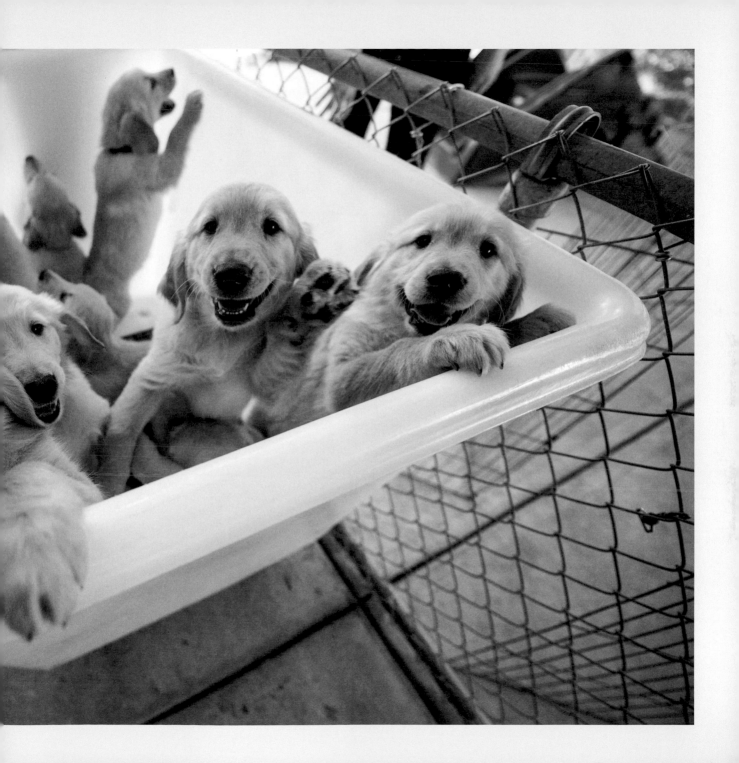

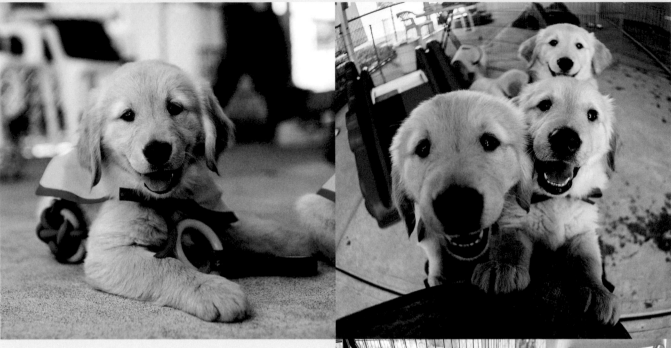

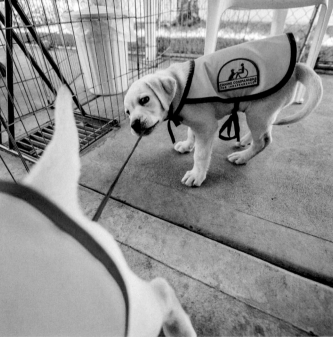

Each puppy is fitted with a small cape to prepare it for the working-dog harness it will wear while on the job.

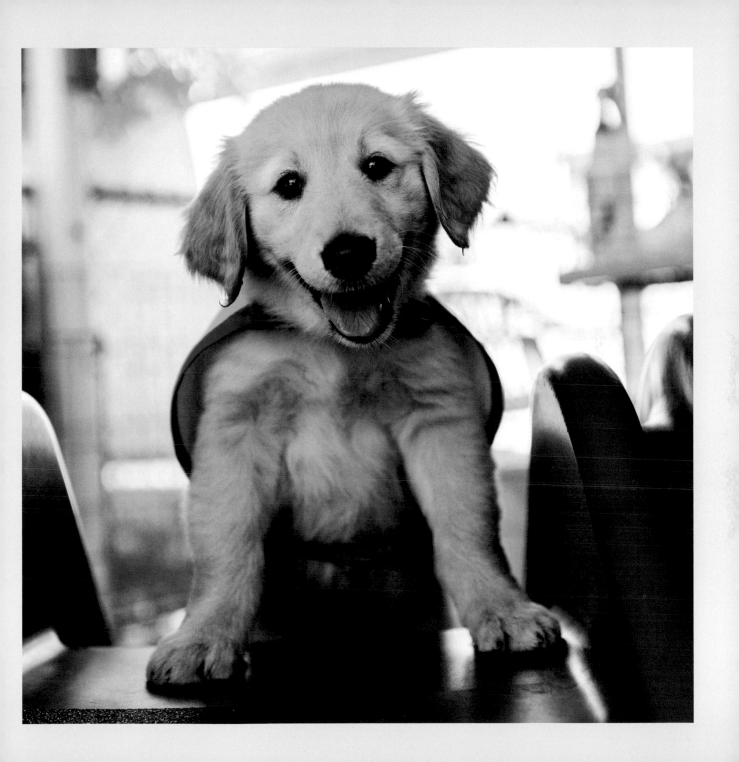

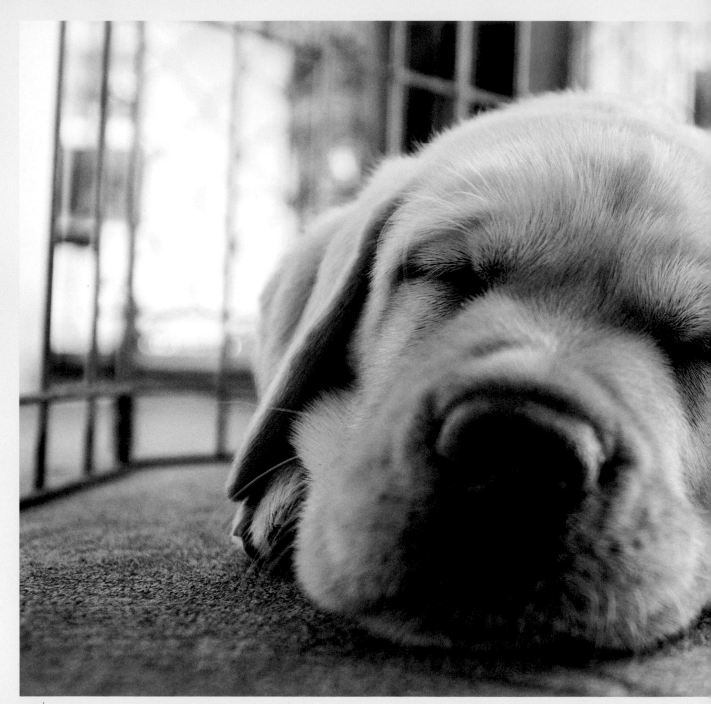

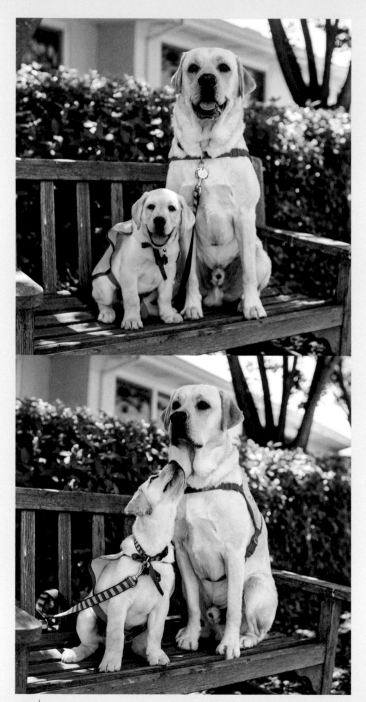

The average service dog works for about eight years before retirement. While these dogs are bred to have as much longevity as possible, at a certain point a dog may lose focus and thus the ability to continue working. At that point the dog will usually be adopted by its original puppy raiser family or by someone vetted by the organization. Occasionally a dog will stay on with its owner but retire from its day-to-day work.

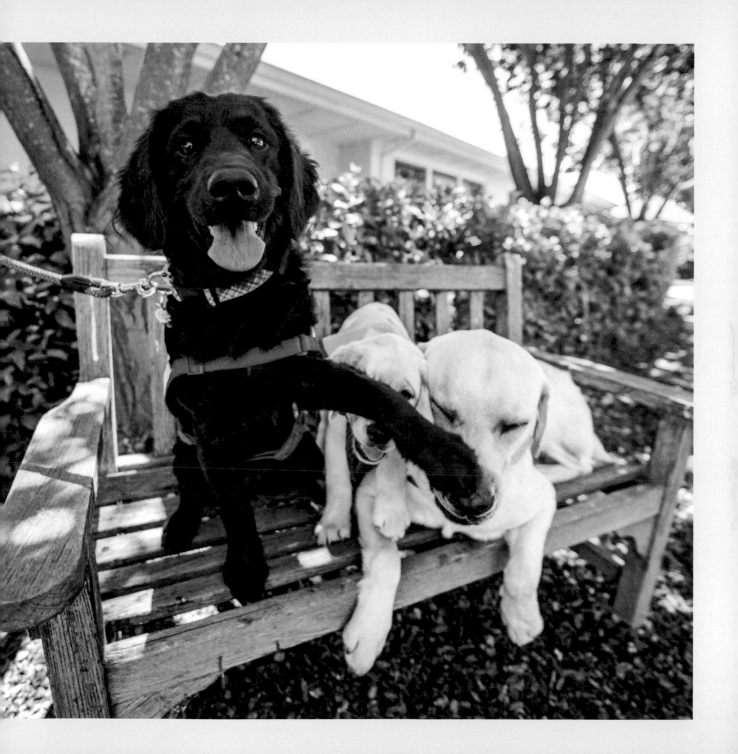

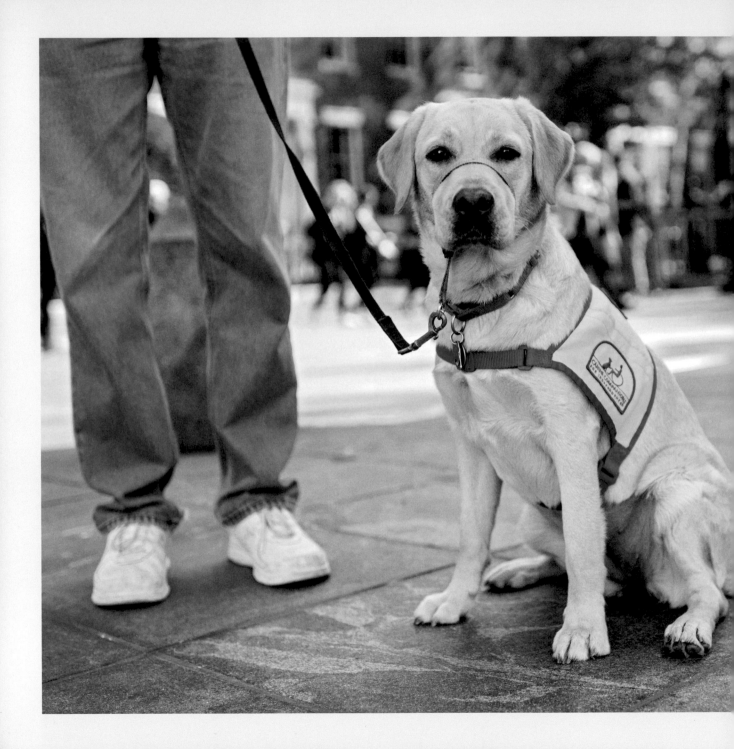

Puppy raisers are dedicated volunteers who take on the financial, medical, and transportational responsibilities for the dogs they raise. They also house-train the dogs and teach them basic commands. A puppy will live with its raiser until it's 1 to 1½ years old. Kandy, here with her puppy trainer, has since graduated from CCI's rigorous program and has been placed with a veteran suffering from post-traumatic stress syndrome.

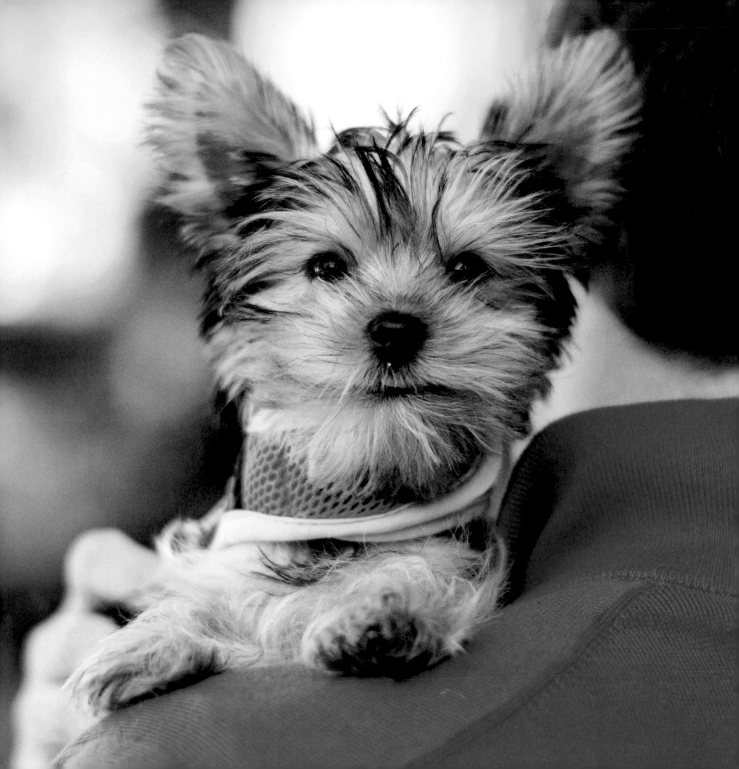

Pomeranian, 3 months old

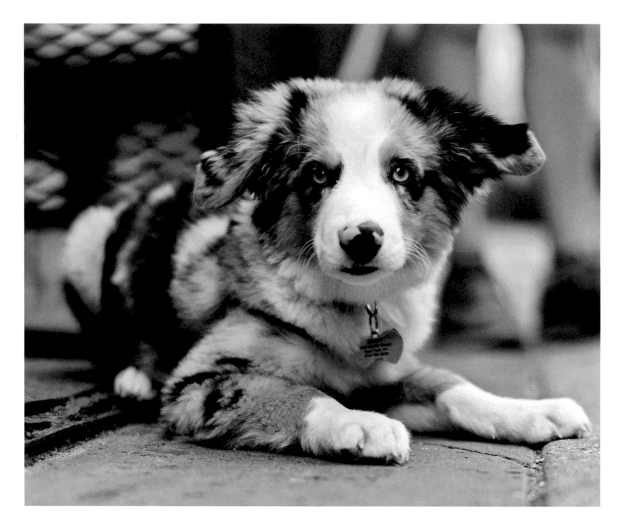

Cody, *Miniature Australian Shepherd, 3 months*

"He loves biting everything, so we call him a piranha."

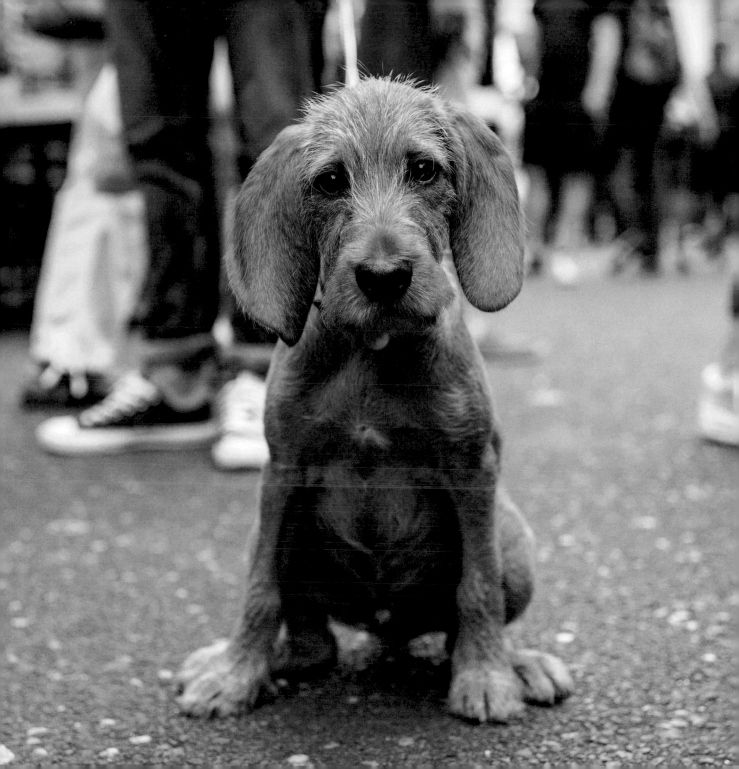

li'l guys

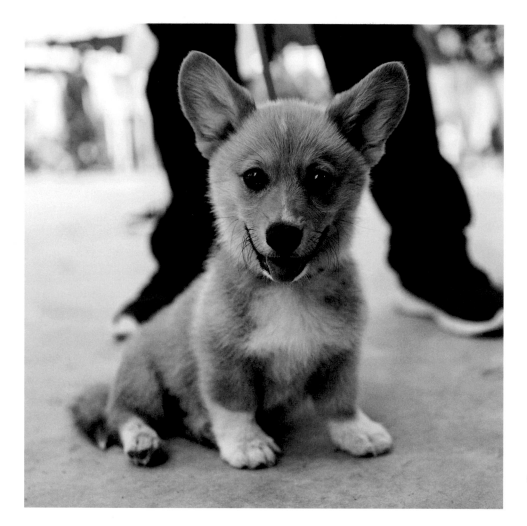

CLOCKWISE,
FROM TOP LEFT

June,
Dachshund,
7 months old

Niko,
Pomeranian,
6 months old

Carter,
Miniature Dachshund,
4 months old

Chago,
Chihuahua,
4 months old

« **Soloman,**
Pembroke Welsh Corgi,
12 weeks old

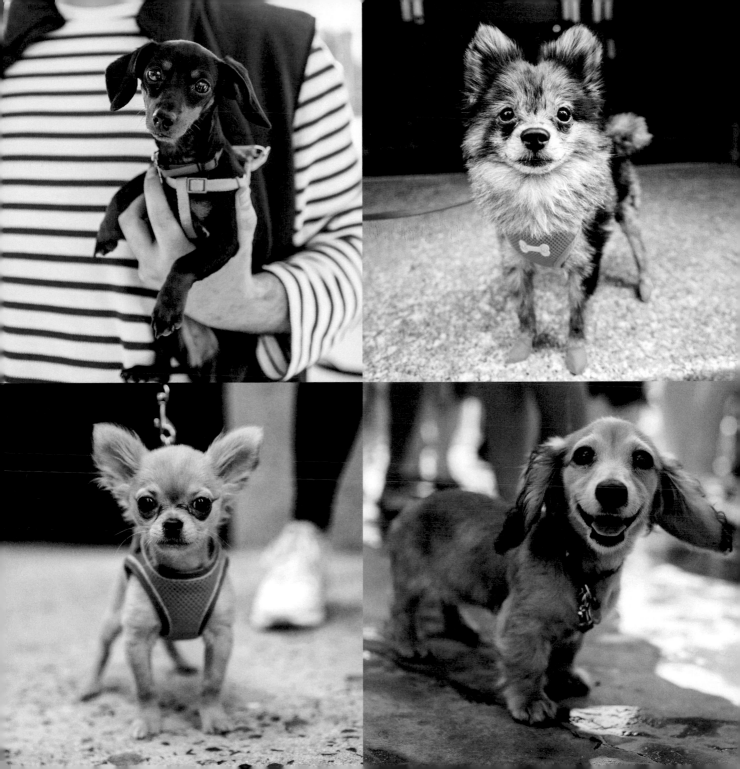

bundled up

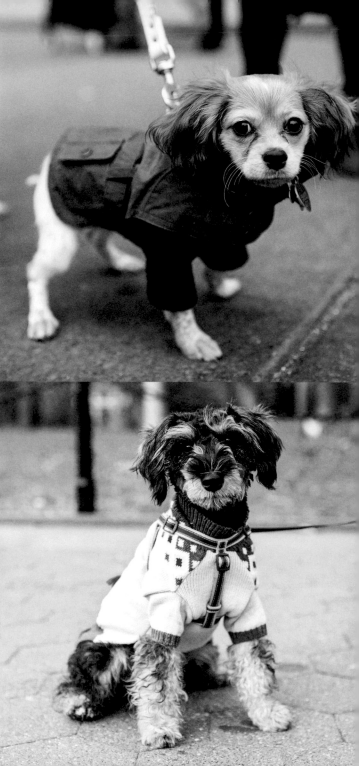

TOP ROW, LEFT TO RIGHT

Blanche Devereaux,
Havanese/Shih Tzu mix,
4 months old

Lucy,
Cavalier King Charles Spaniel,
7 months old

Fritz, *Swedish Vallhund,*
3 months old

BOTTOM ROW, LEFT TO RIGHT

Luna Cheddar,
Labrador Retriever mix,
3 months old

Brownie,
Miniature Schnauzer,
6 months old

Killian, *Goldendoodle,*
10 months old

Milo, *Cavapoo,*
8 months old

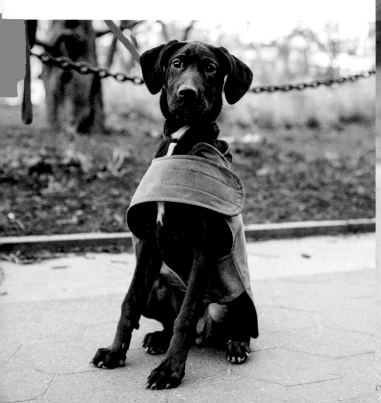

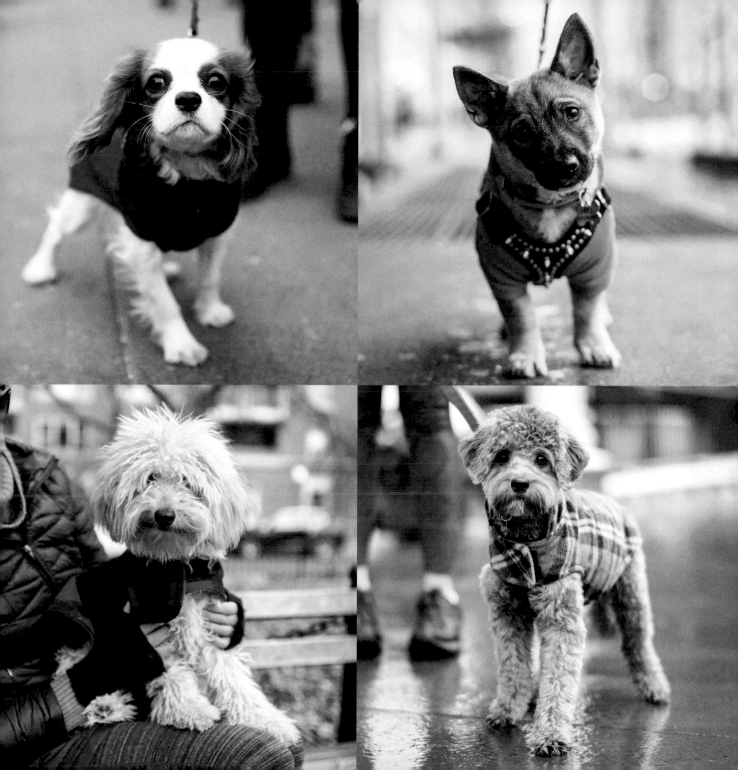

Bobun, *Chow Chow, 5 months old* »

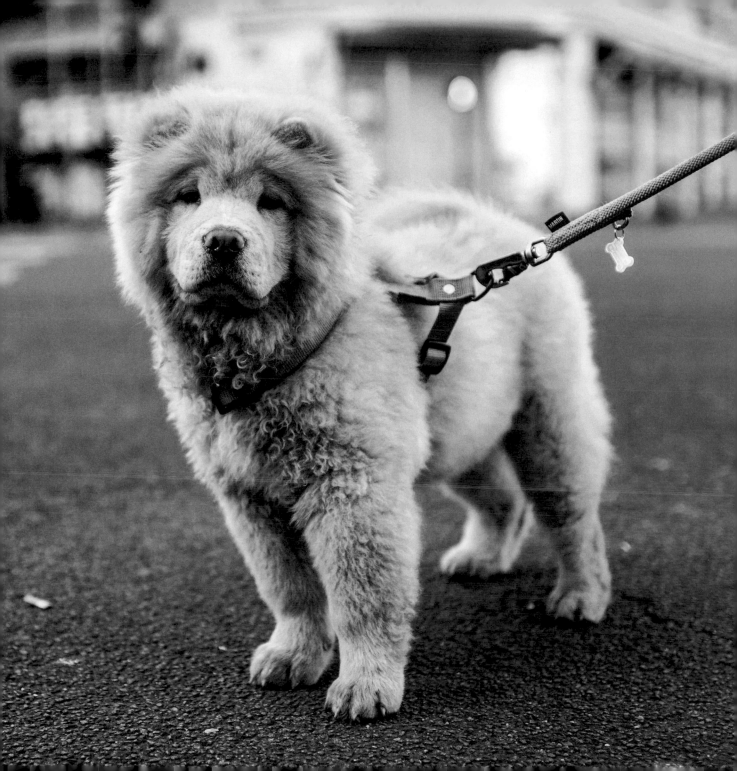

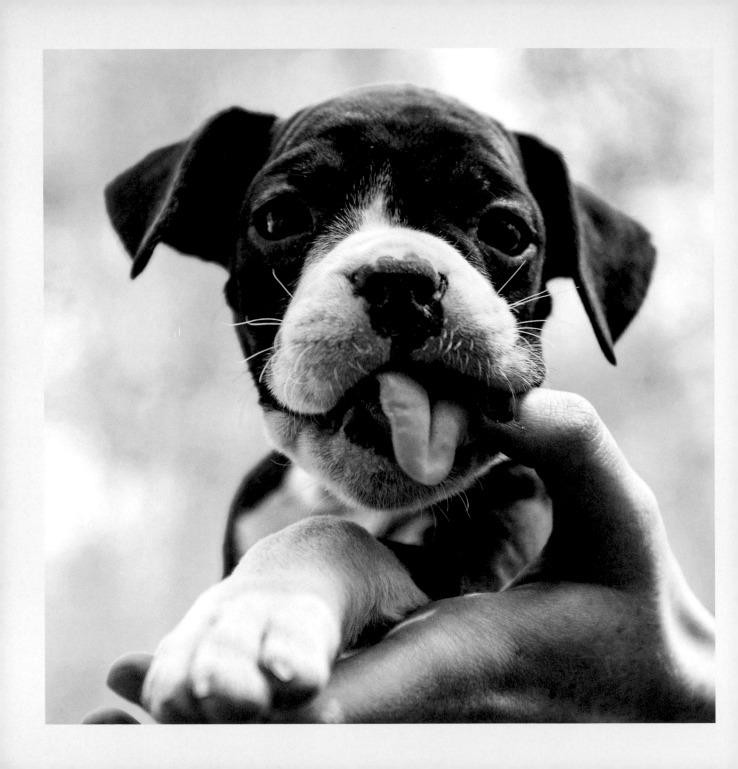

boxers

When I think about Boxers, I always think of one word: *goofy*. They have a seemingly fixed expression that says "Who, me?," and their lively and dubious attitude always comes through in an entertaining way in their portraits. Developed in Germany, this working breed is now most commonly considered a family guardian dog. At Shark Rum Breeders in Hewitt, New Jersey, Millie had recently had a litter of pups.

Boxers are born with one of two coat patterns: fawn or brindle. Millie, the mother of this litter, has a fawn coat, and the father's coloring is reverse brindle, with black fur that has flashes of white. The entire litter turned out to have reverse brindle coats like the father's.

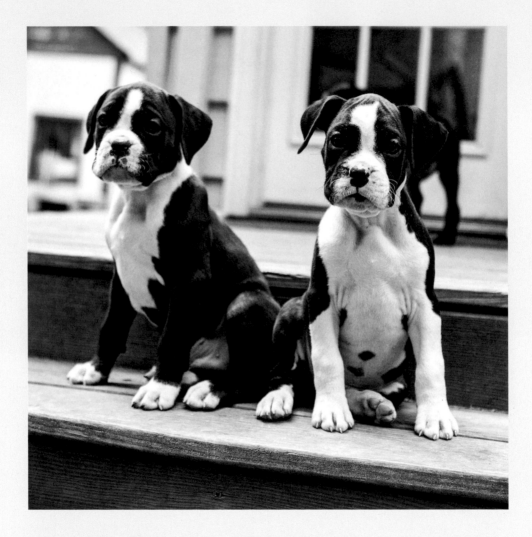

Boxers are part of a larger category of dogs called Molosser, all of which are believed to have descended from one common ancestor. Also in this category are Mastiffs, Great Danes, Rottweilers, Bulldogs, and Newfoundlands, among others.

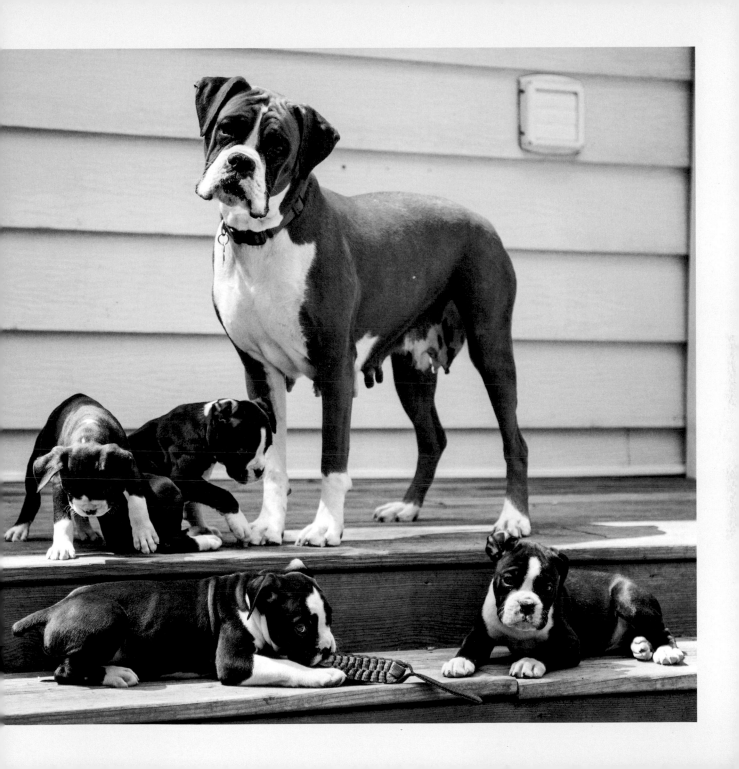

By the age of 3 weeks old, the puppies are big enough and strong enough for play. These 8-week-olds are getting in some playtime with their mom before going to their new homes.

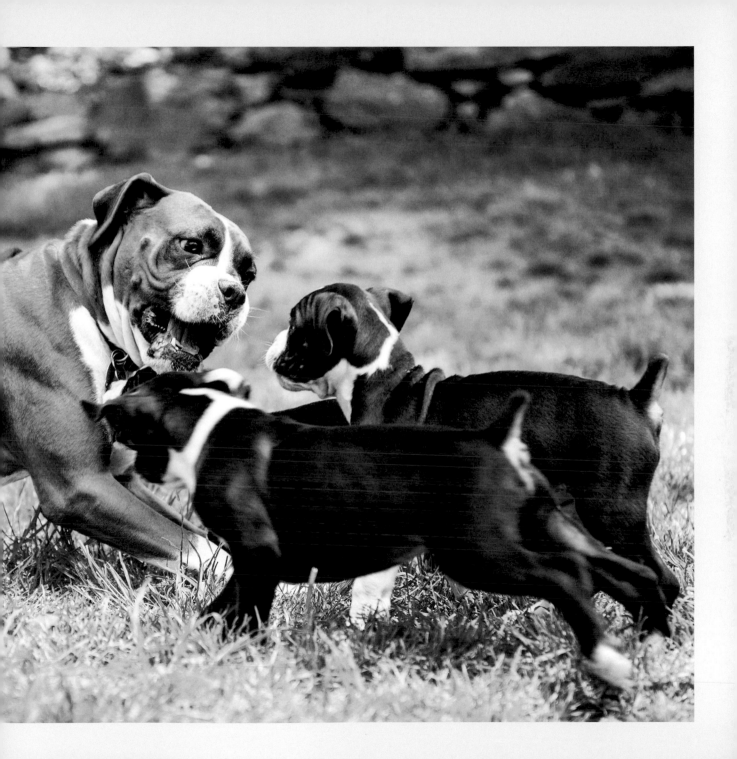

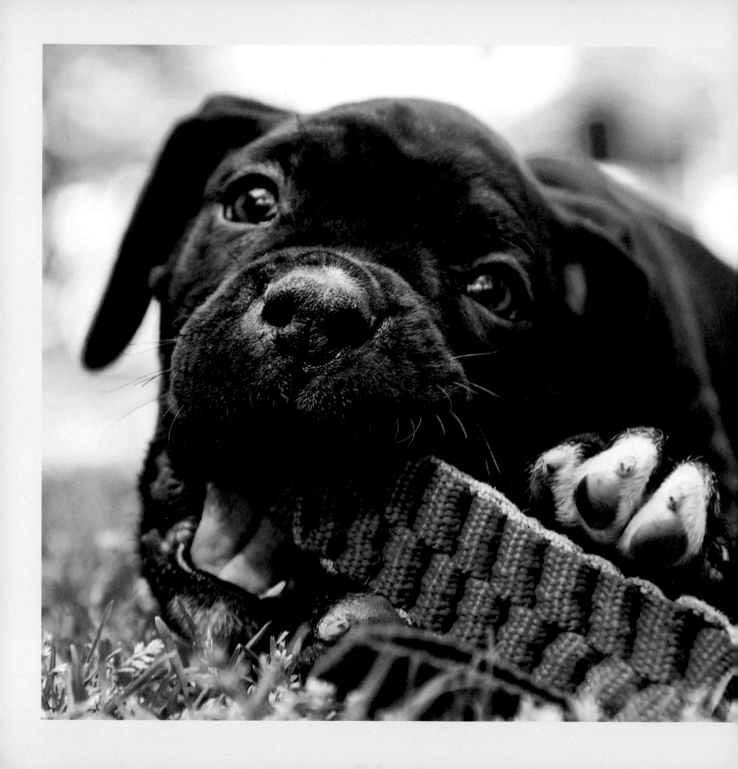

Watch out—teething puppies will chew on everything in sight, including your fingers. They're like little sharks once their teeth come in, which, unsurprisingly, is when mom starts refusing to nurse them, around 6 weeks. It's important to give them toys or sticks to chew, as this helps strengthen their jaws and teeth while also providing them a means to release energy.

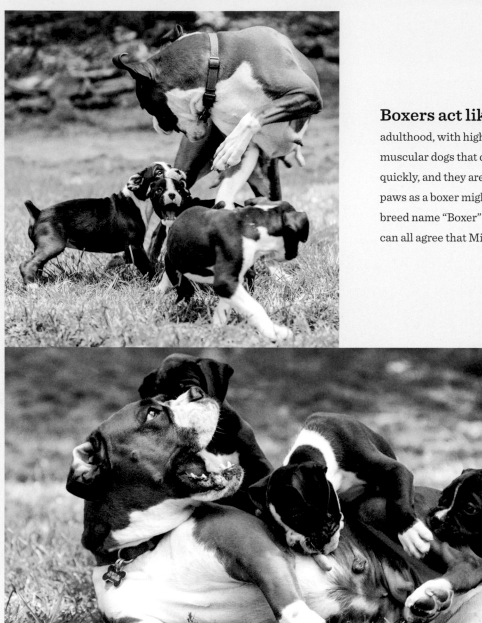

Boxers act like puppies well into adulthood, with high energy. They're lean and muscular dogs that can jump high and run quickly, and they are known for using their front paws as a boxer might. The true origin of their breed name "Boxer" is debated, but I think we can all agree that Millie is a knockout.

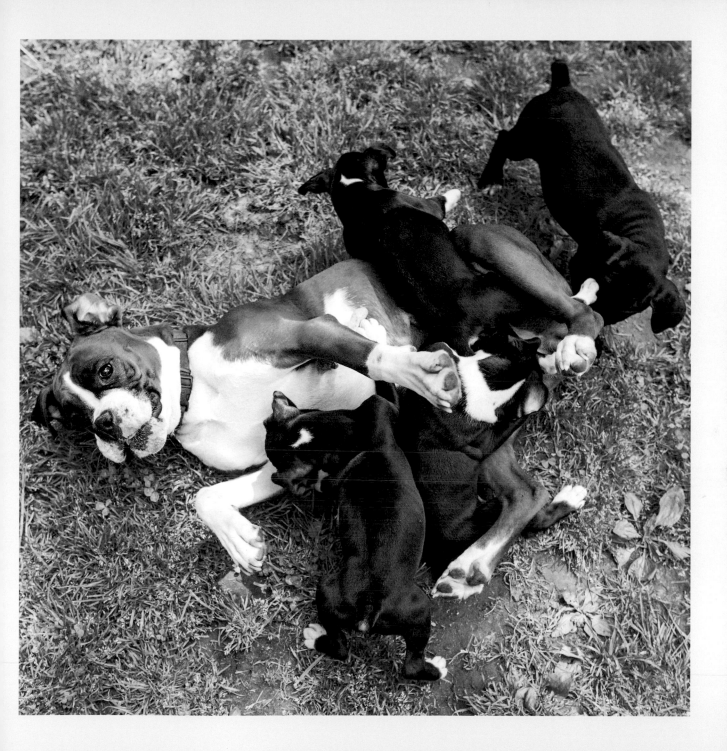

Dinah, *Siberian Husky, 10 months old*

"She's the klutziest dog— she runs into walls."

arm candy

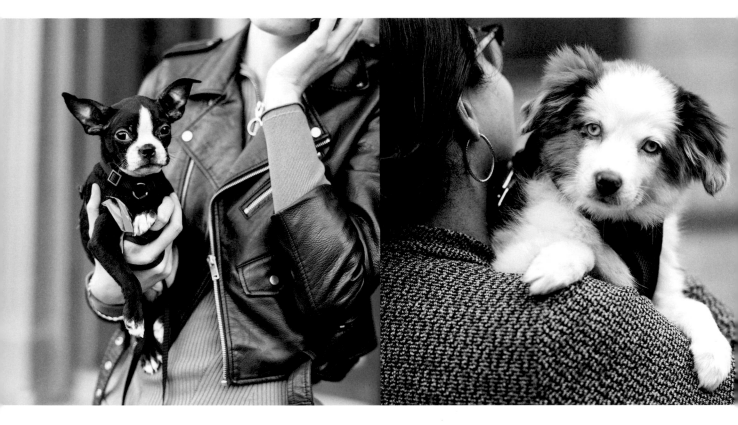

Erin, *Boston Terrier, 9 weeks old*

"We're working on a name."

Miniature Australian Shepherd,
12 weeks old

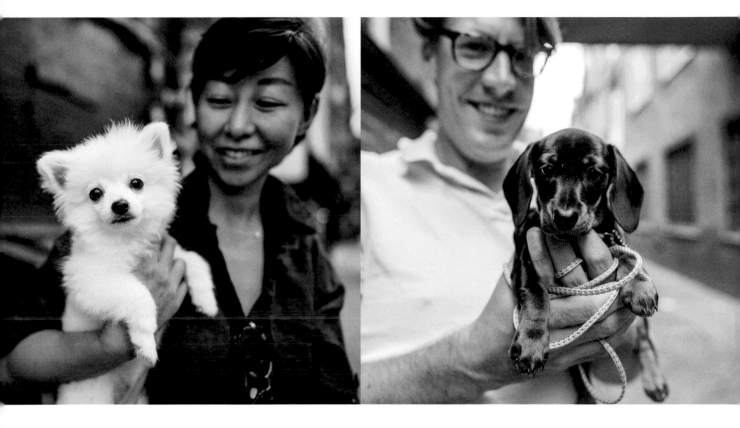

Jun-Ho, *Pomeranian, 4 months old*

Trix, *Dachshund, 12 weeks old*

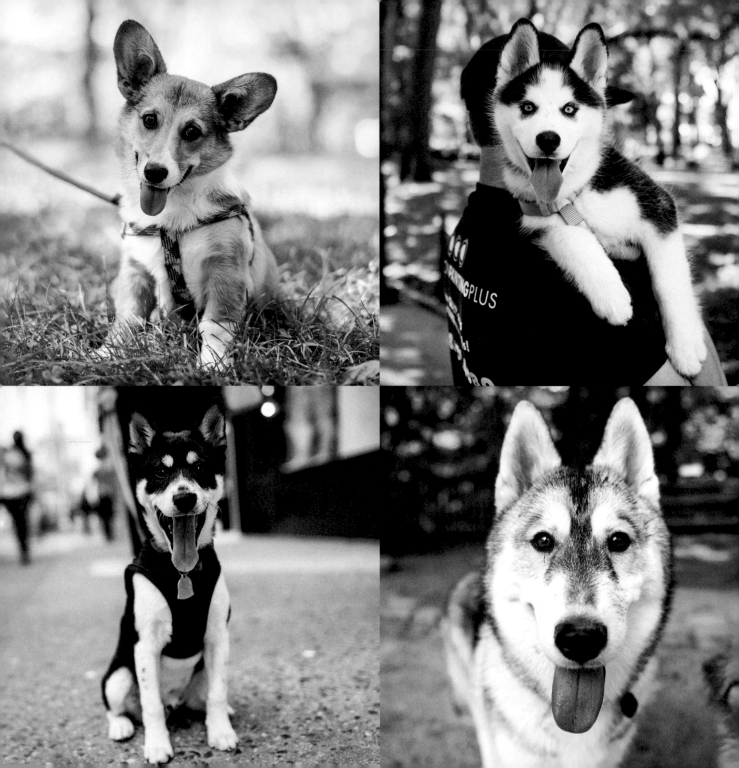

tongues

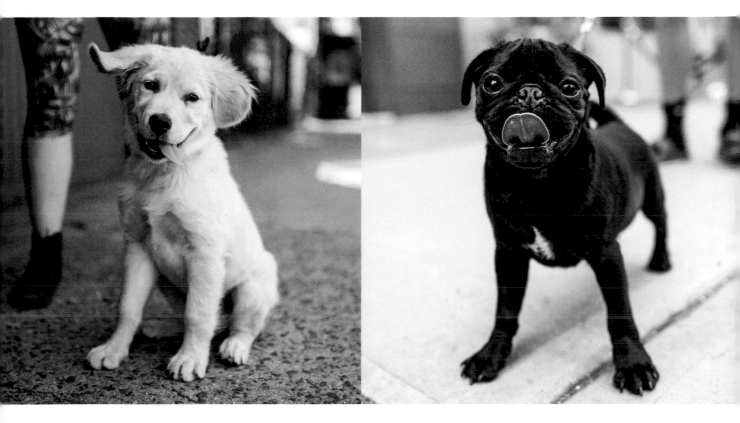

OPPOSITE, CLOCKWISE FROM TOP LEFT

Marley, *Pembroke Welsh Corgi, 6 months old*

Skylie, *Siberian Husky, 16 weeks old*

Charlie, *Siberian Husky, 6 months old*

Spence, *Shiba Inu, 16 weeks old*

THIS PAGE, LEFT TO RIGHT

Tucker, *Golden Retriever, 2 months old*

Lazer, *Pug, 3 months old*

two of a kind

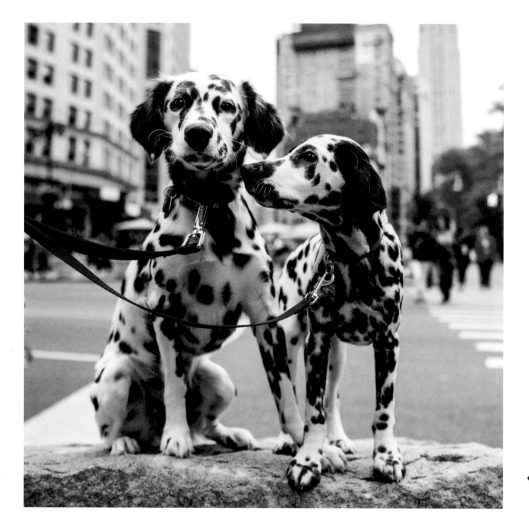

« **Madison** and **Finn,**
Miniature Dalmatians,
12 and 5 months old

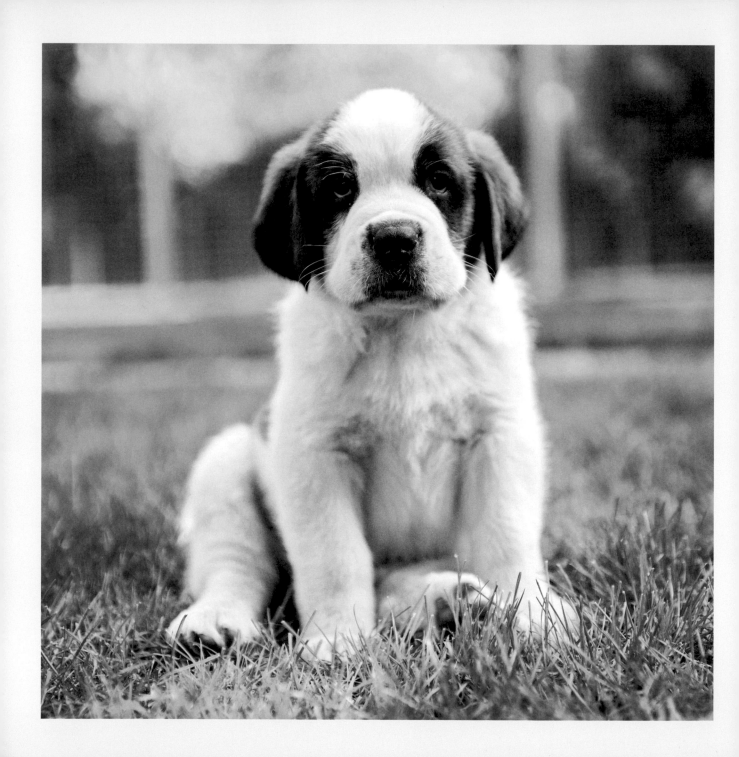

st. bernards

St. Bernards are incredibly loving and friendly, but they are also big and hairy, drool a lot, and will smell like wet dog in perpetuity if they get wet and aren't groomed afterward. If that doesn't deter you from these pups, and you have plenty of space and enjoy the outdoors, a St. Bernard might be just the ticket. Originally bred to search for and rescue those lost near the Great St. Bernard Pass in the Swiss Alps, this breed is very resilient to cold and is known for having a great sense of direction and a sixth sense about potential dangers. The breed is also often portrayed with a cask of brandy around its neck that would have been a welcome remedy for anyone lost in the mountains for an extended period of time. Today the St. Bernard's main role is more that of a loyal family member and potential therapy dog. At Barryland-Musée et Chiens du Saint-Bernard, in Martigny, Switzerland, the mission is to preserve the breed and tell the story of its unique history.

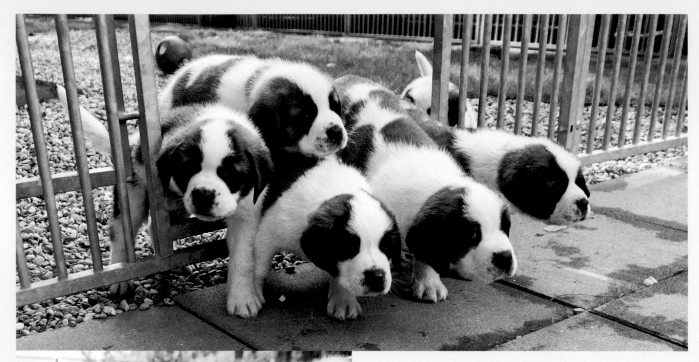

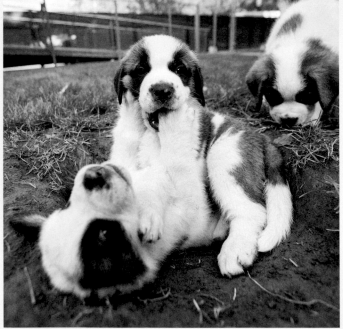

These St. Bernard puppies show little sign of how big they're going to get. When they reach adulthood, they can easily tip the scales at 250 pounds or more. It's a rare thing to be able to see such a large breed at such a young, small size. They grow quickly, and they require lots of food multiple times a day to sustain their growth.

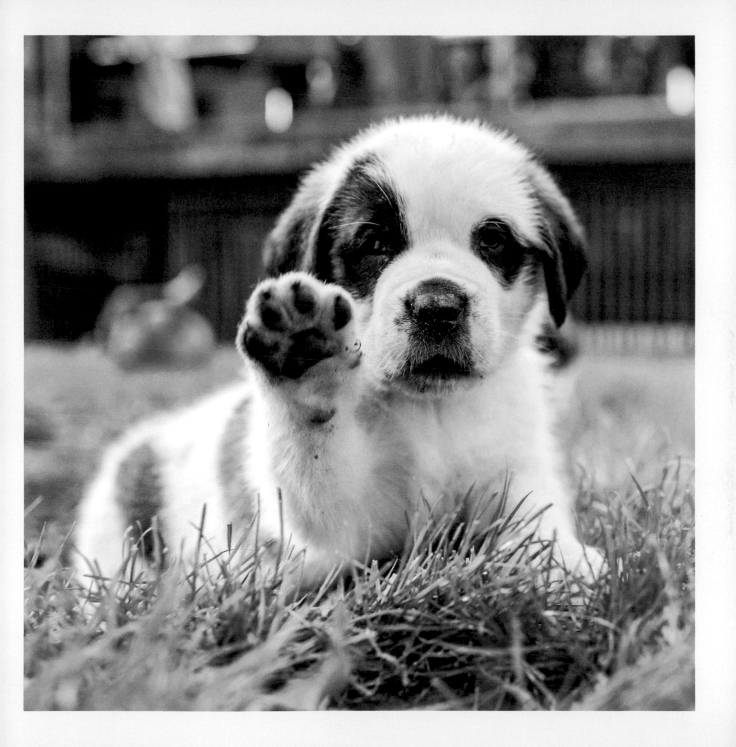

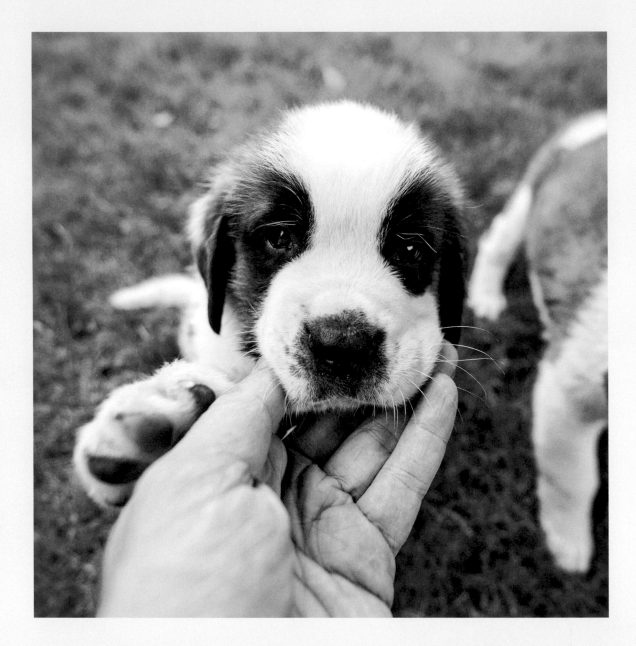

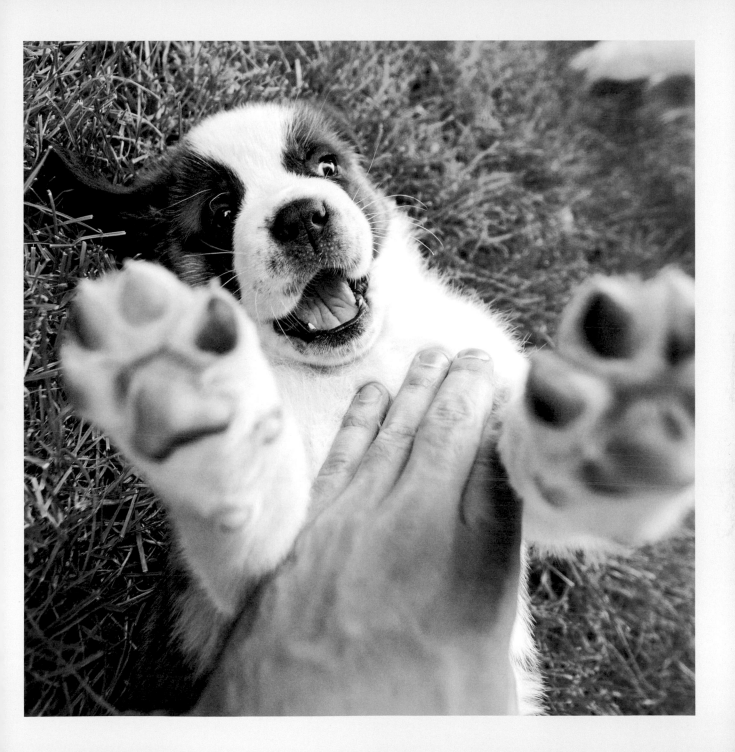

show pups

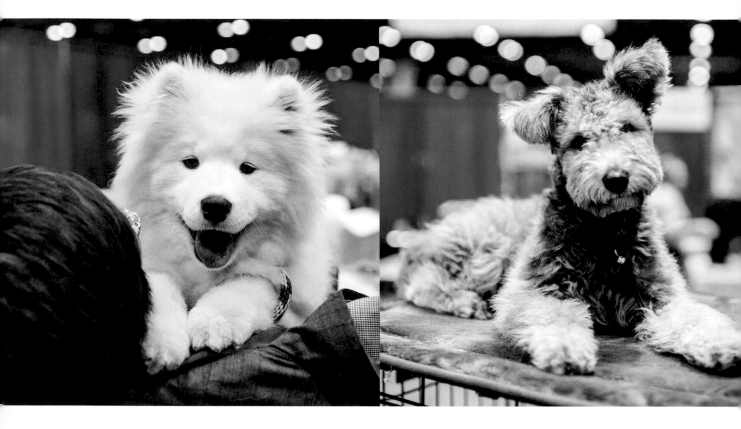

Samoyed, 3 months old

Csobanka, *Pumi, 6 months old*

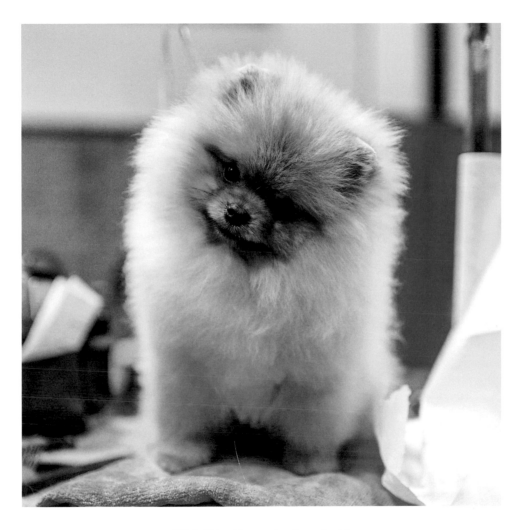

Michel Ray, *Pomeranian, 6 months old*

"He thinks he can take on the big dogs."

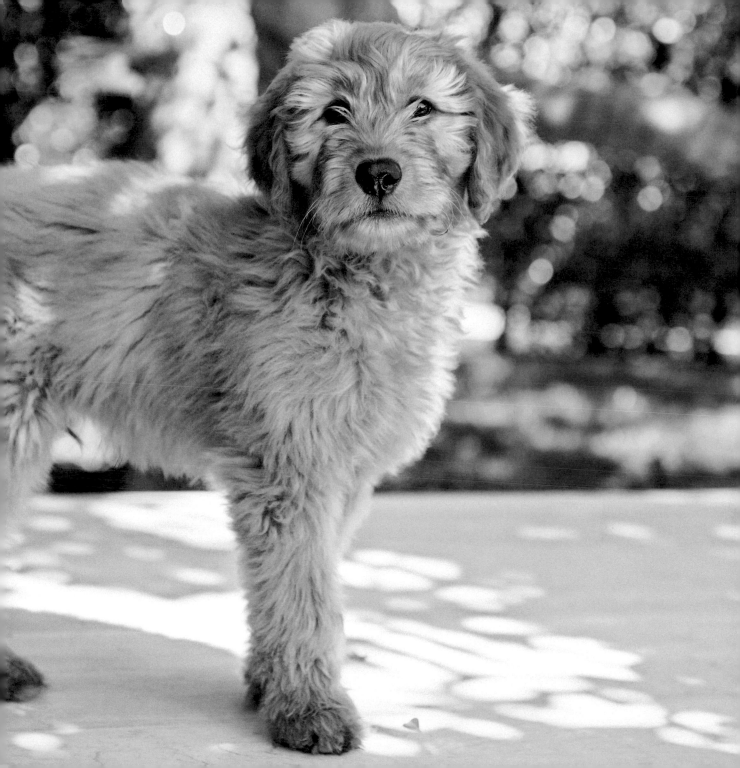

then

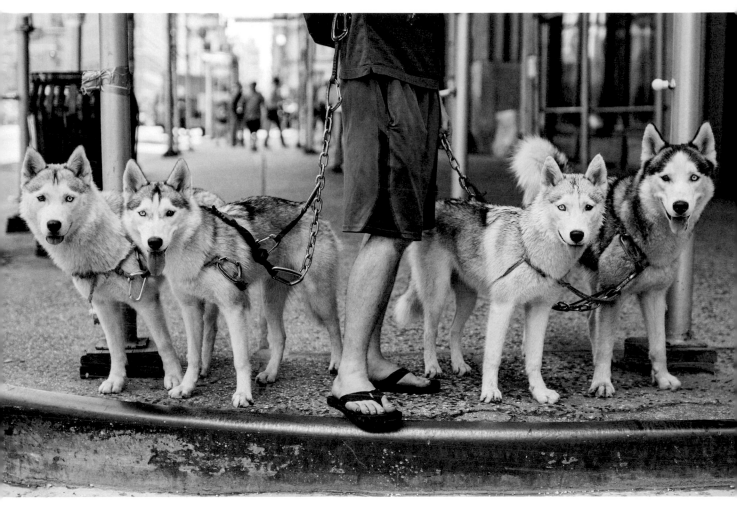

« Flame, *Siberian Husky, 4 months old*

and now

Ice, Flame, River, Storm, *Siberian Huskies, 8 months old*

playtime

CLOCKWISE,
FROM TOP LEFT

Opie Winston,
Cane Corso,
6 months old

Major,
Golden Retriever,
3 months old

Älpi,
Bernese Mountain Dog,
4 months old

Mango,
Golden Retriever,
5 months old

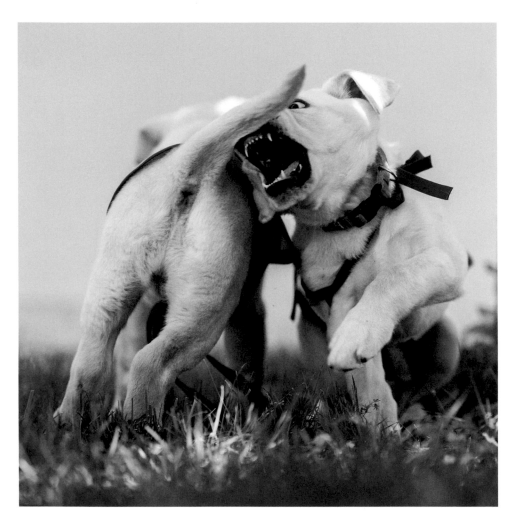

« *Labrador Retrievers,*
6 weeks old

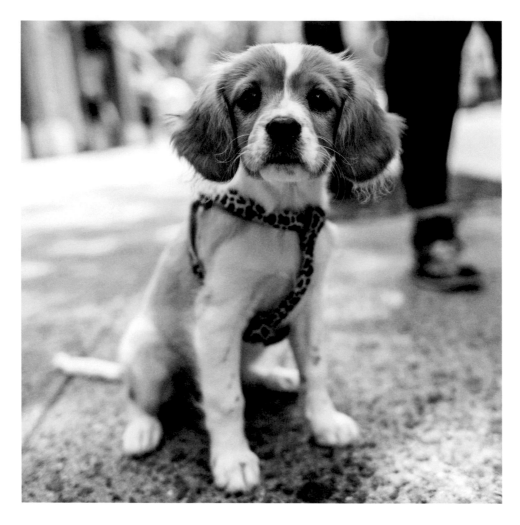

Ella, *Cavalier King Charles Spaniel/American Eskimo Dog mix, 12 weeks old*

"She wants to howl like a big dog, but she still has a baby howl."

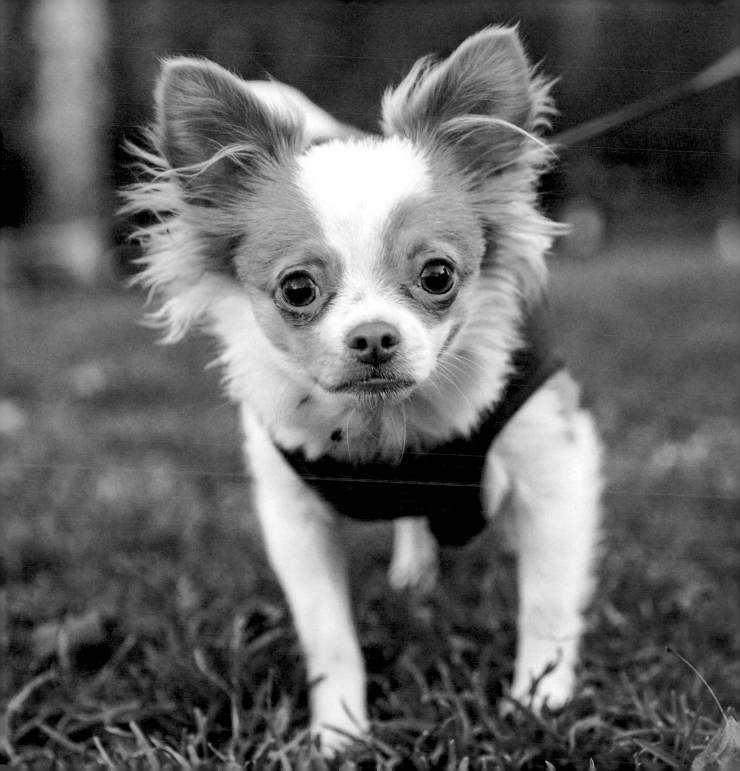

german shepherds

German Shepherds are one of the most intelligent and visually striking dogs you'll ever see. Developed in Germany, where it's referred to as the Deutscher Schäferhund, the breed was originally used for herding sheep. However, due to its athletic nature and trainability, the German Shepherd is now often seen in various working roles, including as police, military, and assistance dogs. When I visited Haus Amberg Shepherds breeding club in Amberg, Germany, they had a group of young pups beginning their basic training and socialization process. For a dog to be considered for this program, it must meet rigorous breed-specific physical and temperamental standards, all in an effort to rear healthier, happier, and more efficient working dogs. While any one pup could go on to live with a family or become a working dog, each dog must be protective, obedient, and able to track in order to graduate from the program.

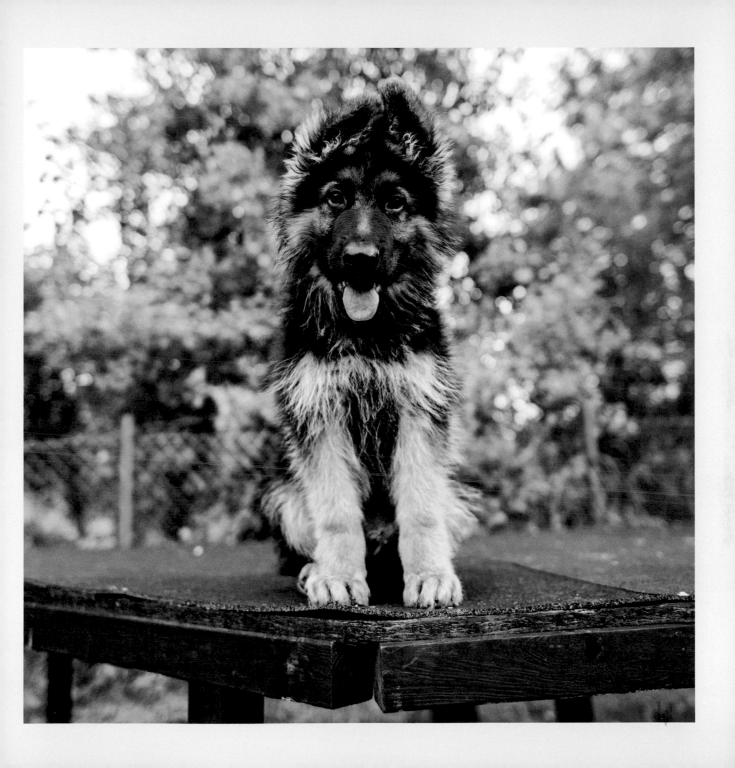

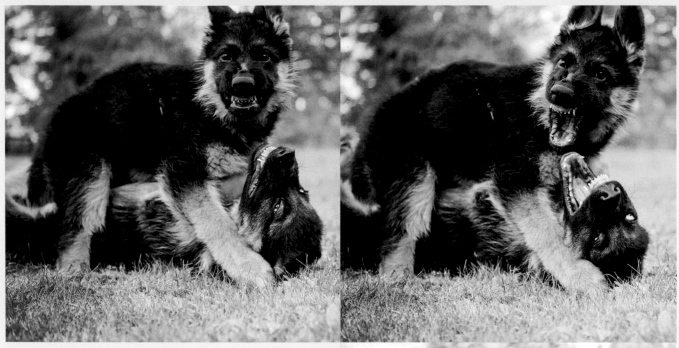

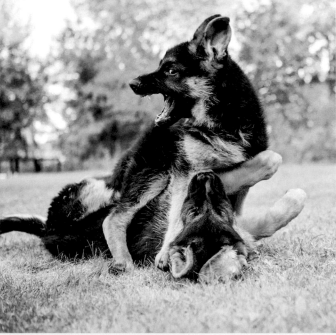

Rough play teaches the pup about boundaries. Here the dogs' body language shows that this is friendly roughhousing and not real aggression.

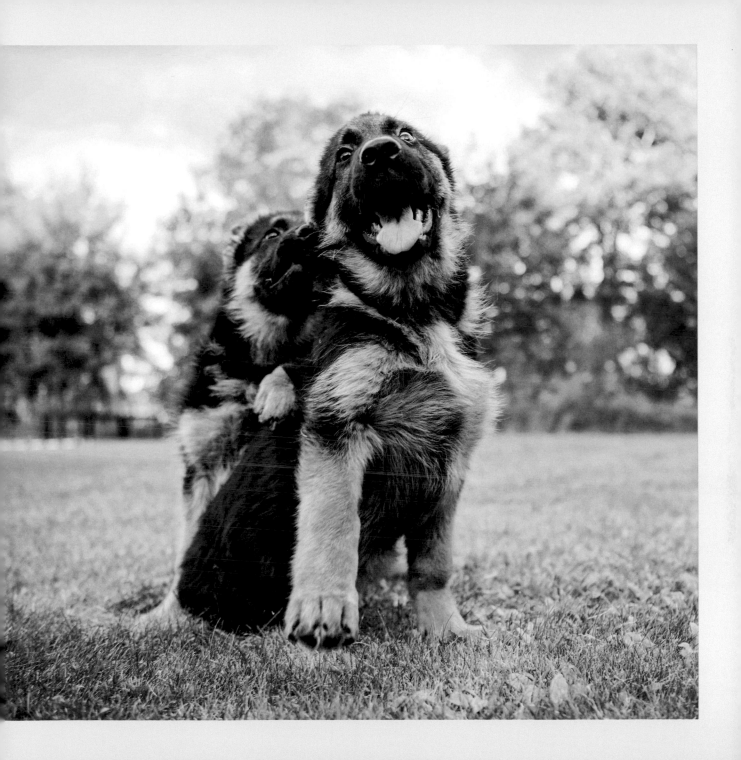

The breeder spends a few hours training the dogs each day. Here the puppies are performing a lure-coursing exercise where they chase a piece of leather. It engages their prey drive, gives them exercise, and is simply fun for them.

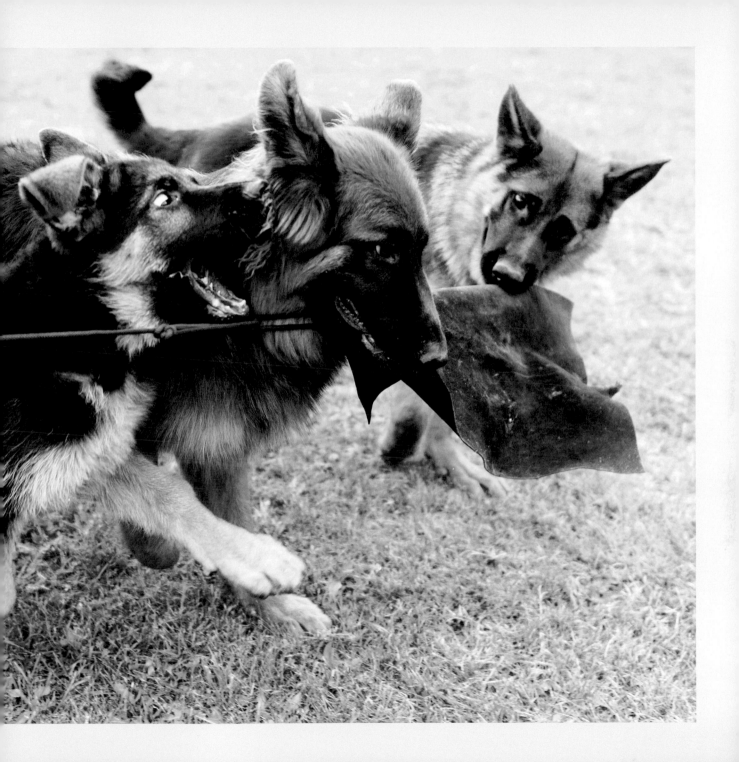

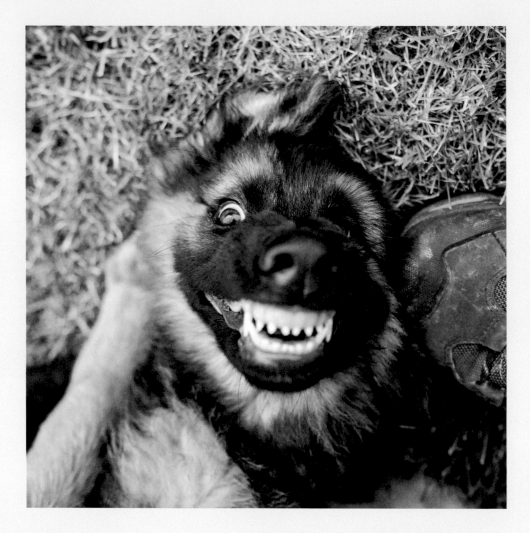

Puppies will get their milk teeth, or baby teeth, within 2 to 4 weeks of birth. By 6 weeks old, they should have all of their 28 baby teeth. Like humans' baby teeth, those teeth will fall out, and the adult teeth will come in when the dogs are 12 to 16 weeks old.

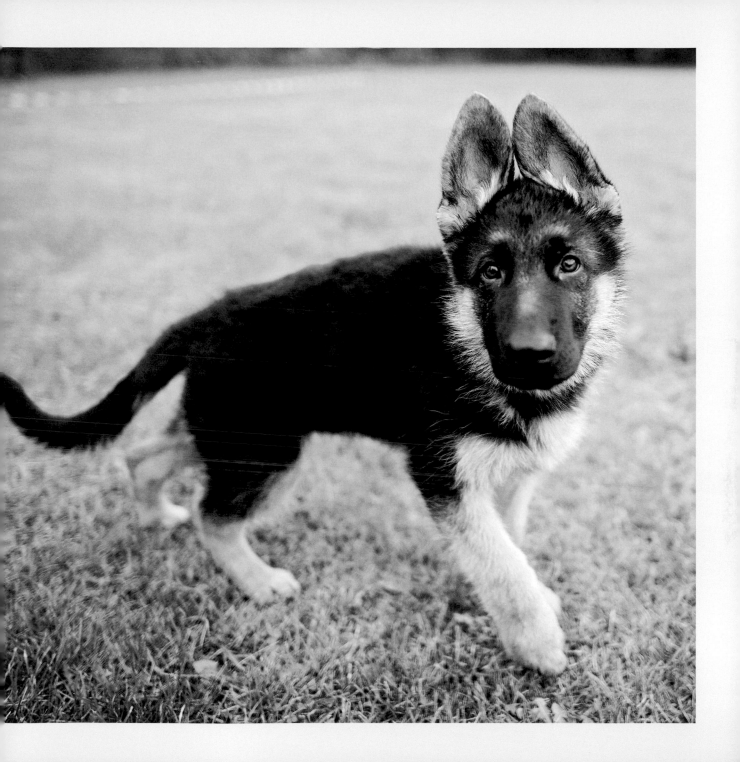

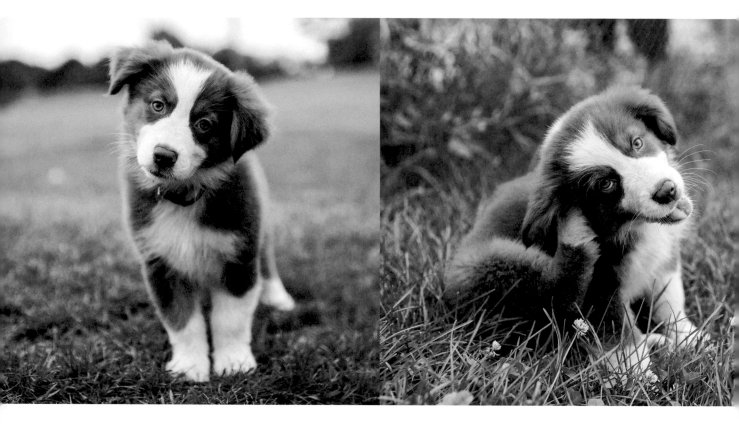

Charlotte, *Australian Shepherd, 9 weeks old*

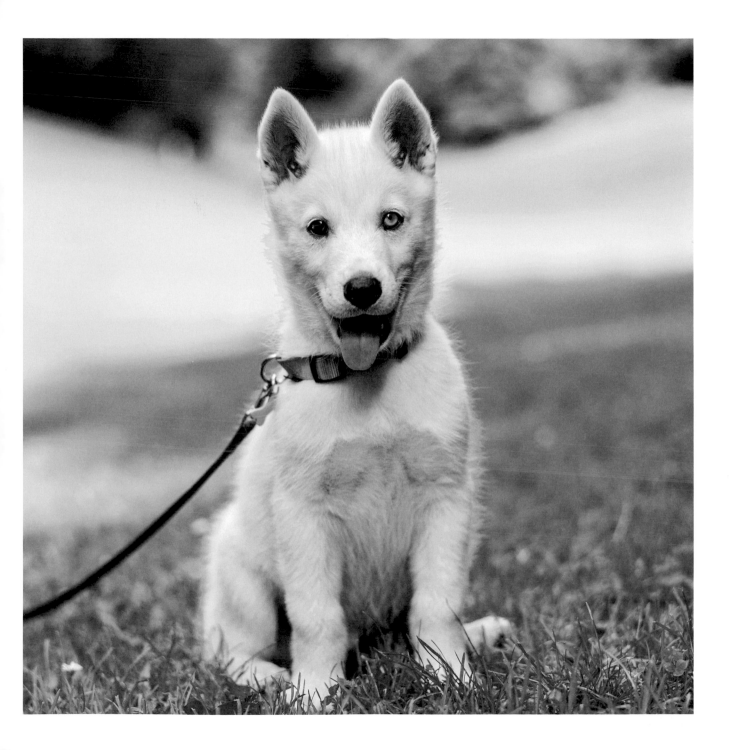

carried away

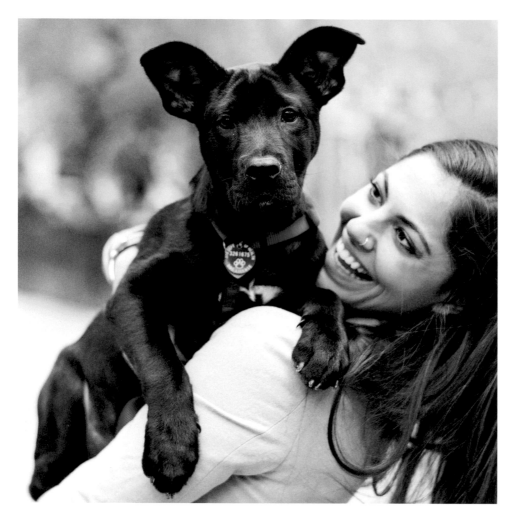

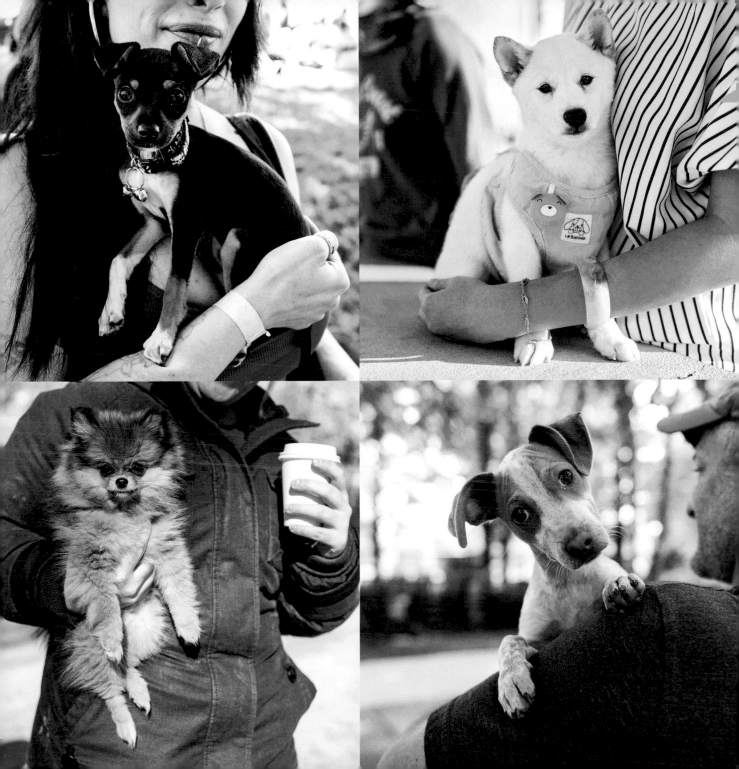

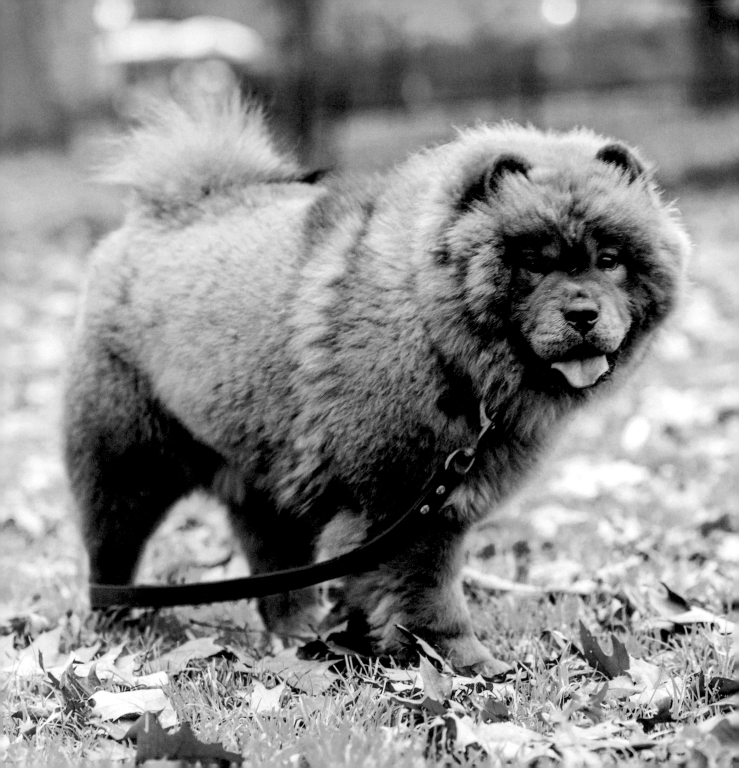

« **Huma,** *Chow Chow, 9 months old*

fluffy

Chester, *Wheaten Terrier,* »
3 months old

eyes

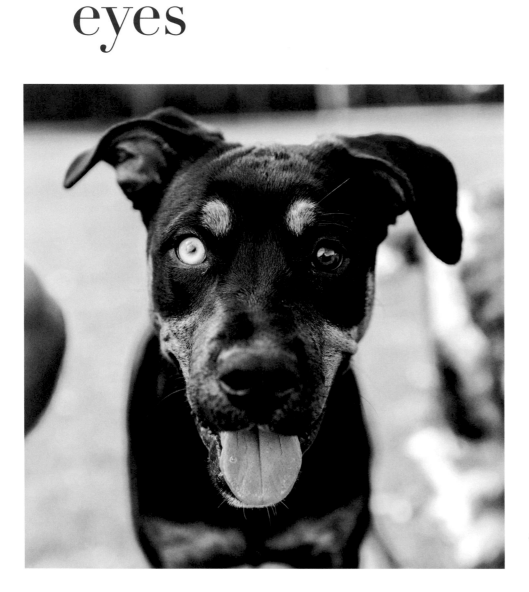

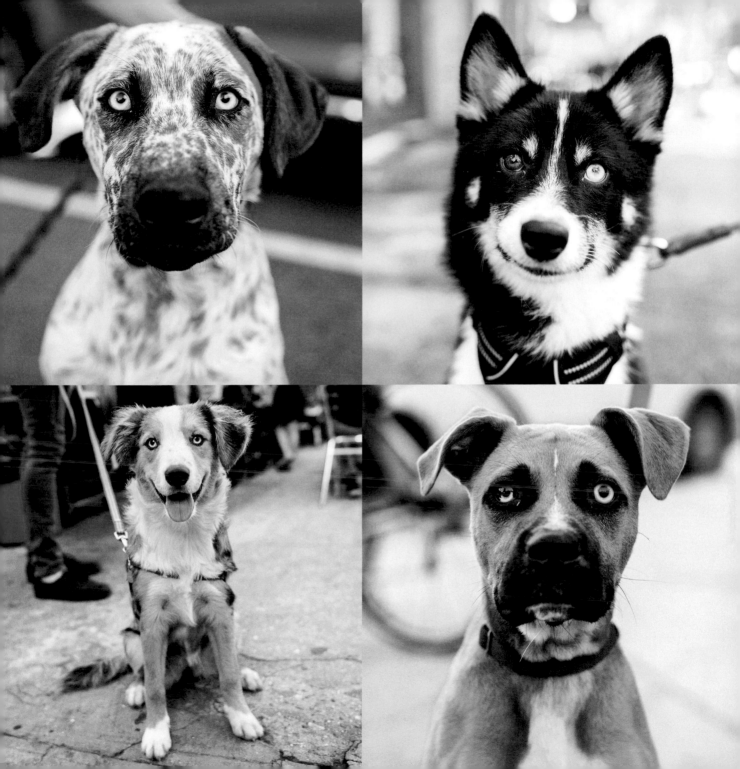

prison puppy program

America's VetDogs provides service dogs to disabled war veterans around the United States. Typically, volunteers raise potential service dog puppies in their homes; however, this special program enables inmates to raise puppies while they're serving time in prison. The puppies spend 24 hours a day with their handlers in prison, and then go home on the weekends to a volunteer family to experience different environments that prison life can't provide. About 10 puppies are part of the program at any given time, and in addition to the pups getting extra attention and training by living so closely with their handlers, the inmates themselves benefit greatly from the program. Being a puppy raiser is a special privilege that gives a prisoner a sense of purpose, patience, and responsibility. As convicted felons, these men may experience a level of stigma when interacting with other people, but the dogs never judge a prisoner for his past. Some of the inmates come from a military background as well, so being able to give back to other veterans gives them an extra sense of pride and duty.

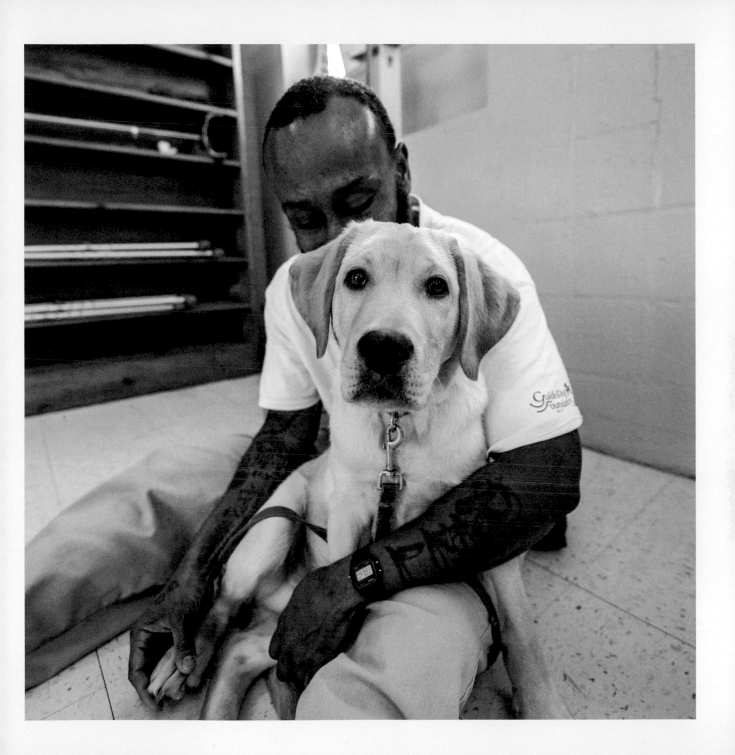

The puppies are taught to open

doors and turn on light switches. The "rest"
command is used for the delivery of an object.
This command is also helpful for individuals
who suffer from PTSD—the eye contact with
the dog is very calming. The trainers teach the
dogs how to be patient, and everything the dogs
learn tends to help the inmates too. The inmates
heal and grow while training the puppies.

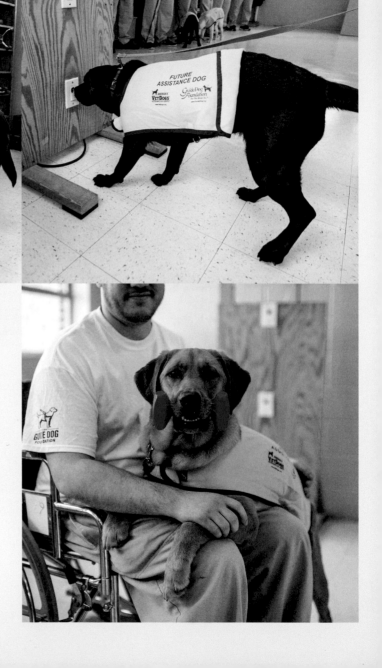

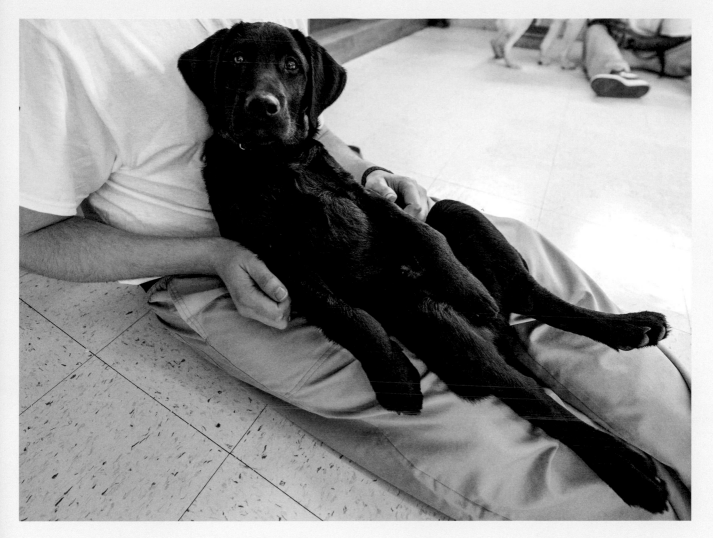

"She's taught me how to love again, and allows me to feel and let my emotions out."

Syria, *Dogo Argentino, 4 months old* »

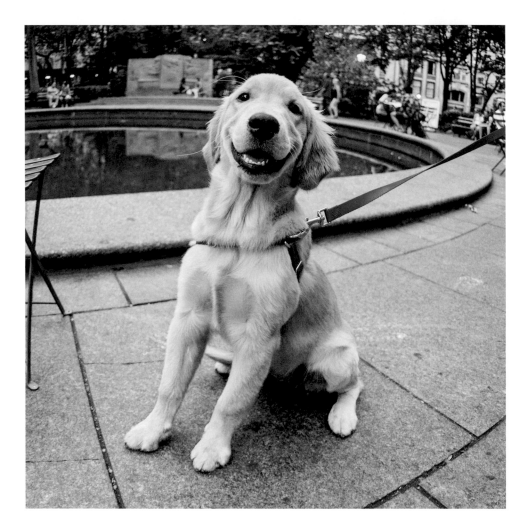

Riley, *Golden Retriever, 5 months old*

doodles

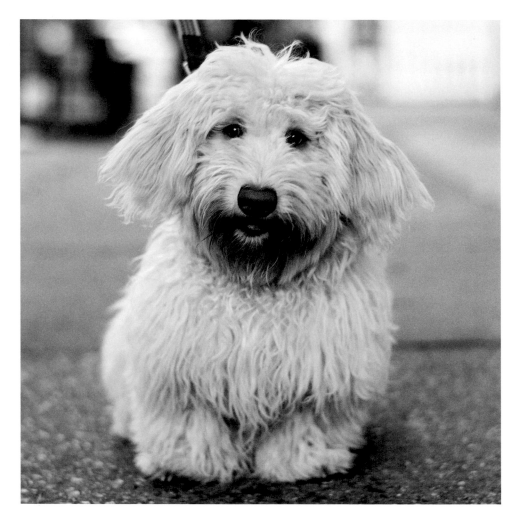

Teddy,
Miniature Goldendoodle,
12 weeks old

Lincoln,
Sheepadoodle,
4 months old

Bodie,
Maltipoo,
5 months old

Bear Cub Grylls,
Goldendoodle,
12 weeks old

Olaf,
« *English Goldendoodle,*
6 months old

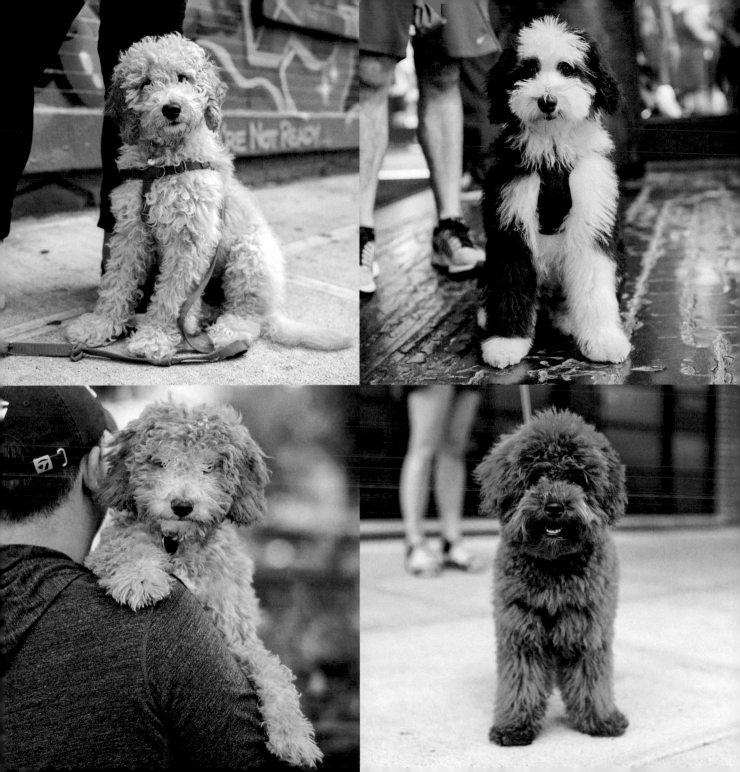

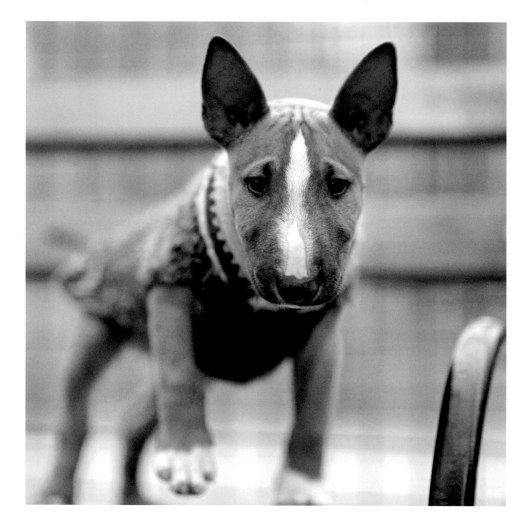

Tusker, *Miniature Bull Terrier, 3 months old*

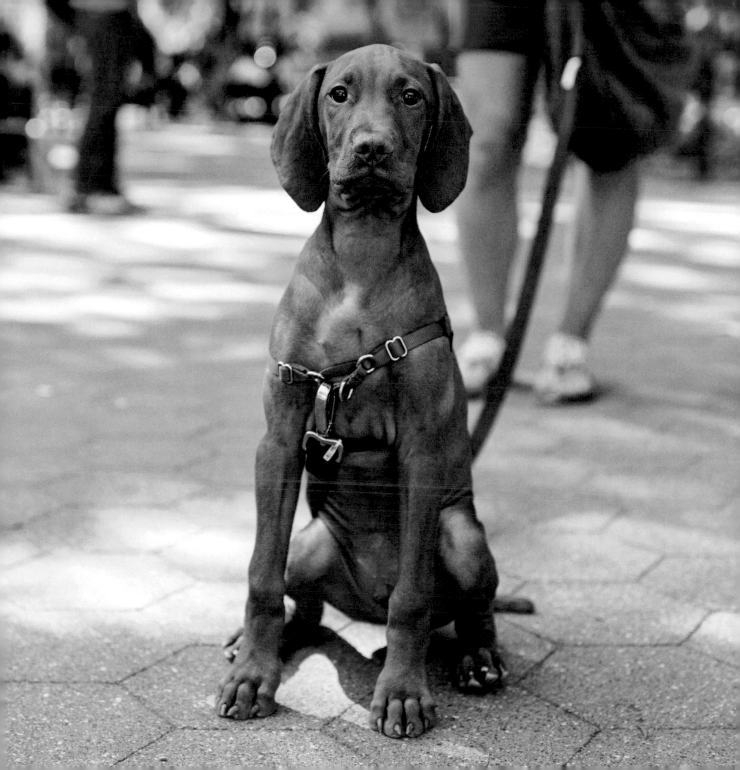

small münsterländers

Small Münsterländers are trained to track, point, and retrieve game with enthusiasm and are one of a select few breeds considered to be "Versatile Hunting Dogs." Other, more familiar breeds in the group include Setters, Pointers, and Vizslas. Developed on farms in and around Münster, Germany, more than 500 years ago, the breed used to point and flush game (like quail, chukar, and grouse) from dense brush, at which point a trained falcon would fly down to capture it. When guns took the place of falcons, Münsterländers took on the role of retrieving the game as well. These dogs are extremely intelligent, have a keen sense of smell, are built like athletes, and are highly biddable, meaning they like to perform tasks for their handler. These qualities make them the perfect hunting dogs and consequently very difficult to obtain. Only about 2,000 exist in the United States, and breeders will always favor homing one with an active hunter. It's what these dogs were bred to do, after all.

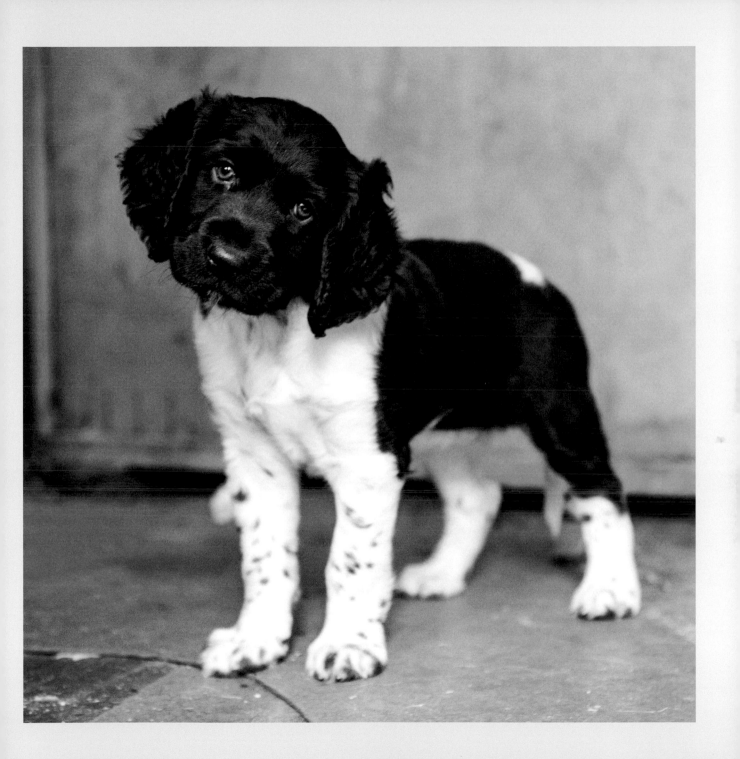

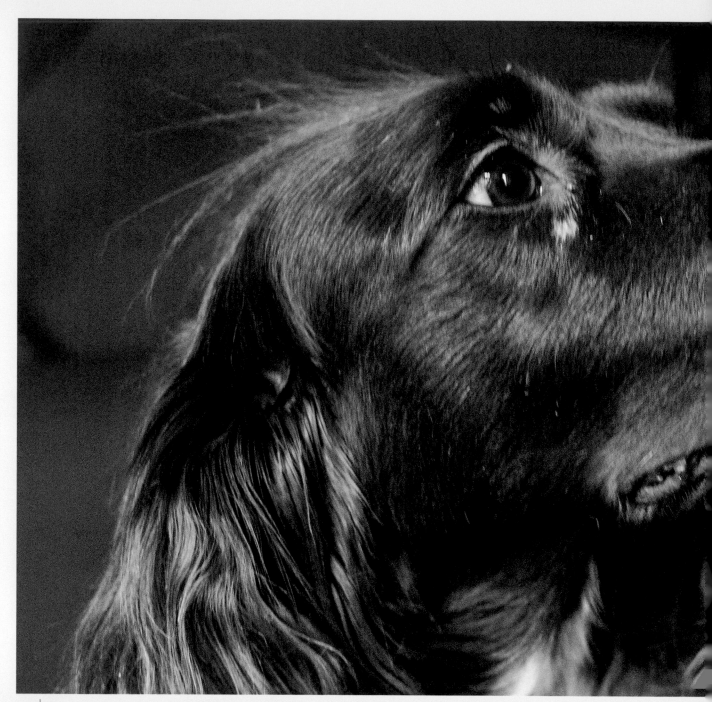

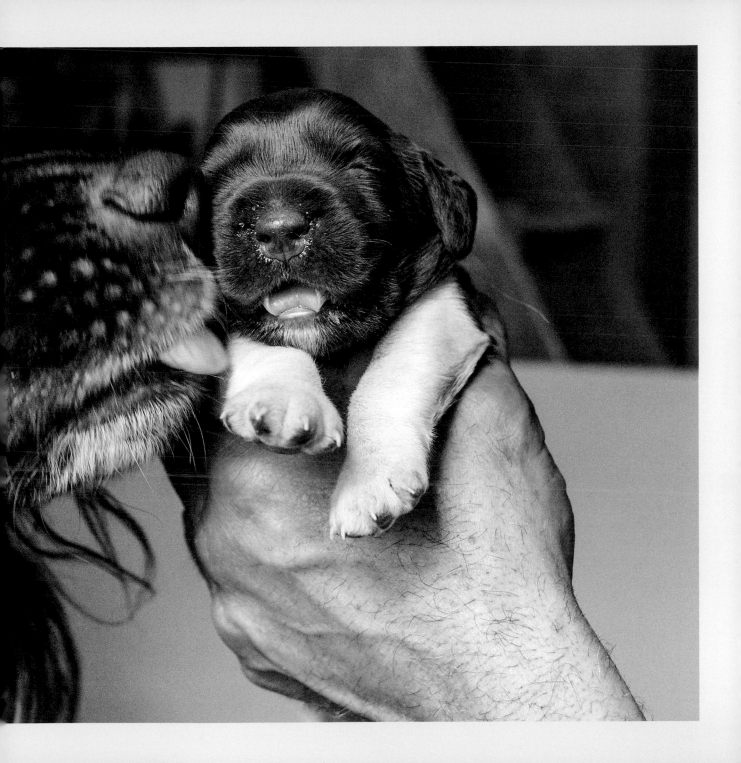

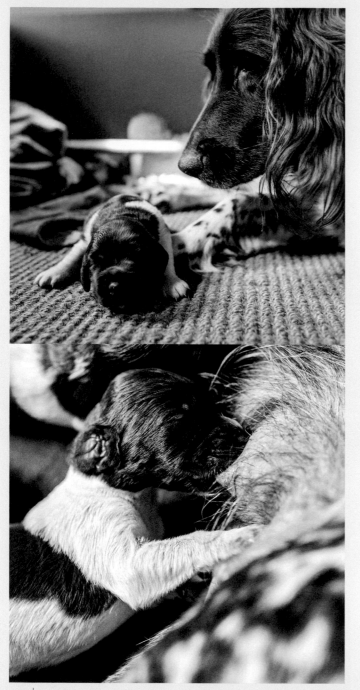

It's normal behavior for the mother to carry her pups in her mouth. She knows the perfect amount of mouth pressure to move the puppies around and out of harm's way. Here she grips a 1-week-old pup; by 3 weeks, the pup will be walking on his own.

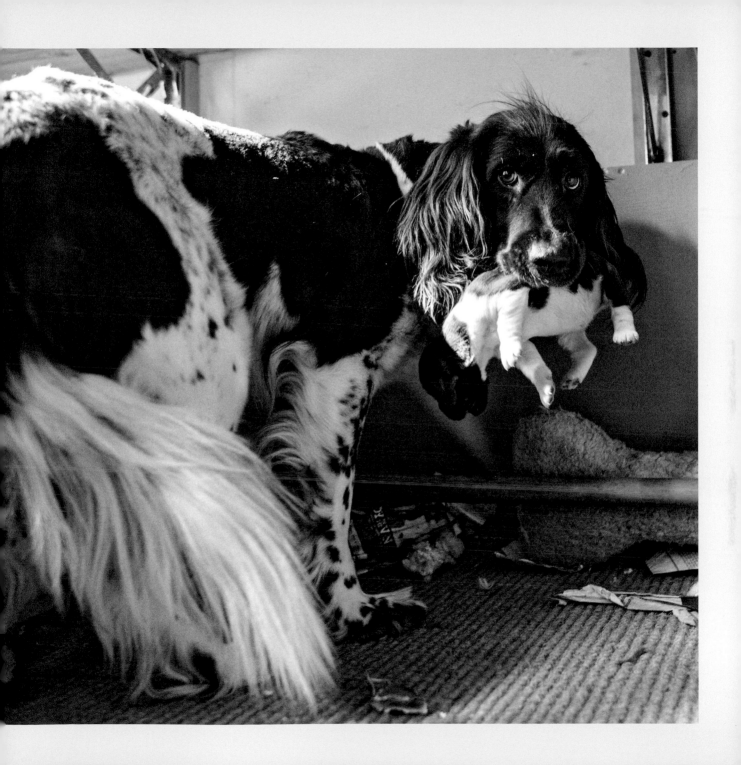

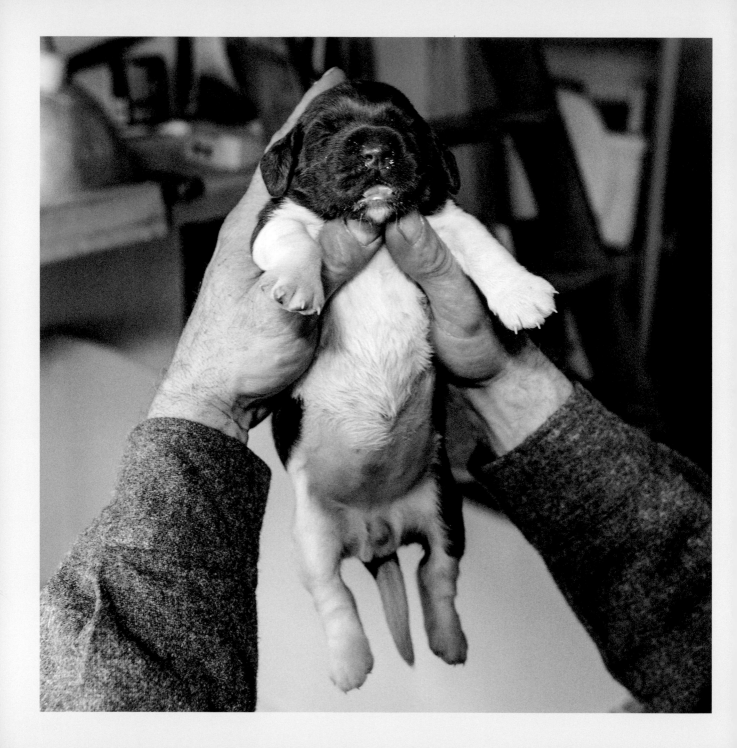

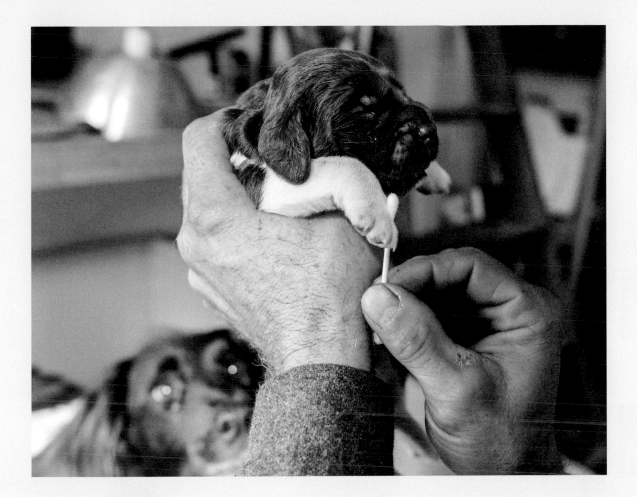

Breeders of working dogs will often stimulate young pups using a biosensor program to help introduce various sensations to better prepare a dog to work in the field. Gently inserting a cotton swab between their toes for a few seconds once a day familiarizes the dog with tactile sensations on its feet. Other stimulation exercises include holding the pup upright, upside down, in a supine position, and on a damp towel for a few seconds each once a day.

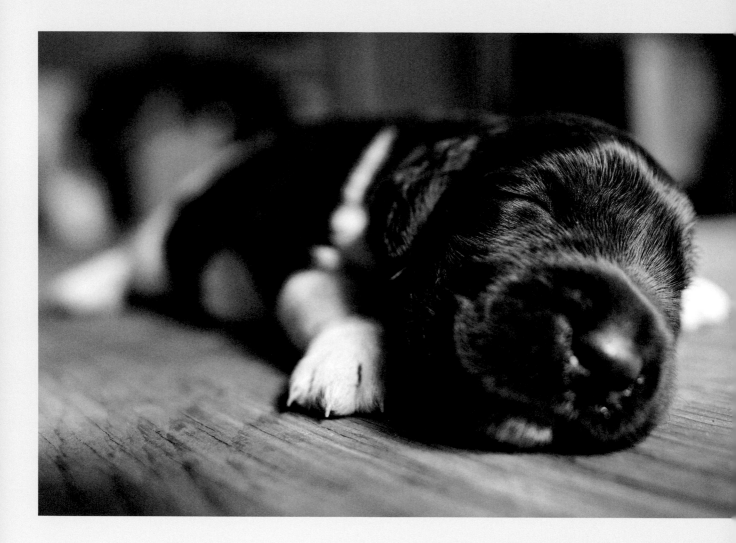

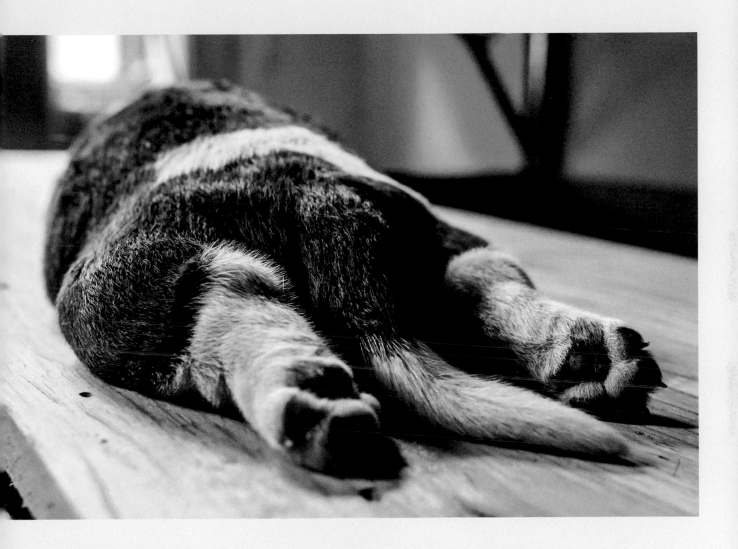

puppy care

The vet will get a puppy accustomed to having his paws handled by clipping his nails when he is young.

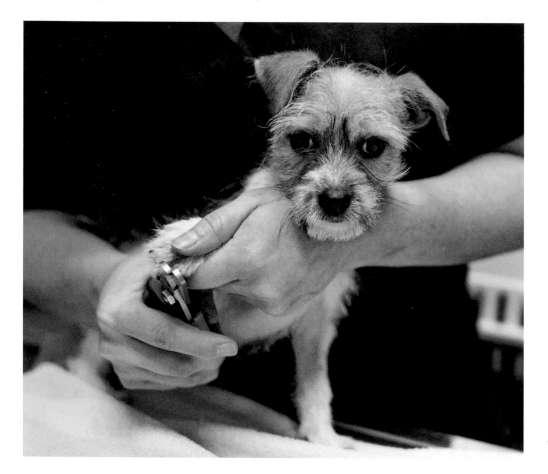

« *Terrier mix,
8 weeks old*

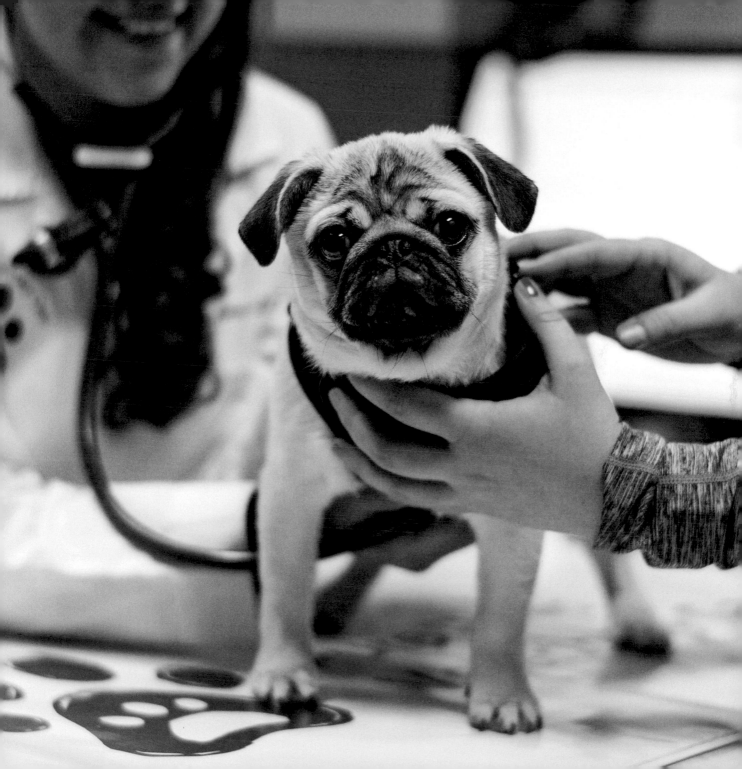

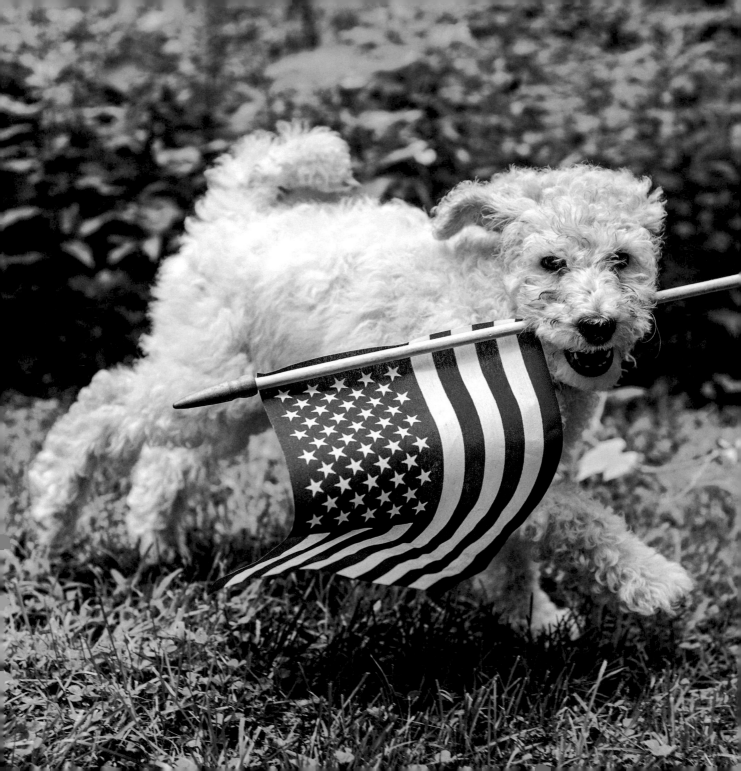

« **Babka,** *Standard Poodle, 9 weeks old*

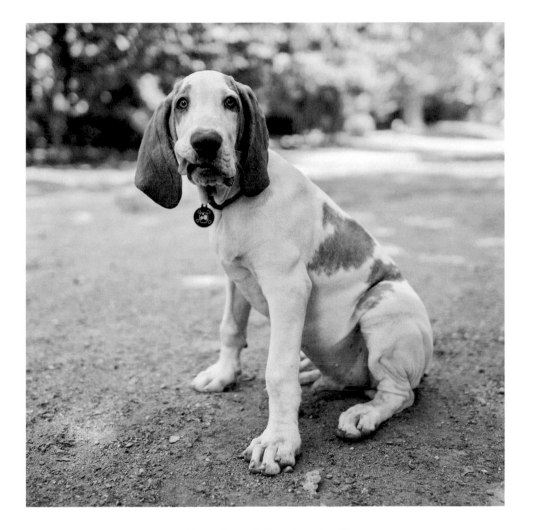

Cirano, *Bracco Italiano, 3 months old*

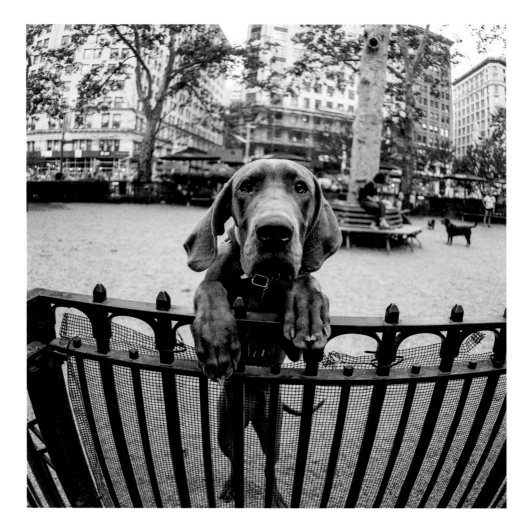

Frankie, *Great Dane, 6 months old*

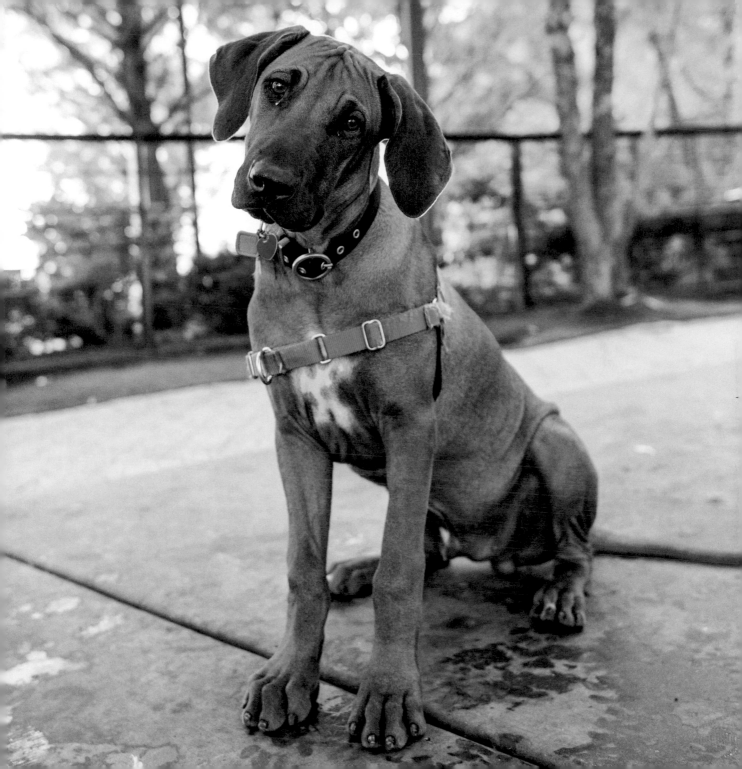

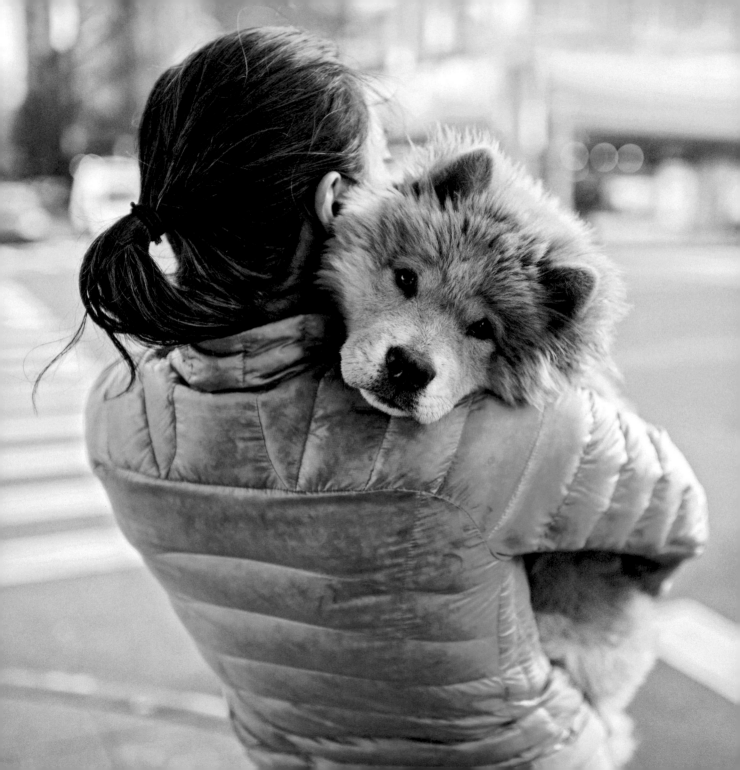

then

« **Michou,** *Chow Chow, 4 months old*

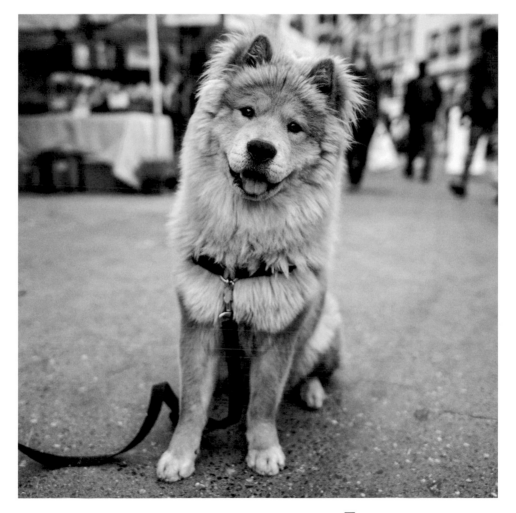

and now

1 year old

frenchies

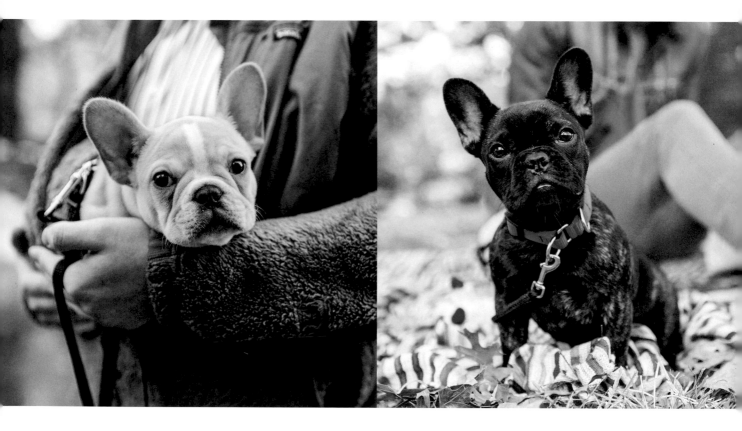

Jameson, *French Bulldog, 11 weeks old*

Stella, *French Bulldog, 4 months old*

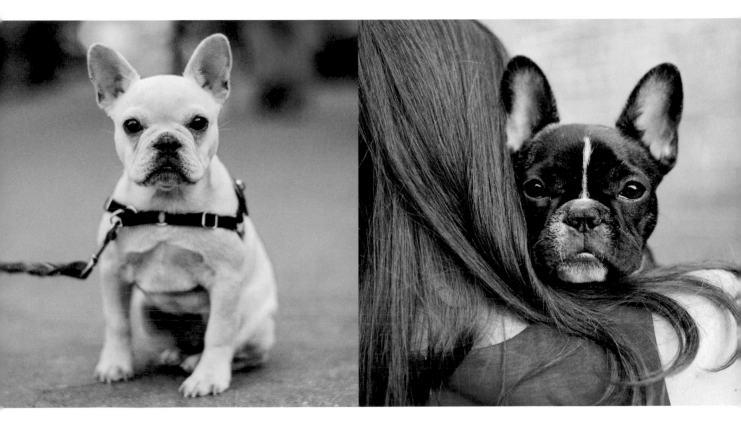

Henri, *French Bulldog, 12 weeks old*

Stella, *French Bulldog, 4 months old*

acknowledgments

This was a very fun book to shoot for several reasons, some of which are obvious. Firstly, puppies! I savored every moment with each puppy, knowing how impressionable they are and that I had the special privilege of photographing some of them before they could even see. Thank you to the newborns for soundly sleeping while I took your photos. Equally as important, I have to thank the mothers who so graciously allowed me to photograph their young puppies. The moms were always nearby, keeping a watchful eye on what I was doing.

Behind every great mama dog was a responsible owner or breeder who prioritized the health and wellness of his or her dogs over everything else. Thank you to the owners and breeders for taking the effort to ensure your dogs have great lives even after they leave your care, including Icewind Farm, Cold Mountain Siberians, Westies R Us, Joyce Country Sheepdogs, Angela Evans, Fall Brook Run, Fairytale Frenchies, Redland Kennels, Saltydog Kennels, Shark Rum Breeders, The Seeing Eye, Canine Companions for Independence, Barryland—Musée et Chiens du Saint-Bernard, Haus Amberg Shepherds, America's VetDogs, and Pure Paws Veterinary Care.

I want to thank the shelters and organizations that I worked with to spotlight puppies that need homes, especially North Shore Animal League America. Litters of all types of dogs can come from all over the country and need all sorts of special attention to make sure they're happy and healthy. And while finding homes for them may be easier than for other adult dogs at the shelter, setting any dog on the right course with the right family is crucial to their success. Thank you for the tireless work that you do.

Behind every puppy I met on the street was a likely sleep-deprived owner, accruing vet bills for their new friend. Thank you for committing the time, energy,

and funds to ensure your new family member lives their best life. I look forward to seeing your dogs all grown up around town.

I want to thank my assistant, Isabel Klee, for liaising with countless people to get all the puppies photographed for this book. You kept me on track and were excellent at holding puppies for the photos. (I know many people would happily hold puppies for free, but few could do it so well.)

I want to thank Judy Pray and Speck, Mura Dominko and Tikka, Jane Treuhaft, Michelle Ishay-Cohen, Nancy Murray, Theresa Collier, Allison McGeehon, Zach Greenwald, Lia Ronnen, and everyone else at my publisher, Artisan Books, who did such an incredible job with my first book—and now my second—that I can proudly add *New York Times* bestselling author to my résumé. I look forward to continuing our work together as my projects evolve.

I'd like to thank Janis Donnaud and Loni Edwards for making sure The Dogist continues to thrive and progress.

To my family and friends: seeing me as a "dog photographer" may have normalized to some degree over the years, but I can't thank you enough for your continued support (and sarcastic mockery). You keep everything in perspective.

To my fans: I've always wanted to consider myself an artist without any reservations or doubt about whether I am one. The millions of voices that celebrate me for my work in every which way leave no doubt in my mind that photography is my calling. I live to make you (and your dogs) smile every day. Thank you for making this all worthwhile.

index

Millie, *English Bulldog, 4 months old*